ARTHUR CARTER

SCULPTURES, PAINTINGS, DRAWINGS

And all shall be well and
All manner of thing shall be well
When the tongues of flame are in-folded
Into the crowned knot of fire
And the fire and the rose are one.

—T. S. ELIOT

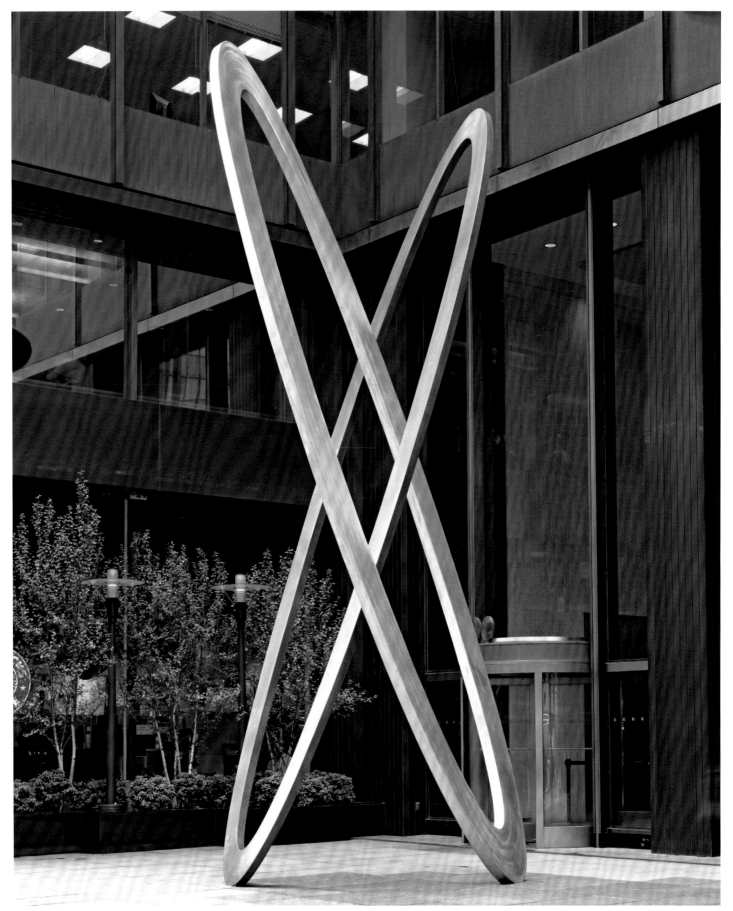

The Couple, 1999. Stainless steel and bronze, 360 x 128 x 96 in.

ARTHUR CARTER

SCULPTURES, PAINTINGS, DRAWINGS

CHARLES A. RILEY

PETER W. KAPLAN

Abrams, New York

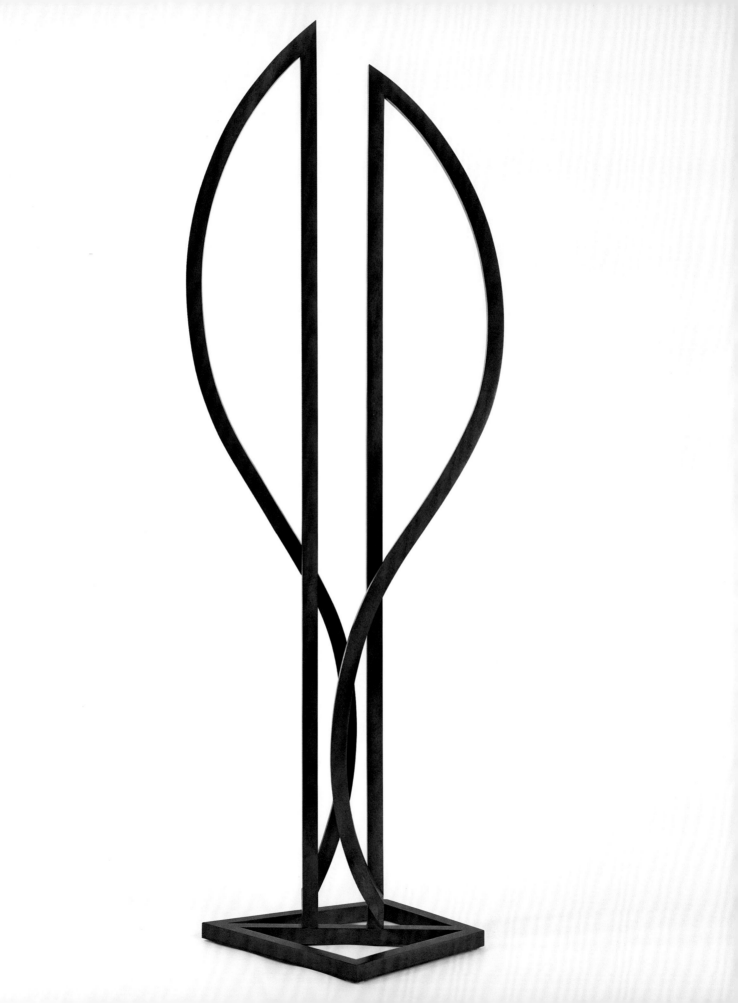

CONTENTS

OPPOSITE: *Inverted Arcs at 180 Degrees with Parallel Chords*, 2005. Bronze with blue patina, 40 x 12½ x 3 in.

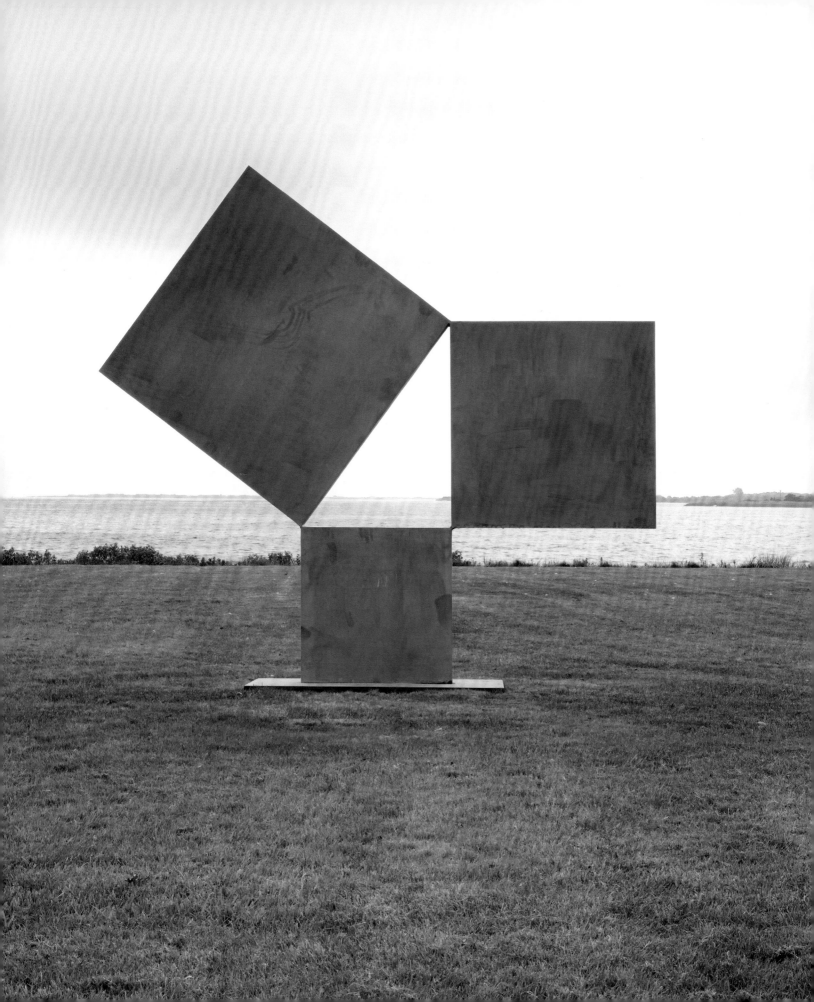

ARTHUR CARTER: SCULPTURES, PAINTINGS, DRAWINGS

CHARLES A. RILEY

> The air is full of infinite lines, straight and radiating, intercrossing and interweaving without ever coinciding one with another; and they represent for every object the true form of their reason (or their explanation).[1]
>
> —Leonardo da Vinci, *The Notebooks*, Manuscript A, Folio 2

Entering the mind of an artist is a delightful and daunting challenge. It took the estimable Paul Valéry two essays to scale the intellect of Leonardo and his double capacity to do art and science simultaneously. "He has the charm of always seeming to think of something else," Valéry observed. Invoking mathematical induction, the poet and critic celebrated a faculty "that leads the mind to foresee itself and to picture as a whole whatever was going to be pictured in detail, together with the effect of the sequence." Thirty-six years later, Valéry added a marginal note to the re-publication of "Introduction to the Method of Leonardo" in which he anxiously wondered, "Is it possible to make anything except under the illusion that one is making something else?"[2]

OPPOSITE: *Mathematika*, 1997. Aluminum, 96 x 105 x 5 in.

Arthur Carter is one of those intriguing artistic double agents—simultaneously operating on multiple aesthetic and intellectual planes—whose work absorbs and rewards close study. Much of his sculpture is based on inverted or mirror structures, like two-part inventions at the keyboard. His chosen medium, welded steel, leads to a "sculpture of ascent" (in the words of Julio González, who, with Pablo Picasso, created the first welded sculptures) and a sculpture of assent, thanks to his affirmative response to Constructivism. Where many artists work in a deductive way, Carter is inductive, even inferential in his serial progress from one piece to the next. An improvisational exercise in Method acting classes has participants starting their responses with the phrase "yes, and . . ." rather than the contradictory "yes, but." The conjunction "and" carries weight. Carter is exuberantly an artist of "yes, and."

Not all artists are thinkers. Some are extravagantly free of this burden, relying on feeling or action. Jackson Pollock was no thinker, no matter how eloquently Clement Greenberg rhapsodized to the contrary. The tiny library in the nineteenth-century farmhouse Pollock shared with Lee Krasner in Springs, Long Island, includes books by James Joyce, André Malraux, Simone Weil, and others, brought out from the city by visitors and resting unread (their paperback spines intact) on the white wood shelves over the door to the tiny living room. By contrast, Robert Motherwell, Buckminster Fuller, and others (in our time, Peter Halley and Matthew Barney) are ostentatiously intellectual, lacing their work with titles, captions, essays, narratives, and manifestos that are political, social, personal, art historical, or all of the above. Arthur Carter belongs in neither class.

Carter moves quietly and laterally from perception to drawing to fabrication. Although the double life of this artist would seem like an invitation for critics to tee up and explicate encoded meanings or translate enfolded texts and subtexts, with his sculpture a headlong ride down the road of interpretive analogy is liable to overshoot the destination. The ideas that he has absorbed, including some sophisticated mathematics and music, are not illustrated by the work, but remain latent presences within it. Despite his high Modernist tendencies, he is not that committed to either of its two main doubling tendencies: irony or allegory. He is not using parody to take the mickey out of David Smith, Alexander Calder, or Piet Mondrian. Nor do his dancing figures spell out a coded narrative, even if they do have the character of calligraphy (see fig. 1). Moreover, his aesthetic runs against the grain of a current art scene that revels in destructive satire and baroque extremes of ugliness, from the "Anti-Monumental" polemic of the curatorial agenda at the New Museum to the jokes and ephemera of the Whitney Biennial. One of the many satisfactions of regarding Carter's work is the feeling that one is quietly pulled toward its poetry, not pushed by rhetoric. This is in part because he is among the blessed few talents at work today who realize there is art apart from politics, including the increasingly boring politics of identity. This is not to say that he is an epigone of a bygone style. Nor that he is a Postmodernist, Post-Minimalist, or Post-Constructivist. Frankly, the best way to situate Carter within the art of our time is to forget the art of our time for a moment. And this will annoy many.

Carter lives and works in the present using an aesthetic language coined eighty years before by the Constructivists and comprehensible to any Formalist today. Form is one touchstone. In a rollicking erotic poem the artist wrote in 1980, "Smudges of Desire," he uses the word "form" nineteen times in the space of 178 lines. Beauty is another. Unabashedly fond of the word, Carter pairs it with "elegance" in a defiantly idealistic way. During a studio visit and interview in the summer of 2008 he offered this basic set of artistic guidelines:

FIGURE 1. *Tektonics*, 2000. Stainless steel painted blue, (from left to right) 94 x 64 x 24 in., 104 x 55 x 24 in., 100 x 36 x 20 in. Translating the gesture of drawing directly from the plane to the three-dimensional world of freestanding objects, this series of dancing figures is a reminder that a silhouette is a line.

I like to keep the slate pure and clean. My work focuses on simplifying and eliminating the excessive. The question is, how does purity of design lend itself to making a beautiful and elegant piece? In basic terms, the important criteria are that it is original, not derivative, even if it is closely connected to Constructivism. It has to be simple. Beyond that, it must have elegance and beauty. Simplicity may be the most difficult to achieve. Perhaps too much time is spent concentrating on these principles, but they are basic to my work.

DRAWN TO STEEL

As Peter Kaplan points out in his captivating portrait at the end of this volume, art is the fourth act of Carter's life story. After a phenomenal walk down Wall Street, he made a second career as a serial entrepreneur, owning one hundred different operating companies, many of which he created and continues to run. A bright red industrial spring stands two feet tall on his drawing table—it was made in one of his factories (see page 43). His third career was publishing, as founding publisher of both the *Litchfield County Times* and *The New York Observer*. A student of the *Tao Te Ching* for four decades, he speaks with the aphoristic clarity of a *sheng ren* (圣人) about his business philosophy, which could double as a guide to the asceticism of his studio practice:

The simpler the economics are, the better. If you don't understand it, you don't do it. Purity in both design and business functions means never dilute, never diffuse, and never bloat.

FIGURE 2. Alexander Liberman, *Diablo*, 1992. Steel painted red, 252 x 132 x 138 in. Arthur Carter Collection.

One of the perks of media ownership is the prerogative to create the look of a publication. As with editorial direction, design in the newsroom is a decision-making process that melds display type, the flow of text columns, and the placement of photographs and illustrations. Carter actively tweaked the classical grid of his newspapers. The creative challenge is more than just establishing an "if it bleeds it leads" hierarchy for stories. Great publication design is curatorial. It guides the reader through a syntactic flow of stories and images that strikes a balance through counterpoint. It avoids monotony and repetition while moving the eye quickly through what is most important on each spread. One technical similarity between layout and sculpture is the need for cutting—not just editorial pruning, but the precise razor work of the "cut and paste" era. This technique resembles torch-cutting in the metal shop, where the precise delineation of forms depends on a sure hand and eye. The test, before the computer-automated days of Quark and Photoshop, was to snip a clean silhouette from a photograph around which type would be flowed and kerned. This skill is obvious in the calculated anatomy of Carter's drawings, the trim edge-work of his steel sculptures, and the clean, tape-guided geometries of his paintings.

Carter was not the first sculptor of our time to launch his art career in the graphic design studio. Alexander Liberman, the legendary Condé Nast design director, blazed this trail. He and Carter were neighbors in Connecticut, and the sole sculpture on Carter's grounds not by his own hands is *Diablo*, a terrific, complex monumental Liberman (see fig. 2).

It stands at the foreground of a meadow, before the rolling hills in view from the front door of the main house. From their design battles, both Liberman and Carter extracted aesthetics they could pursue in the studio, using compositional muscles, well toned from years of filling—issue by issue—every page of their publications with visual interest and significance.

In the steady shuttle between the studio and welding shop, the vital sense that something else is always going on in Carter's art persists. This feeling may be partly attributable to the blur of the past, present, and future caused by the phenomenal progress Carter has made during a relatively short time span (even by comparison with his three earlier careers), an achievement noted by his good friend the eminent critic Hilton Kramer. He not only encouraged Carter early on but wrote the essays for several catalogues published in conjunction with Carter's solo exhibitions at the Salander-O'Reilly Galleries in New York and the Tennessee State Museum in Nashville. In his essay for the Tennessee exhibition, Kramer, who was never lavish in his praise of anything but mastery during his tenure as the chief art critic of *The New York Times*, concluded with an admiring observation about the proleptic nature of the "architectonic" pieces that resonates in Carter's work of that time: "For they are not only constructed of the kinds of geometric forms that are familiar to us in modernist architecture but they also lend themselves to being seen as maquettes, or prototypes, destined to be enlarged to a monumental scale in some modern architectural setting. Their constituent vertical and circular masses are weightier in their girth than Carter's earlier work and more emphatically geometric in form, and they rise from their respective plinths with a more insistent perpendicularity. At the same time, their surfaces are burnished to achieve a softer, pewterlike skin that is more sympathetic to the eye and the hand. These architectonic constructions make a distinct advance in

Arthur Carter's sculptural development, and augur well for its future."[3]

When an artist is developing this rapidly, his or her current work is wrapped with the intimation of "something evermore about to be," to quote Wordsworth's *Prelude* (from Book VI, in which he rhapsodizes on studying geometry at Cambridge). Each of Carter's sculptures marks a step forward in a succession, whose culmination can be extrapolated only in part. Perhaps what is to come can be anticipated on an expanded scale, as Kramer notes, and certainly in the direction of refinement of form and composition, or of elegance through simplification, to use the artist's own terms.

To see like a sculptor is to lend completion to suggestion. Carter may be a marvelous example of how this anticipation occurs, but he is not the first. In 1951 Alexander Calder wrote in response to a survey on "What Abstract Art Means to Me" for the *Museum of Modern Art Bulletin*: "When I use two circles of wire intersecting at right angles, this to me is a sphere—and when I use two or more sheets of metal cut into shapes and mounted at angles to each other, I feel that there is a solid form, perhaps concave, perhaps convex, filling in the dihedral angles between them. I do not have a definite idea of what this would be like, I merely sense it and occupy myself with the shapes one actually sees . . . Thus what I produce is not precisely what I have in mind—but a sort of sketch, a man-made approximation."[4] Just as Carter's constructions are often visually reminiscent of Calder's, they harmonize along the natural progress from the schemata of drawings to the three-dimensional realization of sculpture.

CONSTRUCTING A LEGACY

To situate Carter and his work historically is to open an album of thinkers: composers, mathematicians,

and many artists, including Naum Gabo, Aleksandr Rodchenko, Alexander Archipenko, El Lissitzky, Fritz Glarner, Jan Matulka (a force at the Art Students League starting in 1927 and David Smith's painting teacher), and Max Bill (the Swiss sculptor and arch-theorist who took his Bauhaus training to Latin America). An important sculpture by Bill, all compressed energy, perches on a low coffee table in Carter's Manhattan apartment. Carter's response to it is *Suffusion* (1999), a large bronze that has the stellar grace of an armillary sphere (see fig. 3). The Bill

FIGURE 3. *Suffusion*, 1999. Bronze with blue patina, 60 x 60 x 60 in.

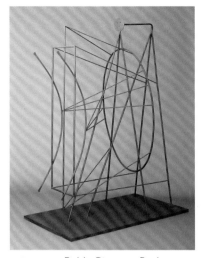

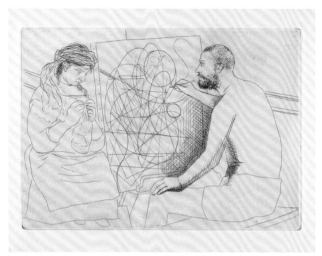

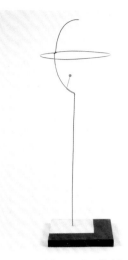

FIGURE 4. Pablo Picasso, **Project for a Monument to Guillaume Apollinaire**, 1962. Painted steel, 78 x 29⁷/₈ x 62⁷/₈ in., with base. The Museum of Modern Art, New York. Gift of the artist. (72.1979)

FIGURE 5. Pablo Picasso, **Peintre et modèle tricotant** (Painter and Model Knitting) from "*Le chef-d'oeuvre inconnu*" ("The Unknown Masterpiece") by Honoré de Balzac. Print executed 1927. Etching (from an illustrated book with thirteen etchings, sixty-seven wood engravings, and sixteen pages reproducing dot and line drawings), 7⁹/₁₆ x 10¹⁵/₁₆ in. (plate), 12¹⁵/₁₆ x 9¹⁵/₁₆ in. (page). Publisher: Ambroise Vollard, Éditeur, Paris. Printer: Louis Fort, Paris. Edition: 340. The Museum of Modern Art, New York. The Louis E. Stern Collection, 1964. (967.1964.12)

FIGURE 6. Alexander Calder, **Sphérique I**, 1931. Wire and brass on wood base, 39¹/₈ x 13¹/₂ x 11³/₄ in. Whitney Museum of American Art, New York.

in Carter's collection is surrounded by major works by Picasso, Hans Hoffman, and Wassily Kandinsky, among others. These Modernist giants are, of course, Carter's antecedents, along with the formidable yet lesser-known figures from the sculptural tradition.

Although the early welded sculptures of Picasso, González, Calder, and Smith are distinctly figurative—Picasso's *Project for a Monument to Guillaume Apollinaire* is the archetype for the genre (see fig. 4)—a hint of Carter's work is apparent in these same artists' most geometric and abstract repertoire, where wires and lines carom at angles resembling advanced shots on a snooker table. Much of this early canon of abstraction exists on paper. For instance, Picasso's sketchbook of July to December 1928 contains a series of drawings, light as air, for the Apollinaire monument. These are related to his earlier "constellation" drawings published in 1925 in *La Revolution Surréaliste* as well as to the enigmatic central tangle of lines in *Peintre et modèle tricotant* (*Painter and Model Knitting*) (1927), an etching

included in an edition of Honoré de Balzac's "*Le chef-d'oeuvre inconnu*" ("The Unknown Masterpiece") (see fig. 5). Take these and add Kandinsky's lithograph for the spring 1938 edition of *Verve* dedicated to "*étoiles*" or Miro's *Constelaciónes* on paper, and the idiom is established. For its sculptural realization, turn to Calder's curling *Sphérique I* (1931) (see fig. 6) or Smith's *Sentinel* (1961) (see fig. 7) as additional references.

Carter has a curious system for relating his completed works to the canon. Once a piece is finished, he conducts "research" to ensure that it does not infringe too closely upon any precedent. This process is interesting in and of itself because it prevents him from making work in response to an evasive maneuver to steer clear of an existing sculpture, often a primary concern of contemporary artists, most of whom would find the sequence of making first and checking later backward. It also permits him to work, even in series, unencumbered by the often paralyzing fear of repetition. As Carter notes:

Once the piece is completed, I begin to research what might be its evolution. One only has to study the twentieth century; that is clearly the most relevant period. Some of the research is related to the art, as well as the interplay of mechanics, materials, and graphics, such as the tools for cutting and finishing, and the development of materials that only came about in the last half of the twentieth century, e.g., stainless steel.

To start his research, Carter often pulls down his well-thumbed copy of George Rickey's magisterial book *Constructivism: Origins and Evolution.* Carter and Rickey have much in common, not only in terms of their soaring stainless-steel sculptures but also in how they structured their work spaces. Rickey's studio was a tiny shacklike appendage to his kitchen, where, like Carter, he tinkered with small wire and steel constructions that days later, if they swung just right and were balanced, would serve as models for the twenty- or thirty-foot-tall welded structures that would be constructed in a hangar down the driveway. There, a team (consisting mainly of engineering students from Rensselaer Polytechnic Institute) was ready to fabricate them (see fig. 8).

Rickey's book, dedicated "To Gabo," is remarkable. It offers an encyclopedic survey of the Suprematists, Constructivists, and Minimalists from the viewpoint of an artist who may have been in the thick of the action in 1967 but who wrote with the dispassionate eye of a scholar. (It modestly includes only one reference to Rickey's own work, and that is in the third person.) He explores the persistence of Constructivism in the mid-1960s, when fitful gusts of Pop and Minimalism were colliding with late exhalations of second-generation Abstract Expressionism. Many moments in Rickey's book can be applied to Carter and the progression of his work. For example, he celebrates the welded steel joint: "It has permitted the sculptor to outdistance the architect and even the

bridge builder." In a passage that appears opposite an illustration of a Donald Judd stack, he ponders the significance of "multiples" and series: "There is also a belief, special to our time, that an artist must develop exhaustively all the possibilities of minute differences within a particular idea. This procedure, while resembling science, is not borrowed from it; the scientist, as soon as a new door is open, passes through. But an artist will linger and examine every aspect of a room,

FIGURE 7 (left). David Smith, *Sentinel*, 1961. Stainless steel, 108 x 21 x 24 in. The Museum of Modern Art, New York. Fractional and promised gift of Leon and Debra Black. (531.1998vw1)

FIGURE 8 (below). George Rickey, *Five Open Squares Gyratory Gyratory*, 1981. Stainless steel, 112 x 72 x 42 in. Storm King Art Center, Mountainville, New York. Gift of the artist and of Joan O. Stern by exchange.

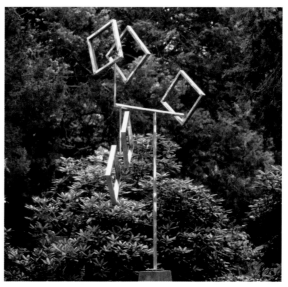

even when the doors are open."[5] Further along, he turns to the particular way in which the Constructivists responded to the world around them: "Nature as landscape, still-life, or portraiture is ignored; but nature, as a great fount of physical phenomena, inexorable laws, and orderly relationships, is investigated by the artist and made the vehicle for his statement. Forces such as gravity or energy such as light, serve as stimuli for the observer, supplanting those projections of the appearance of the natural world, which formerly had made the face of art. Thus nature, as aerodynamics, mathematical relationships, probability, chance, or magnetic lines of force is turned, by the artist's hand, to confront the observer. The artist himself then withdraws, sometimes covering his tracks by the use of an alter fabrication as his alter ego, and a title, which reads like a science textbook."[6]

FIGURE 9. *Octacube*, 1996. Silver and copper, 15 x 21 x 15 in.

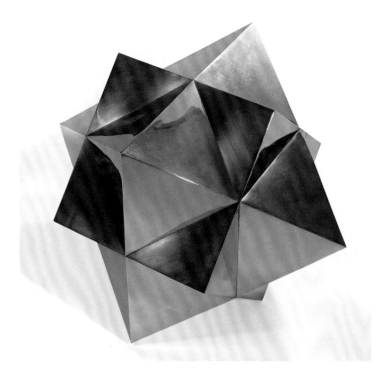

What lends Rickey's book its remarkable currency is the continued relevance of Constructivism in our time. Constructivism, like its more austere cousin Minimalism, is a movement too dynamic to roll over and become an historic school. It pervades today's painting and sculpture, as well as architecture and design, including both graphic and fashion design. After its beginnings in Holland and Russia in the early 1920s, it took hold in Germany's Bauhaus of the 1930s before migrating to the United States, to such centers as the Cranbrook Academy of Art in Michigan and New York City, where it was promulgated by the ardent group of painters gathered around Piet Mondrian (Ilya Bolotowsky, Charmion von Wiegand, and others). Arthur Carter's work offers the latest affirmation of just how right Rickey was in his claims for Constructivism.

Together with art history and graphic design, a love of mathematics is an important element in Carter's intellectual background. While earning his MBA at the Amos Tuck School of Business Administration at Dartmouth College, he became a student of the great mathematician John Kemeny, who was Albert Einstein's graduate assistant at Princeton University and later the president of Dartmouth. Kemeny predicted that his student—had he not gone into finance—would have had a bright future in mathematics. Just as Carter's natural talent in mathematics aided him in business, it plays an important role in his studio. His work is inspired in part by the ideas about recursive visual processing, mirror imagery, and "strange loops" offered in *Gödel, Escher, Bach: An Eternal Golden Braid* by computer scientist Douglas R. Hofstadter. Carter cites this weird and brilliant cult classic as one of the central books in his library, a vatic experiment in aesthetics (it was published in 1979 on the cusp of the cybernetic revolution) that has been instrumental in his own way of interweaving mathematics, art, and music. This mathematical thinking

is at its most literal in *Octacube*, one of Carter's earliest works—its original fabrication was in wood, later to be rendered in silver and copper (see fig. 9).

Carter also is inspired by the ideas of Fibonacci, the pioneering Italian who launched a renaissance in mathematics. Based soundly on Euclid, and informed by the classical geometries of Diophantus (200–284 CE) and Al-Kharkhi (910–929 CE), Fibonacci's work offered new solutions to a mathematical chestnut involving the sequence of numbers made by adding two terms to produce a third term, which is in turn added to the sum of the two previous terms. (Starting with two "seeds" 0 and 1, the sequence 0, 1, 1, 2, 3, 5, 8, 13, 21, 34, 55, 89, and so forth, is produced.) By contrast with the additive formulae of symmetrical geometries, most of which are quadratic in nature, the Fibonacci sequence lends itself to curves. Both mathematically abstract and natural, it originated as a calculation of the reproductive rate of rabbits and also describes the spiral of the chambered nautilus and the placement of the sound-holes in Antonio Stradivari's violins. Elegantly intricate, it flows with a visual variety that is organic rather than mechanical. Carter uses this sequence as a compositional tool as opposed to subject matter and relies on it in part to determine the points of intersection between straight and curved elements in his sculpture (see fig. 10). The ratios guide the proportions like a pair of mental calipers; they are so ingrained in his compositional sense that he can gauge them by eye. Their sub-rosa role confers a powerful if subliminal sense of order to the proportions and points of intersection in the work.

FIGURE 10. *Inverted Arcs at 90 Degrees with Parallel Chords*, 2002. Stainless steel painted red, 40 x 10 x 10 in. When arcs cross chords in Carter's sculpture, the points of intersection and the intervals between are prescribed by the incremental steps of the Fibonacci progression.

STATES OF GRACE

The additive progression from light, open sketch to more heavily worked statement is a common tendency in many art forms, including music with its themes and variations. Carter's serial alterations resemble that other great medium that calls for the cutting, burnishing, scraping, and polishing of metal: etching. Moving inductively from state to state, accumulating marks that give the later states their heft, the etcher is a kind of serial metalworker with a graphic agenda. Considering Carter's work in a state-by-state order, let us start with the drawings and where they are made, and that takes us a little over two hours from Manhattan to a 1,500-acre farm in Connecticut, to a house originally built in 1691, and, 230 paces along a lilac-lined path from its front door, to Carter's studio. The farm is tucked into the hills near Roxbury, and from across the property, the artist hears the faint treble of the brook that feeds the Shepaug River.

Carter's sprawling farm includes a studio of his own design, with tall windows facing the woods, perfect acoustics, and a massive stone fireplace (see fig. 11). A white barn down the road, with sixty feet of clearance for the tallest work, houses the shop where, six days a week, from early morning until well into the evening, he and two assistants fabricate his sculptures. They torch-cut and arc-weld by hand, working from light, open drawings and wire maquettes. The two assistants are brothers who live on the farm in houses that are within sight of the shop. Carter trained them in welding and metal work, teaching them the techniques he learned in the Coast Guard and later polished at the prestigious Polich Tallix Fine Art Foundry (where his first sculptures were made).

The "material culture" and cacophony of the shop is the opposite of the sealed studio where Carter draws and creates models from copper wire and clay in silence. And it is the drawings that bring us close to the artist's thinking. They reveal the fundamental decisions that the paintings or sculptures conceal:

FIGURE 11. Arthur Carter's Connecticut studio.

the confidence of a ruled line, the wavering hesitation as pressure is applied to pencil, or the flurry of erasures that dissolve an earlier idea. The modesty of a sculpture's beginnings is disarming, as Carter reveals:

You don't really need much—a pencil and a piece of paper. For many months there may be no new ideas, but the fabrication of the structures in play continues. The production of a piece usually takes a minimum of one month from start to finish, from drawing to maquette, coupled with revisions. While the work is in the shop I begin the process all over again.

The call and response between Carter's drawings and sculptures is a tangible aspect of doing one thing while simultaneously doing another. His drawings are preparatory as opposed to a posteriori (as Richard Serra's mostly are). He scales them up from small, swiftly made studies to larger, more carefully rendered plans. Though these later versions are not as precise as the final blueprints for a thirty-foot-tall steel work would be, they serve to get the fabricators started. Carter usually draws in pencil, and sometimes felt-tip pen or charcoal, on small tablets of good woven paper. Even the earliest studies have a remarkable three-dimensionality, the bases sketched in perspective and the circular forms shaded in charcoal to suggest the contours of spheres. Firm lines, guided by a straight edge, anchor the freer gestures of the curves (see fig. 12). The shorthand of drawing mediates between the mental ideal and the first attempt, often in wire, to create an object based upon it.

The studio is brimming with small copper-wire maquettes, three-dimensional sketches

FIGURE 12. **Study for Construction**. Pencil and ink on paper, 8 x 6 in. Carter's drawings reveal the course of ideas and decisions that lead to a finished work. The three-dimensionality of even the most cursory one indicates an awareness of the depicted form's imminent orientation in real rather than representational space.

only a few inches high that are set in thick bricks of gray clay and held together by nodes of clay. They crowd the edge of Carter's desk like the saplings at the border of the woods outside the studio (see figs. 13 and 14). Behind them, larger steel maquettes stand on the floor along the window. The choice of copper wire is practical, of course, because of its easy malleability, but it is also a perfect complement to the linear fluidity of the drawing. The round filament adds volume to the pencil line, while its shiny surface foretells the bounce of light that the finished works offer. The maquettes open miniature windows through which other segments of the sculpture pass, an effect that is difficult to render on paper.

Carter's signature style—the airy steel geometry rising from a flat base epitomized by *Tektonics* (2000) (see fig. 1)—is commonly described as "drawing in space" or "drawing in air." So much of the literature assigned to this genre (going back to González and Picasso) emphasizes the positive role of the interstices, sometimes to the extent that the substance of the solid is rendered subordinate. *Entre le vide et l'événement pur* ("between emptiness and the pure event") runs the finest line in Valéry's "*Le Cimetière marin*," ("The

Graveyard by the Sea") a lyric meditation set on the margin between sea and land that articulates the passage from the void to what comes next. There is an equilibrium between steel and air that needs to be struck. As poetic as the windows in Carter's forms are—especially since they often frame an exquisite landscape or architectural detail—the eye is firmly held by the steel itself. It travels along the ribbons of the early, cobralike *Morph* (1998) (see fig. 15), an unusually monolithic work, or the later *Elliptical Loops* (2005) (see pages 53–55), clinging to the switchbacks and curves as they accelerate and then return to the base. Steel has its own attraction. Relatively unknown as an art material until the 1940s, stainless steel was invented in the nineteenth century but only turned to general use in 1912 or so, when the first flatware

FIGURE 14. Arthur Carter in his studio, 2008.

FIGURE 13. **Studies for Constructions**. Copper wire on wood base, each approximately 11 x 5 x 2½ in., with base. On paper, the elements are arranged and the first thoughts about proportions and intersections are drafted. As the idea is translated into a copper wire maquette, the open spaces and the three-dimensional relationships become clearer.

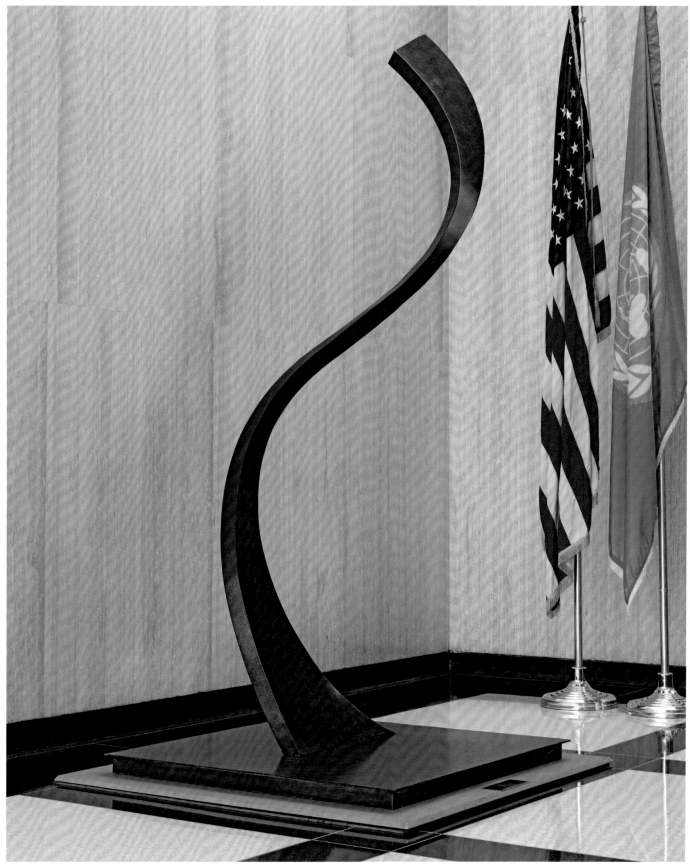

FIGURE 15. *Morph*, 1998. Bronze with dark blue patina, 96 x 40 x 32 in.

was commercially produced. After such a late start, it is just reaching its adolescence as a material for sculpture (stone, bronze, wood, and clay are the venerable old-timers, while LEDs and other techno-gimmicks are allegedly the future). In Carter's hands, it shines brilliant-edged like water, threaded with a luminous grain that lends it an anomalously organic quality, romancing the light with surprising lyricism. Many of Carter's works have rounded or beveled seams sealed with viscous lines of exposed weld that join sheets of stainless steel. Even the welds deliver optical charms, like the rippling scallop overlay at the seams of many of the elliptical works. Some are honed like the outside edge of a hockey skate, pushing the linear continuity of the form to an aggressively precise finish that carves the air all the more crisply than the rounded solid (even in silhouette there is a tighter effect). As with glass or the surface of white Parian marble, light collects along the polished borders, the silvery tone of the steel limned against the blue of the sky or a dull background.

In one of Valéry's favorite anecdotes, the poet Stéphane Mallarmé once coolly admonished Edgar Degas (who was lamenting his inability to convert his surplus of ideas into poems) that "poetry is made of words, not ideas." Likewise, sculpture is made of steel, not of ideas. This realization is perhaps closer to William Carlos Williams's great epiphany (expressed in *Paterson*) "No ideas but in things" than to the evanescent Mallarmé. Yet reification brings compromise. Even the most obedient of metals cut and welded with the greatest precision is bound to fall short of the mind's ideal of perfection, as David Smith, Donald Judd, and so many others have found. This does not spell failure per se, but prompts the continued serial progress of sculptors, including Carter, from one version to a closely related revision, each of which assumes the status of a work of art.

The state-by-state declension of Carter's work is not just a matter of moving from drawing to maquette to sculpture, but also from sculpture to sculpture: Each iteration leads to its variants. Crisply rational, the substantial power of *Mathematika* (1997) (see pages 6 and 200) is partly owing to the solidity of the three squares, especially in the bronze incarnation. This early piece, which explores the basic Pythagorean geometry of the right triangle, is one of Carter's heaviest by impression, although the tipping of the largest square at the top foreshadows a lightness to come. In 2003 Carter revisited the triadic grouping, letting the squares amble into three dimensions, opening the ninety-degree angles in a tipsy, air-filled response to the sober solidity of the original (see fig. 16) The same jaunty disrespect for the plumb line is apparent in the earlier series called *Psyche* (see pages 34, 36–37, and 199), *Elliptyk* (see pages 31 and 33), and *Connecting Irregular Quadrilaterals* (see pages 35 and 38), in which looped rectangular or elliptical forms in ascending chains epitomize González's rhapsodic claim that welded sculpture should be "as free as smoke." But Carter was not finished with the triadic idea—yet. A couple of years passed, and he decided to fill in the openings with partial membranes, which paradoxically drew all the more attention to the windows in the pieces even as they added a dose of opacity. The gesture is a hallmark of several sculptures by Carter, including the painted series of *Overlapping Arcs at 90 Degrees with Inserted Membranes* (see pages 113–117) as well as the most recent work, as yet untitled, which not only fills in the crescents once traced in air by arcs but gently curves them away from the vertical plumb line, as well.

For all their rectilinear geometry, there is plenty of motion in Carter's oeuvre to enjoy. The sculptures in the elliptical series rise gracefully from the floor before suddenly gaining altitude, turning over at their zeniths, like acrobatic planes, and plunging steeply in swooping descents. The *Elliptical Loops* are double strands, intertwined in dances in erotically charged

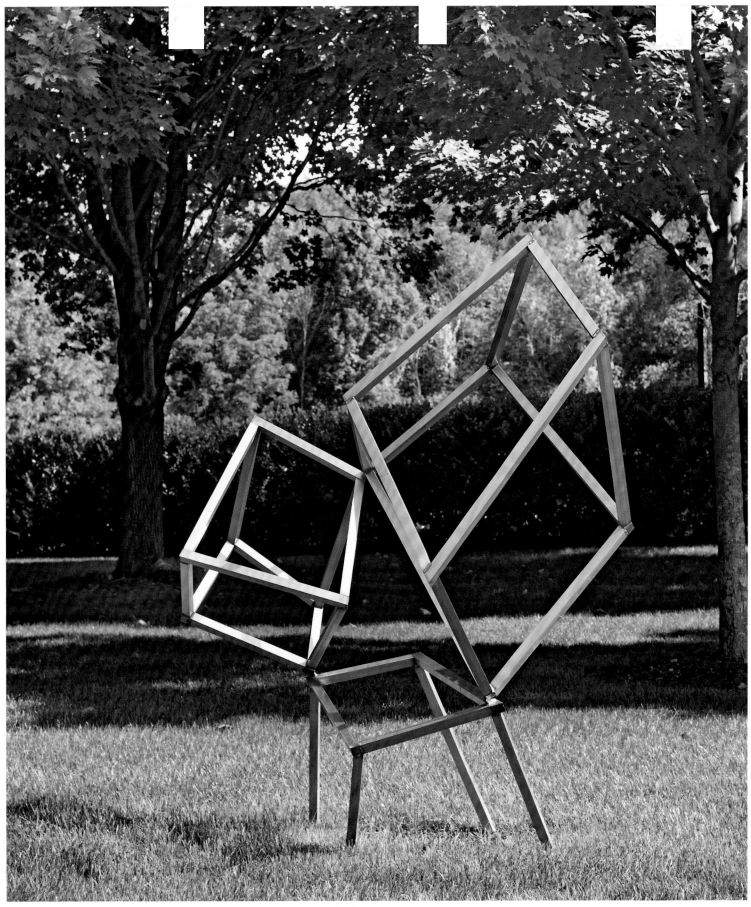

FIGURE 16. *Untitled*, 2003. Stainless steel, 64 x 56 x 36 in.

reminiscences of *The Couple* (1999) (see page 2), one of Carter's best-known works that stands thirty feet high on Park Avenue, a sculptural highlight of a stretch of some of the greatest Modernist architecture in the world (including Lever House and the Seagram Building), in which the work is right at home. Remarkably, another version of *The Couple* (see page 72) is equally at home in the trim confines of a garden. Carter's sculpture has a compasslike ability to orient both itself and the viewer no matter where they meet,

FIGURE 17. *Interconnecting Ellipses*, 2003. Sanded stainless steel with satin finish, 120 x 88 x 79 in.

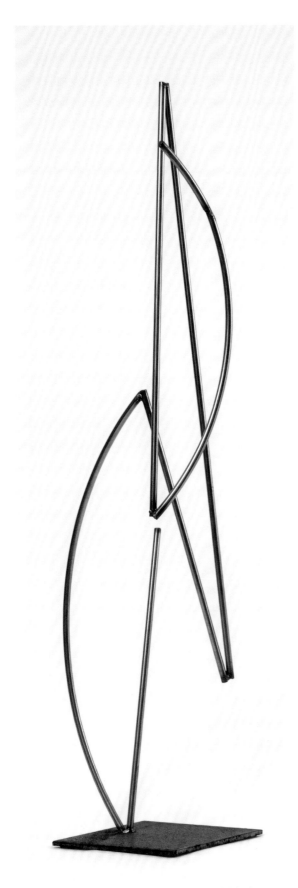

FIGURE 18. *Arcs and Chords in Series*, 2003. Stainless steel, 39 x 10 x 8 in.

a quality in art once noted by the late John Russell, who wrote, "It is fundamental to the white magic of art that it does away with the nightmare of disorientation."[7] Another untitled work from 2005 is monadic, like a Möbius strip, crossing itself a dozen times on the trip up and around and back again, five intersections clustering in one busy knot to one side of the asymmetrical structure, leaving the other side loose and open (see page 50). With *Continuous Elliptical Loops* (2007) (see page 52), Carter introduces a stronger horizontal orbit, which pulls apart the crescent top loops, while retaining that cluster of intersections on one side. Then there is the departure signified by the doubling and even quadrupling of the strands in *Interconnecting Ellipses* (2003), which rises ten feet and tightens the motif in a powerful intimation of the spring tension that would be unleashed if it were to unlock (see fig. 17). Perhaps it is the weight of the multiple ribbons (like the addition of octaves to a melodic line), or the huge scale, or even the more machined look of the brushed steel, but this is the closest Carter's work comes to what a power broker in the sphere of business might be expected to create.

A tight family of work based on what Carter calls "arcs" and "chords" evolves from the interplay of straight lines and delicately extracted curves in a remarkable variety of permutations. The model for the series is an ultralight drawing in air, *Arcs and Chords in Series*, which lifts quickly from one single arc and descends momentarily along a chord before shooting up again straight to a peak from which it loops out into another arc (see fig. 18). Pay attention to the false start that also rises from the base, going nowhere—for now. As the series develops, this vestigial chord adds muscle, as do the rest of the components, whose abrupt cubic endings add to the overall sense of solidity the work accrues. At that later stage, the second chord off the base grows to become a parallel spine around which the arcs grow and flow, sinuously descending from the

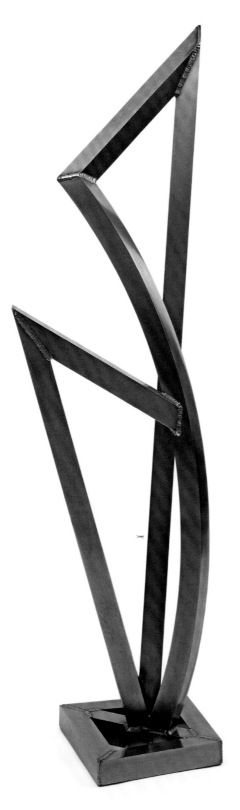

FIGURE 19. *An Arc Connected by Two Acute Angles*, 2002. Stainless steel, 48 x 16 x 10¹/₄ in.

upward trajectory of the two sturdy chords, softening their linear, hard-edged rigidity in a protective coil. Then Carter's tendency toward simplification takes hold. The spiraling legato of the line in *Three Inverted Arcs with Parallel Chords* (2002) (see page 111) loosens as it drops to a hip that swings out much farther from the axis than the topmost arc—the amplitude slows the motion and challenges the hegemony of the parallel straight spines. In the early maquette in copper wire, the largest bulge is at the top and the shallowest arc at the bottom—Carter inverted the hierarchy as the series developed.

One of the challenges Carter issues himself in this series is the always tricky introduction of color to objects. In the cinnabar version, which rises from a circular rather than quadrangular base, an even tone of glorious red eases the transition from straight to curved, and the balance of the symmetries between the two arcs and the parallel chords makes this one of the most restful pieces in the series, despite its fluid dynamics. Then Carter introduces membranes, in *Overlapping Arcs at 90 Degrees with Inserted Membranes* (2002) (see page 113), which he paints with creamy strokes, some in an absorbing gray-green, others in vibrant red and yellow that are signposts to the paintings. The etching has, state by state, acquired color.

To grasp the way these sculptures evolve from one to another, let us return with Carter to the studio, where the sculptor stands alongside the forty-two-inch-high version of *An Arc Connected by Two Acute Angles* (2002) (see fig. 19), which is to be the basis for a larger work that was recently commissioned. Between its inception as a drawing six years before and the summer of 2008, when this book was coming together and the artist generously granted a studio visit to open the process for observation, the emphatic thrust of the work has undergone a tremendous metamorphosis. The maquette gently rises to two peaks, flared slightly away from each other. The tallest is

formed by a spire that rises from the base tangent to the chord that culminates in the lower peak. They echo one another as accents, but Carter is beginning to contemplate a new set of options. The variables are surprisingly manifold, even abundant. He stands like a dance partner, his right hand resting on top of the highest peak, and his long left forefinger extended out into the air at about the distance of the lower chord's sway but shifted in another direction. There is nothing there, but he sees how this wing might swing forward or backward along an arc that would preserve the Fibonacci-based proportions. A new work emerges from the old (see fig. 20).

Carter's paintings begin conceptually in much the same way the sculptures do, as drawings that are flagged with bright colors, and he has a simple criterion for how they progress: "They become paintings if I can't build them." At a distance, they bear a strong resemblance to the black grids and primary color regions of Mondrian and his American followers. The writings of both Mondrian and Kandinsky, particularly the latter's seminal volume *Concerning the Spiritual in Art,* join Rickey's survey of Constructivism as being among the books that have most influenced Carter. For an artist in 2009 to work within one of the strictest formal vocabularies of the early days of Modernism is an astonishing challenge, and not just to the cult of originality that dominates the twenty-first-century art scene. It places the modern artist's work in the midst of a highly regarded existing canon of works, as though he has been granted his wish to time travel to a particular moment in art history, and chose Paris in 1921. Mondrian himself left the door wide open, writing in "Plastic Art and Pure Plastic Art," an exhilarating essay he published in 1936: "If all art has demonstrated that to establish the force, tension, and movement of the forms, and the intensity of the colors of reality, it is necessary that these should be purified and transformed, if all art has purified and

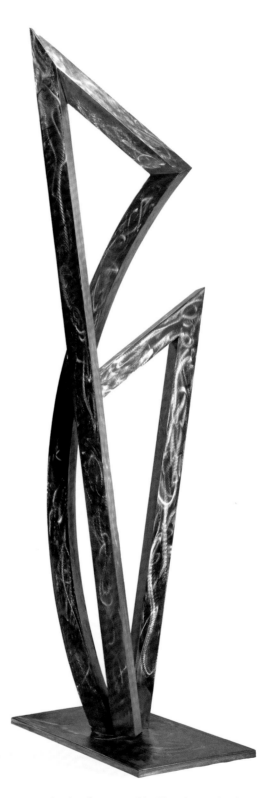

FIGURE 20. *An Arc Connected by Two Acute Angles*, 2008. Stainless steel, 72 x 25 x 15 in.

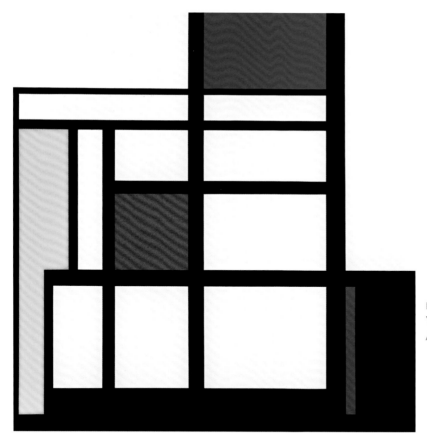

FIGURE 21. *Composition in Red, Yellow, Blue, and Black*, 2007. Acrylic on canvas, 33 x 33 in.

transformed and is still purifying and transforming these forms of reality and their mutual relations; if all art is thus a continually deepening process: why then stop halfway?"[8] Carter takes Mondrian at his word and continues the deepening with ever bolder black lines and rich juxtapositions of blue and red diagonals that Mondrian would never have countenanced (he insisted on orthogonals), and complex blues or yellows that slyly slip out of the closed chamber of the primaries (see fig. 21). The effective range of grays alone is liberating, from the absorbent matte of a naval hull to pearlescent lustres, as are the embedded black lines within red rectangles that start and stop—just like Carter's sculptural chords—of their own volition. Modernist orthodoxy deserves this kind of reinterpretation. When musicians awoke to the possibilities opened by Arnold Schoenberg's twelve-tone system—rather than focused on the strictures it seemingly imposed—they realized that merely from a mathematical

standpoint, their range of compositional tactics had broadened. In much the same way, Carter's work is an expression of possibility, not restriction: How open or closed can an angle be made? How far off the perpendicular plumb line can a cubical form be shifted? In the privileged relationships once assumed to be finite, he reveals what is actually infinite. In other words, the finger Carter held in air just outside the sculpture could arrive at any point, around or up or down.

ALONG THE EDGE

It may seem sacrilegious to suggest that touching a sculpture is a good idea (especially a pristine stainless steel surface), but the haptic appreciation of small bronzes has always been an important aspect of connoisseurship. And in fact, Carter in his studio is always laying a hand on one piece or another. There are two ways to enjoy his work by touch. One is to let the hand travel

along a swooping curve or up to the point accentuated by a jutting corner, to feel the grain of the steel and the remarkable precision of the edges. Those joints between two plates of steel are not easy to make. Another is almost musical in its activation of the kinetic properties of the slender structures—to pluck them. Like a tuning fork, the freestanding steel will vibrate for as much as a minute or more after a light-fingered strumming, trembling on its own across a tight arc at its tip. The hum is inaudible and the blur is invisible (unlike the famous image of the Gabo kinetic sculpture, which wavers across a sine wave), but the tuning fork stuck in space instantly transforms the surroundings. It activates the air to a chosen wavelength, a formal basis upon which, as with the visual focus of the work, the ambient sensations are attuned. The musical analogy is not a stretch in Carter's case. Entering his Connecticut house or the New York apartment, one's first sight is a concert grand piano, upon which he plays a broad repertoire, from Bach and Scarlatti through Chopin, Liszt, and Brahms. As a child in Woodmere, Long Island, Carter pursued a serious course of piano study that nearly led to a career in classical music. (Concerns about making a living led him to Brown University and eventually to an MBA from the Tuck School.) That level of skill presumes a competence in musical thought and a familiarity with the inner workings of music: its rhythmic intervals, structural relationships and, for lack of a more neutral term, stratagems that offer parallels in geometrical sculpture.

There is another parallel to consider, one between two estimable artistic innovators alike in many ways. On his drive back and forth between the studio and Manhattan, Carter passes a small brown roadside sign directing traffic (precious little) to the birthplace museum honoring Charles Ives, who with Aaron Copland and John Cage is among the most significant figures in American music. It is hard to resist comparing Ives and Carter. Ives, an admirer of Picasso's sculpture, was a Modernist whose pragmatic spiritualism was based on an impassioned reading of Ralph Waldo Emerson. Like Carter, Ives was an immensely successful financier. Considered the father of estate planning, his mastery of the mathematics of actuarial tables was matched by the verbal dexterity he displayed in the newspaper advertising copy he wrote for the insurance company he started a few years after graduating from Yale. Carter is also known for his snappy writing, for the news and editorial copy he contributed to his newspapers (sometimes under the pen name Veblen). Both Ives and Carter supported publications. (In Ives's case he kept alive the important journal, *Perspectives on New Music*.) The cohesion of an Ives score, finally, is especially like one of Carter's syncopated asymmetrical dancing cubes. Both let the rhythms and ideas roll along their individual ways without imposing undue restraints. Ives had a knack for holding tight on the reins of two motifs, rhythms, or key signatures simultaneously (he even shuttled between two upright pianos that were tuned apart), a maddening use of doubling for those who have trouble listening to two jarringly different sounds at once. If there are two Ives pieces to enjoy while contemplating Carter's sculptures, the most fitting are the Allegretto from the Fourth Symphony, for the way it bends the tones in Carter-esque arcs, and the third, most pensive section of *Three Places in New England* (1903–1914), "The Housatonic at Stockbridge," which gently carries a winding line up and around a steady, straight chord before descending again. There are even technical similarities between the feline way that Ives would let a piece fade away at its close just as Carter's ellipses return from their flights to their bases, his textures of quotation (much like Carter's invocations of Smith or Mondrian), the cumulative variations and—to borrow an original phrase that captured the fancy of Schoenberg—his "shadow counterpoint."

Ives operated in a near-innocent aesthetic locale, outside the academic and avant-garde mainstream of the moment (practically every study or biography uses

the term "vacuum" to describe his isolation); although the story that he had no awareness of such Modern masters as Schoenberg and Igor Stravinsky is apocryphal. Carter occupies his own curious place away from the Chelsea-Berlin-Basel-Miami circuit, content to invent on his own terms. "My greatest fantasy is to just get away . . . I mean really get far away," Carter confides. Ives in his tiny composing shack in West Redding and Carter in his studio not far away, have listened to brooks feeding the same river, have driven along the same hills to their offices in Manhattan. Not far away in Hartford, another insurance executive named Wallace Stevens was tucking some of the greatest Modernist poems into his desk drawer each evening, including the appropriate line from his "Adagia," "The momentum of the mind is all toward abstraction."[9]

CODA

One incomparable July afternoon, Carter relaxes on the couch of his home in Remsenburg on the east end of Long Island, where a luminous pair of prints by Robert Mangold on the wall suggest another comparison to one of the great artist-thinkers of our time. The sun glitters along the waves of Moriches Bay and the sail of a yacht passing westward is framed by the triangular aperture at the core of his early work *Mathematika*, which is poised on the lawn between the house and the waves. Carter is shuffling through printouts of the images for the present volume, commenting on the genesis of various works, handling questions on technique, skirting explications of meaning. After rapidly turning over a thick stack of images, he slows, pausing to look at a particularly complex recent work. Shifting the sheet to his left hand, momentarily bemused, he begins to trace an idea over it with his right forefinger, indicating how the piece might provide the basis for a variation that would in essence fill in the gaps:

Now here's a steel work that might be cast in bronze. Or what if we create some membranes to block the open areas? One might solidify parts of it, or the whole structure, or expand the aperture. That's one way to approach the process. Perhaps the structure could be changed, not necessarily for the better. One part could be changed from space to solid, or the reverse. That is the fundamental theory. Once it is completed and then observed with the possibility for organic change. Take a simple piece and there are a range of variations one could apply. Here, for instance, what if . . .

Carter's voice trails off. A sculptural project of this magnitude is expected to drive to its cadence, a solid *quod erat demonstrandum* delivered in a declarative tone. By contrast, the telling note in that statement is the recurring conjunction that debate coaches warn rhetoricians to avoid when starting a strong argument. It opens possibilities, and it is anything but a last word: *if.*

Endnotes

1 *L'aria a piena d'infinite linie rette e radiose insieme intersegate e intessute sanza ochupatione luna dellaltra rapresantano aqualunche obieto lauera forma della lor chagione.*

2 Paul Valéry, "The Method of Leonardo" in *Leonardo, Poe, Mallarmé*. Translated by Malcolm Cowley and James R. Lawler. (Princeton: Princeton University Press, 1972), pp. 3–63.

3 Hilton Kramer, *Arthur Carter: Stainless Steel* (Nashville: Tennessee State Museum, 2004), not paginated.

4 Alexander Calder, "What Abstract Art Means to Me," cited in *Picasso and the Age of Iron*, edited by Carmen Gimenez (New York: Guggenheim Museum, 1993), pp. 290–291.

5 George Rickey, *Constructivism: Origins and Evolution* (New York: George Braziller, 1967), p. 81.

6 Ibid.

7 John Russell, "Art Tells Us Where We Are," first published in *The New York Times* in 1981, collected in *Reading Russell* (London: Thames & Hudson, 1989), p. 184.

8 Piet Mondrian, *Plastic Art and Pure Plastic Art* (New York: Wittenborn, 1945), p. 61.

9 Wallace Stevens, "Adagia," in *Opus Posthumous* (New York: Knopf, 1980), p. 179.

OPPOSITE: Detail of **Elliptical Loops**, 2005. Sanded stainless steel, 38 x 38 x 23 in.

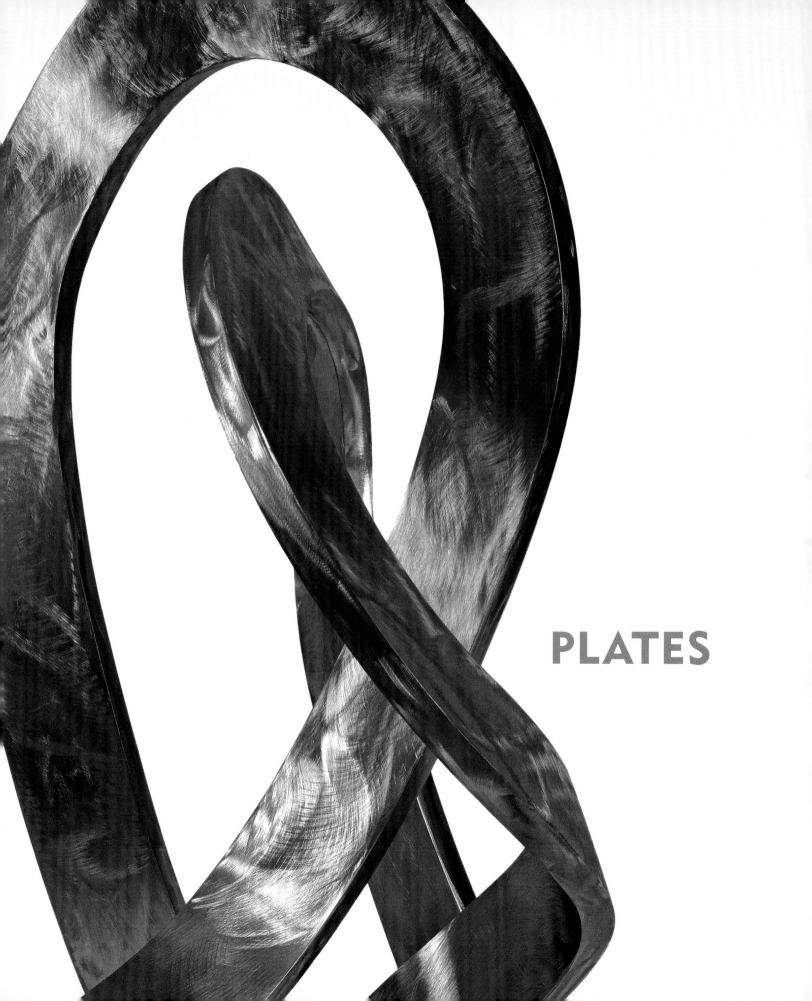

PLATES

Carter's process begins in the studio with small, meditative drawings, often simply pencil on paper, occasionally with the restrained addition of color. Using a hybrid vocabulary of geometric forms that combines Constructivism and pure mathematics, he explores the sculptural permutations through which circles, squares, ellipses, triangles, and irregular quadrilaterals can be drawn into relation. In three dimensions, even the most apparently simple works become surprisingly multivalent from different perspectives, initiating a learning curve toward greater complexity as more and more components are introduced.

ABOVE: *Study for Construction*. Charcoal on paper, 8 x 6 in.

OPPOSITE: *Elliptyk*, 1999. Bronze, 82 x 34 x 26 in.

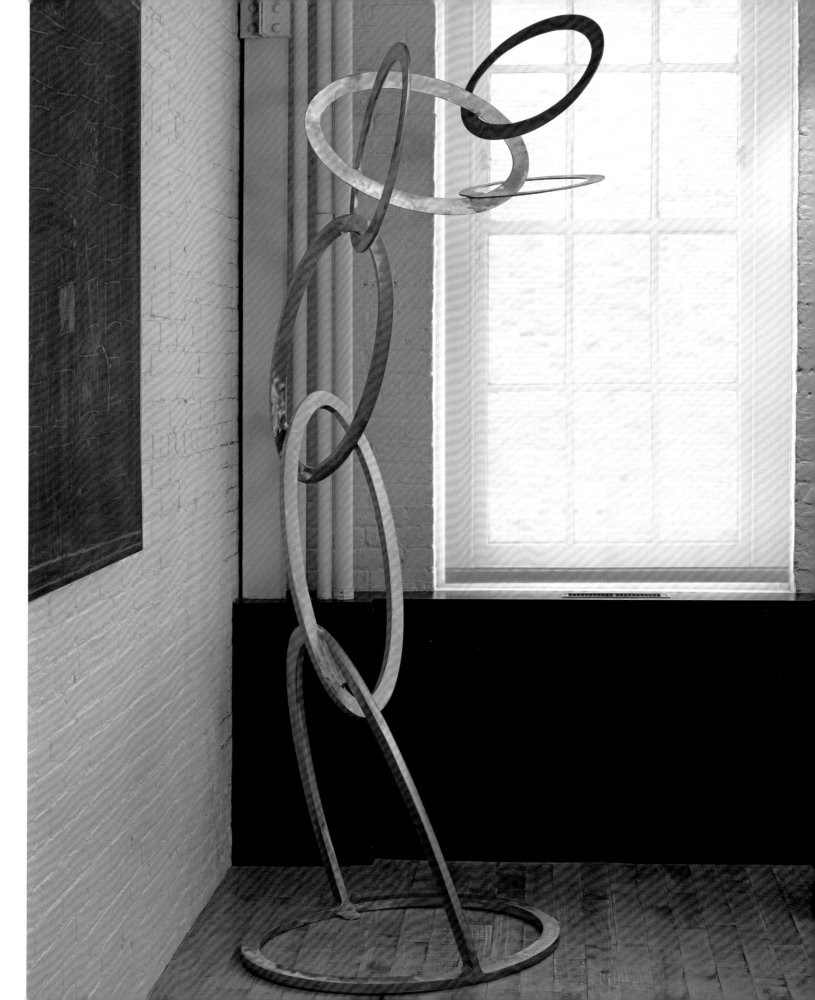

Study for Construction. Charcoal on paper, 8 x 6 in.

Study for Construction. Charcoal on paper, 8 x 6 in.

Study for Construction. Charcoal on paper, 8 x 6 in.

Study for Construction. Charcoal on paper, 8 x 6 in.

OPPOSITE: *Elliptyk*, 1999. Bronze, 84 x 38 x 30 in. The ellipse as gesture defines the components of *Elliptyk* as well as the way it leads upward and into a graceful serpentine curve.

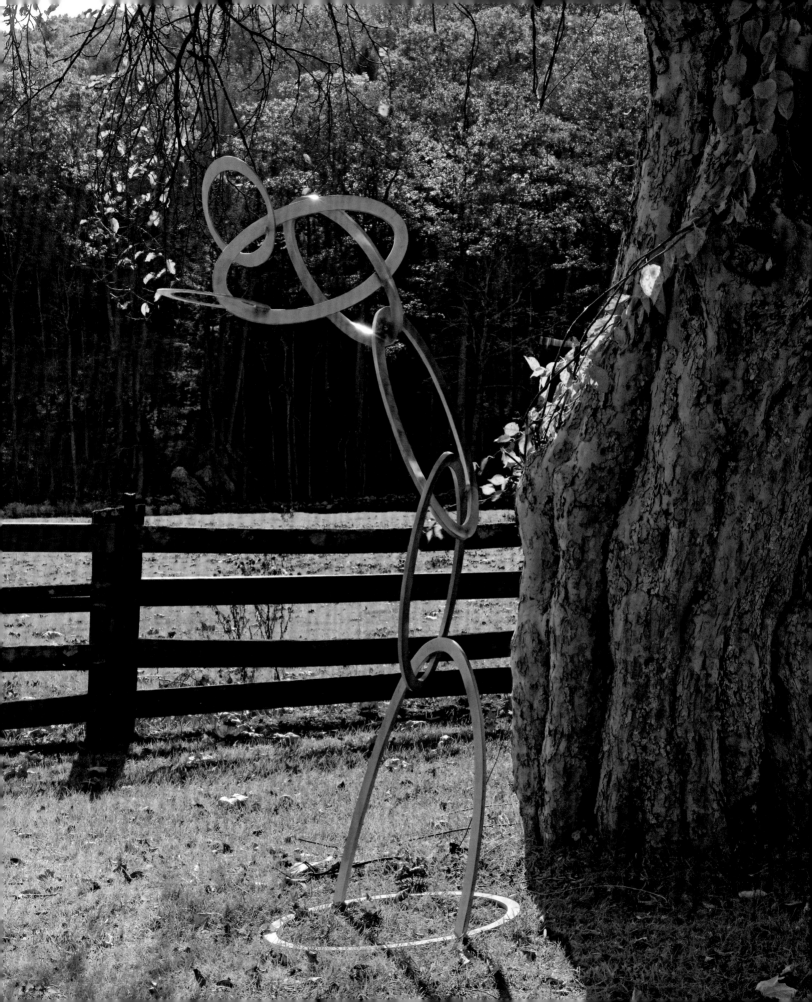

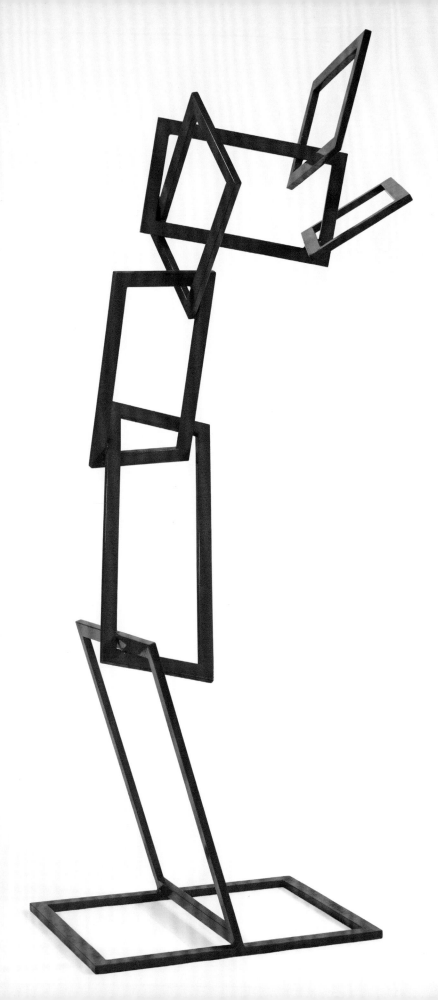

'COMPLEXITY' - PNT. RED

Study for Construction. Pen and ink on paper, 8 x 6 in.

I CONSTRUCTION IN RED

Study for Construction. Pen and ink on paper, 8 x 6 in.

LEFT: *Psyche II*, 1998. Stainless steel painted red, 58 x 24 x 18 in.

OPPOSITE: **Connecting Irregular Quadrilaterals**, 2001. Stainless steel, 78 x 40 x 36 in. The ascending chains of torqued, open forms in *Psyche II* and *Connecting Irregular Quadrilaterals* arise from the additive process inherent to welded sculpture.

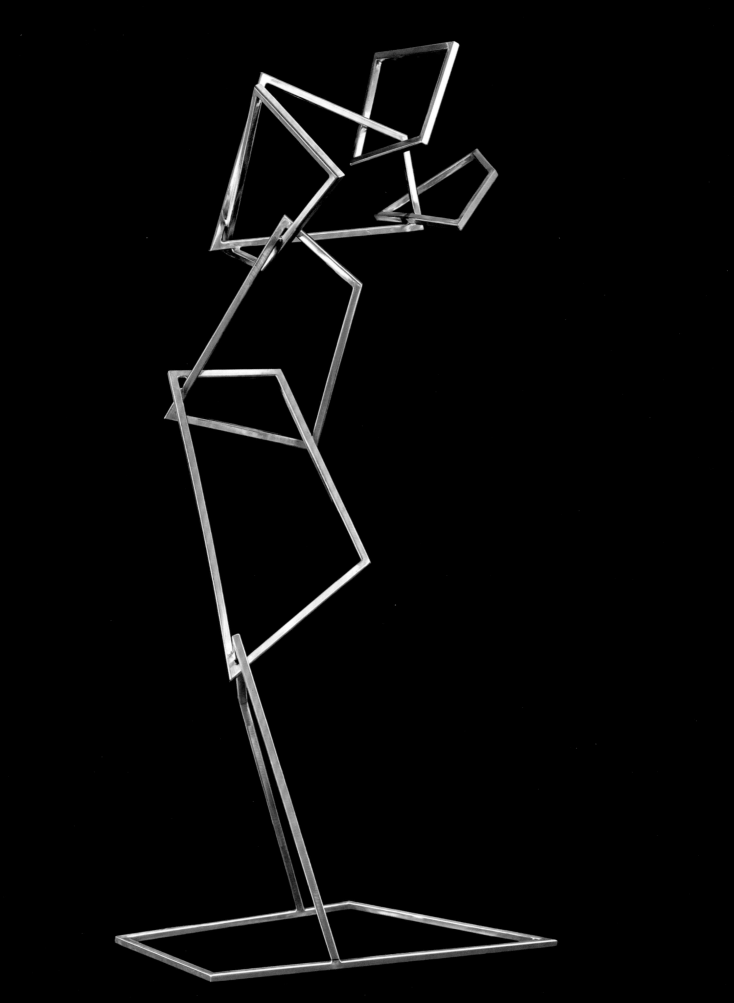

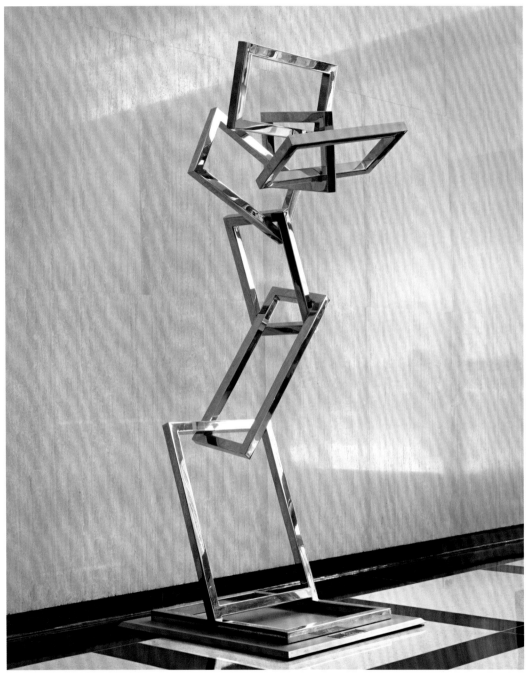

Psyche II, 1998. Polished stainless steel, 84 x 34 x 26 in.

OPPOSITE: *Psyche*, 1997. Bronze, 89 x 48 x 31 in.

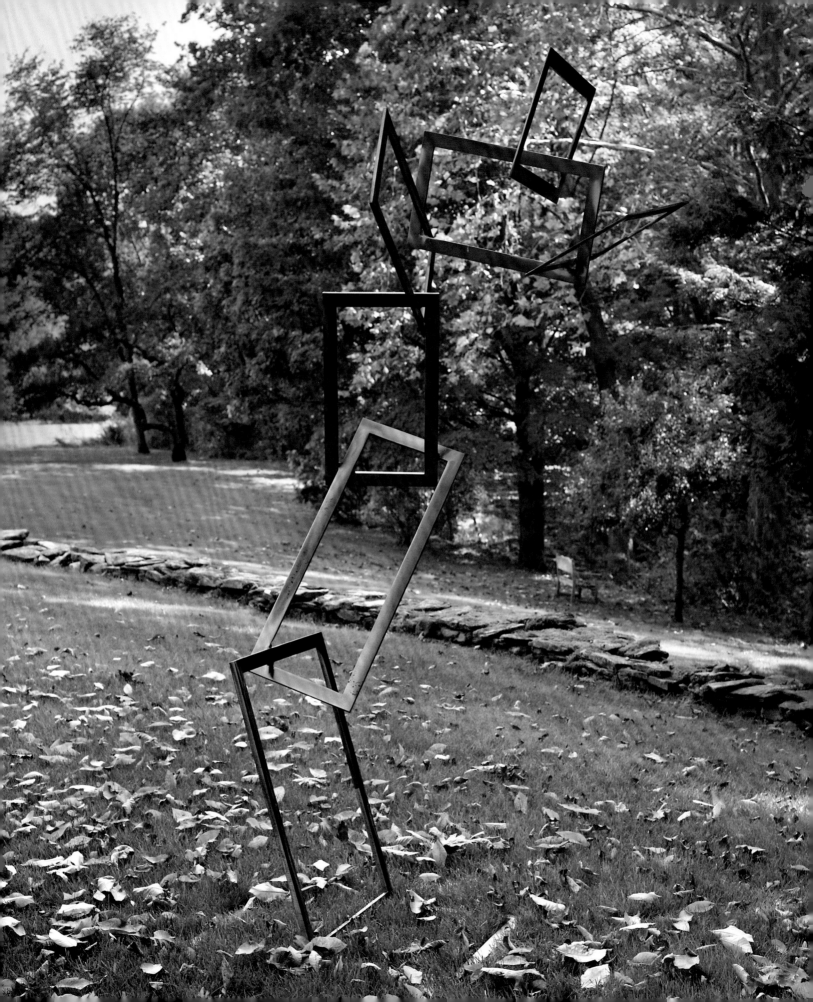

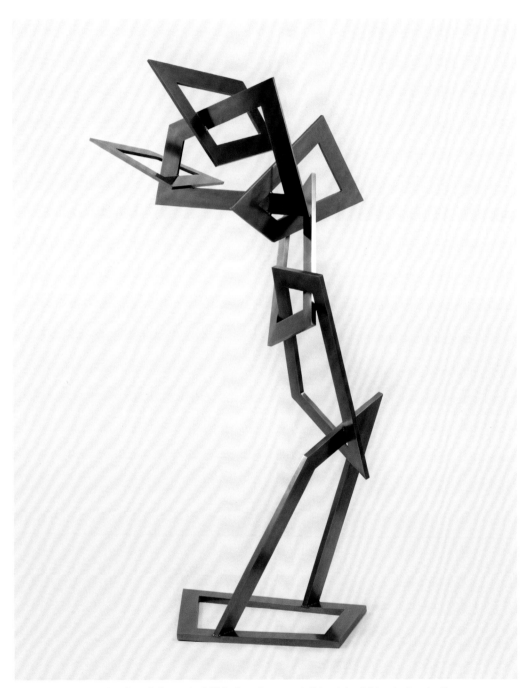

Connecting Irregular Quadrilaterals, 2002. Stainless steel, 84 x 44 x 36 in. Arthur L. Carter Journalism Institute at New York University, New York, NY.

OPPOSITE: ***Signifier II***, 1999. Bronze, 96 x 60 x 5 in.

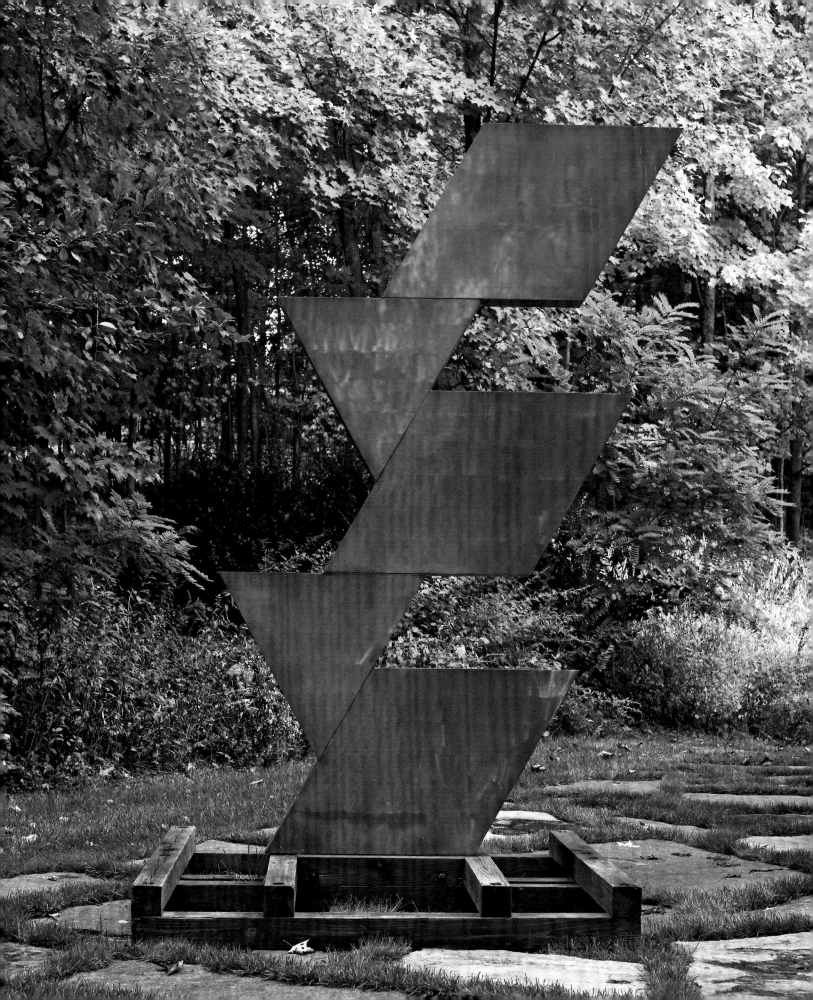

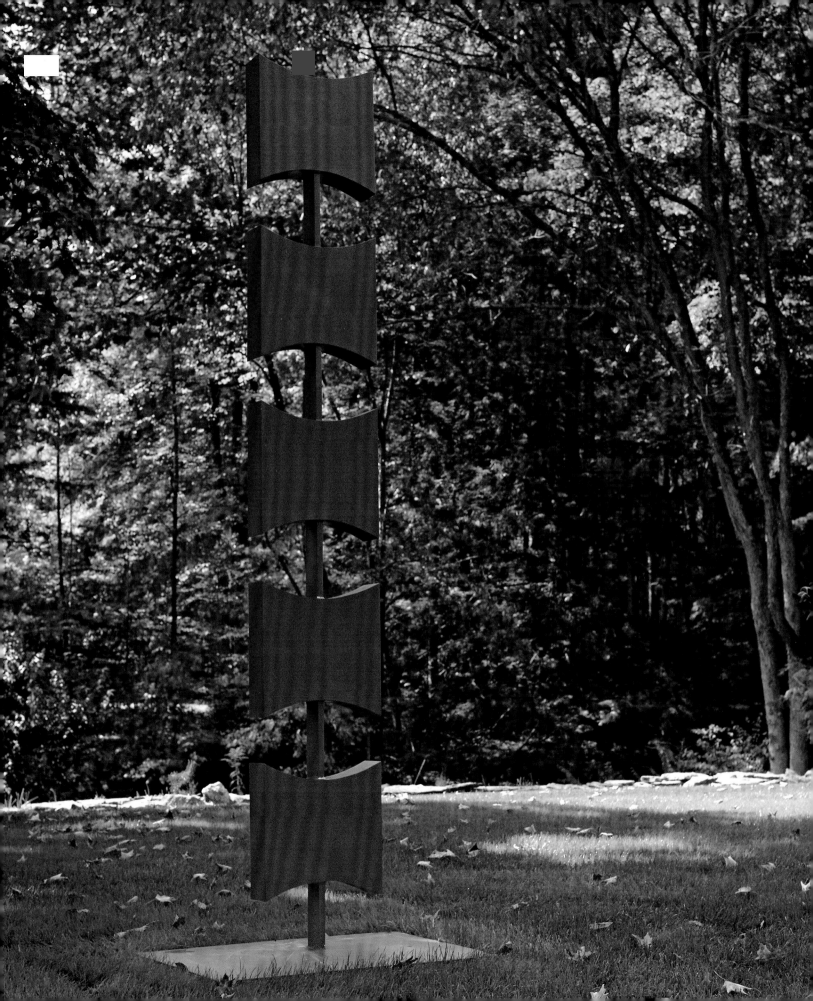

Octacube, 1996. Painted wood, 15 x 21 x 15 in.

Octacube, 1996. Painted wood, 15 x 21 x 15 in.

OPPOSITE: *Signifier I*, 1999. Aluminum painted red, 96 x 15 x 4 in. Offering homage to both Brancusi and Smith, *Signifier I* injects bold color into a high Modernist sculptural ideal.

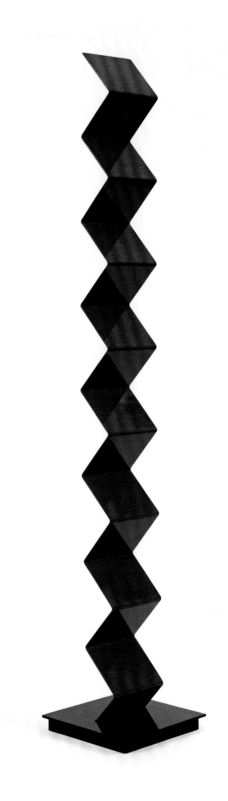

Linear, 1998. Stainless steel painted red and black, 55 1/2 x 10 x 10 in.

OPPOSITE: *Ceres*, 2000. Spring painted red, 24 x 5 x 5 in.

The endless legato effect of the *Continuous Elliptical Loops* series arises from the way the works cycle along orbits that have multiple focal points rather than fixed centers. Tracing the loops reveals that some are double structures and some are single continuous lines. The ellipse is a significant yet often overlooked formal premise used by many contemporary artists and architects, including Carter, Robert Mangold, Richard Serra, Bernard Vernet, Santiago Calatrava, and Jean Nouvel.

Study for Construction. Copper wire, approximately 10 x 3 x 3 in.

Study for Construction. Copper wire, approximately 8 x 4 x 4 in.

OPPOSITE: **Continuous Elliptical Loops**, 2000. Polished stainless steel, 30¹/₂ x 30¹/₂ x 19 in.

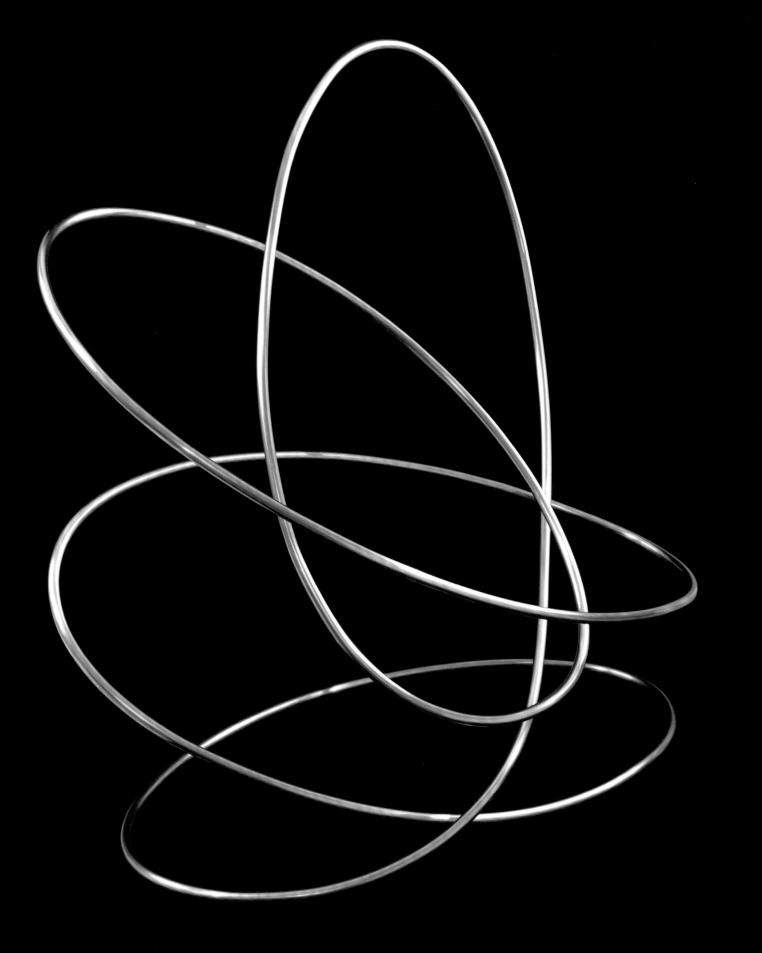

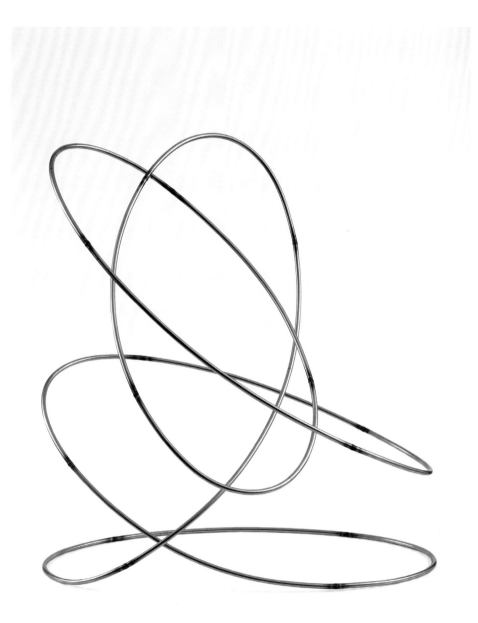

Continuous Elliptical Loops, 2000. Stainless steel, 31 ½ x 32 x 20 in.

OPPOSITE: *Continuous Elliptical Loops*, 2000.
Stainless steel, 30 ¹/₂ x 30 ¹/₂ x 19 in.

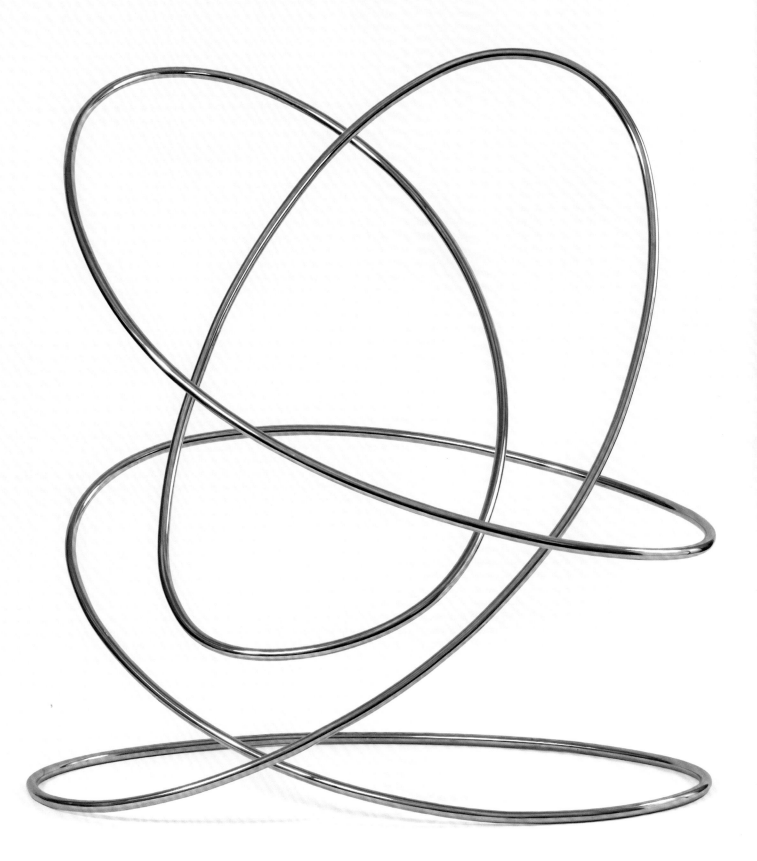

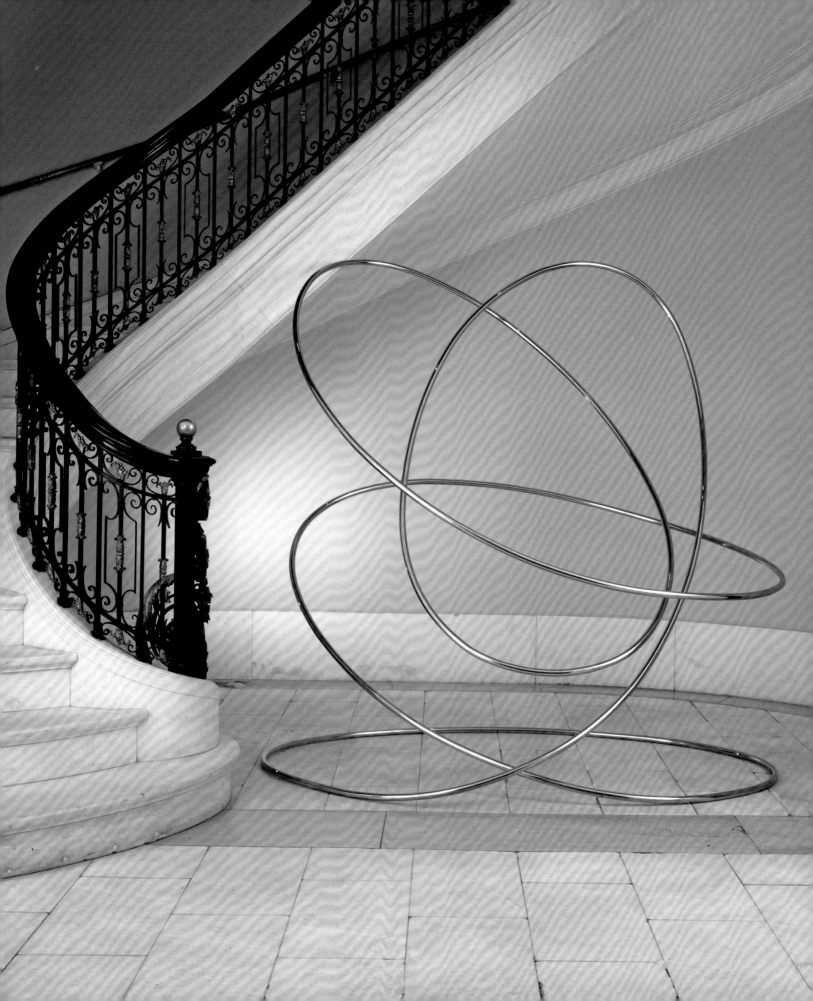

Study for Construction. Charcoal on paper, 6 x 8 in.

OPPOSITE: ***Continuous Elliptical Loops***, 2000. Stainless steel, 80 x 80 x 48 in. The pulse of light along the steel circuit of *Continuous Elliptical Loops* evokes a sense of almost nuclear energy.

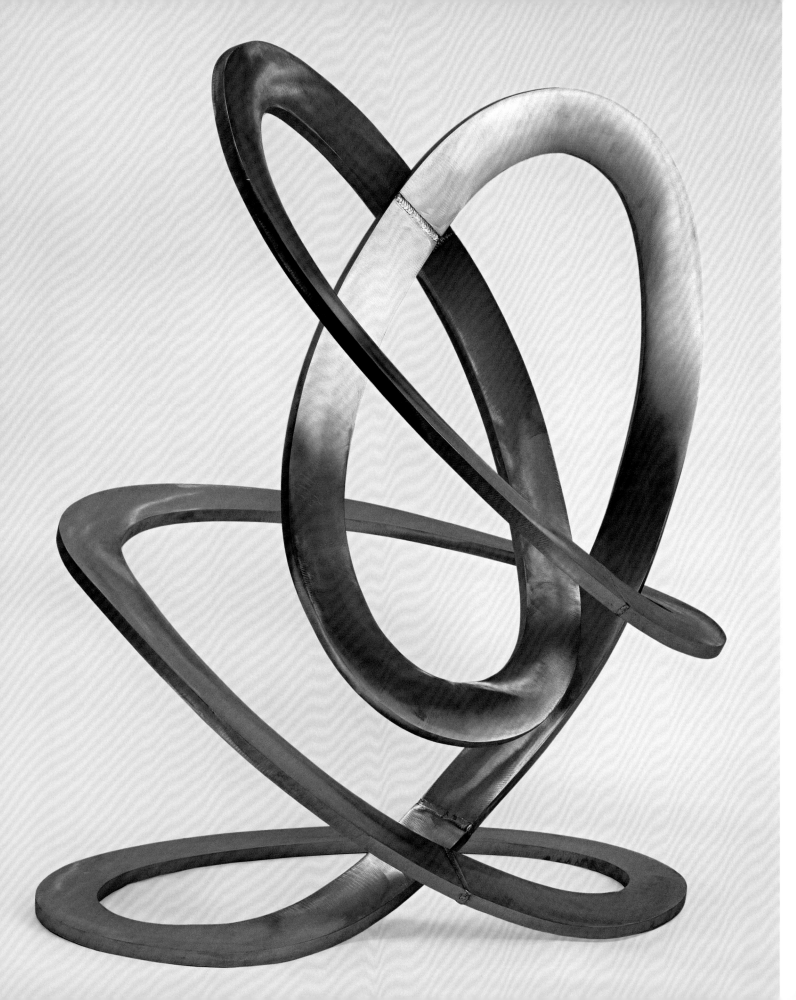

Study for Construction.
Charcoal on paper, 8 x 6 in.

Study for Construction.
Charcoal on paper, 8 x 6 in.

OPPOSITE: *Continuous Elliptical Loops*, 2005. Sanded stainless steel, 42$\frac{1}{2}$ x 37 x 26 in.

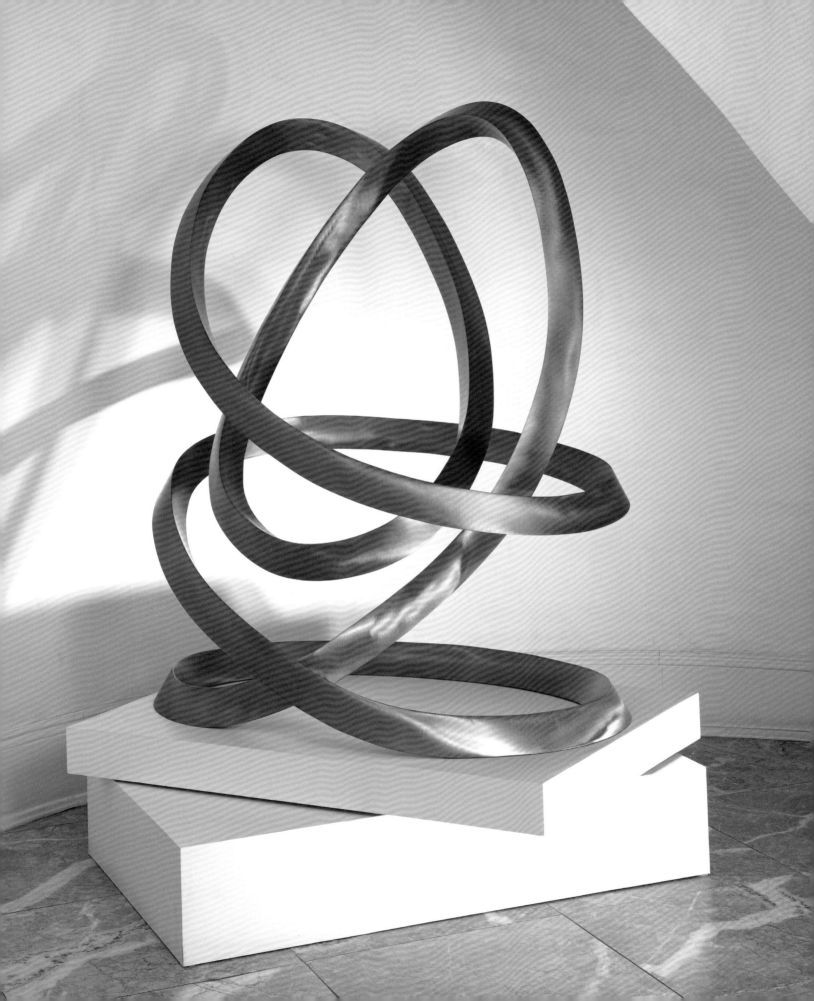

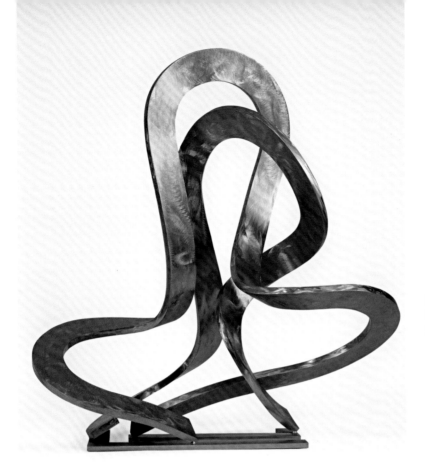

Elliptical Loops, 2005.
Sanded stainless steel,
38 x 38 x 23 in.

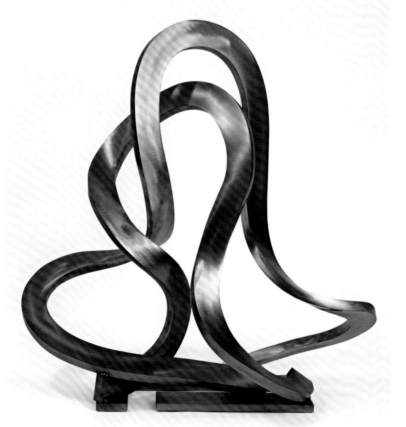

Elliptical Loops, 2005.
Bronze, 38 x 37 x 22 in.

OPPOSITE: *Continuous Elliptical Loops*, 2007.
Bronze, 40 x 36 x 24 in.

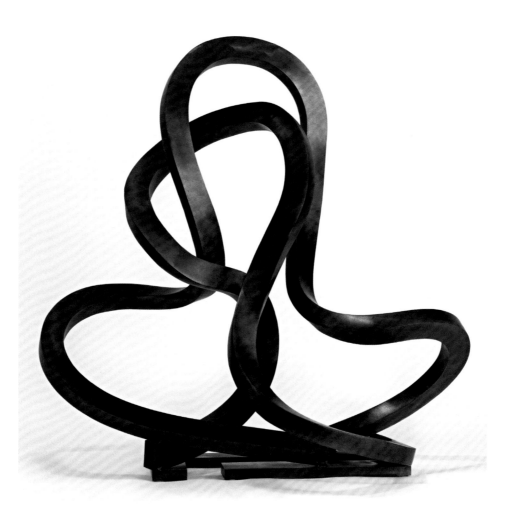

Elliptical Loops, 2005. Bronze with blue patina, 38 x 37 x 22 in.

OPPOSITE: *Untitled*, 2004. Stainless steel, 37 x 36 x 16 in. The visual puzzle of the elliptical loops is posed by the knowledge that they are isomorphic, belied by the perception that they diverge.

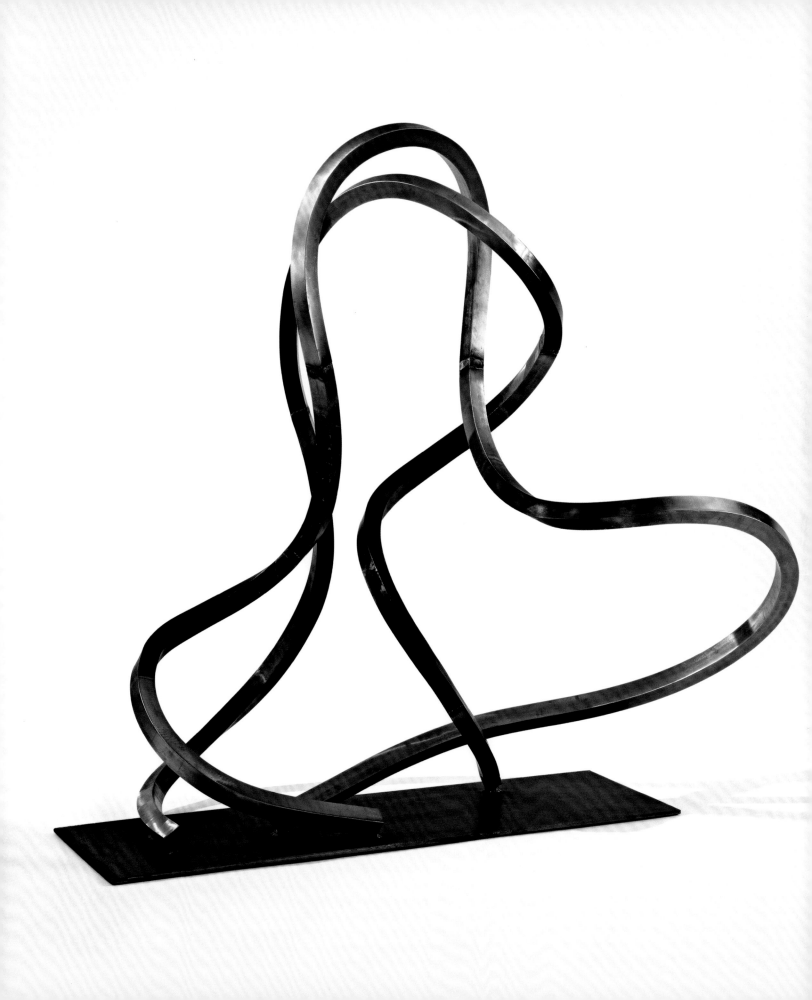

Study for Construction.
Charcoal on paper, 8 x 6 in.

Study for Construction.
Charcoal and ink on paper,
8 x 6 in.

OPPOSITE: *Ellipse
Intersected by Two
Concentric Ellipses at 45
Degrees*, 2002. Stainless
steel, 47 x 31 x 22 in.

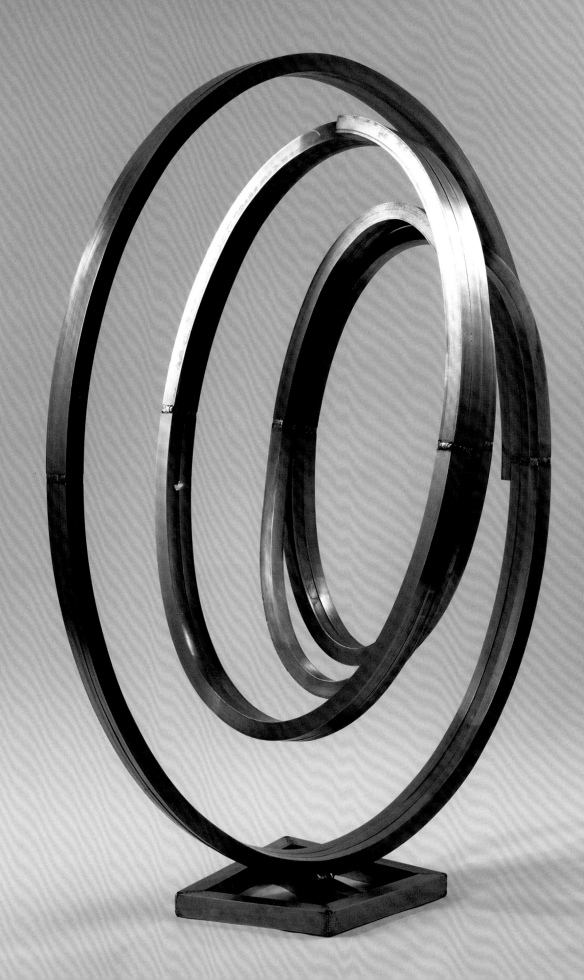

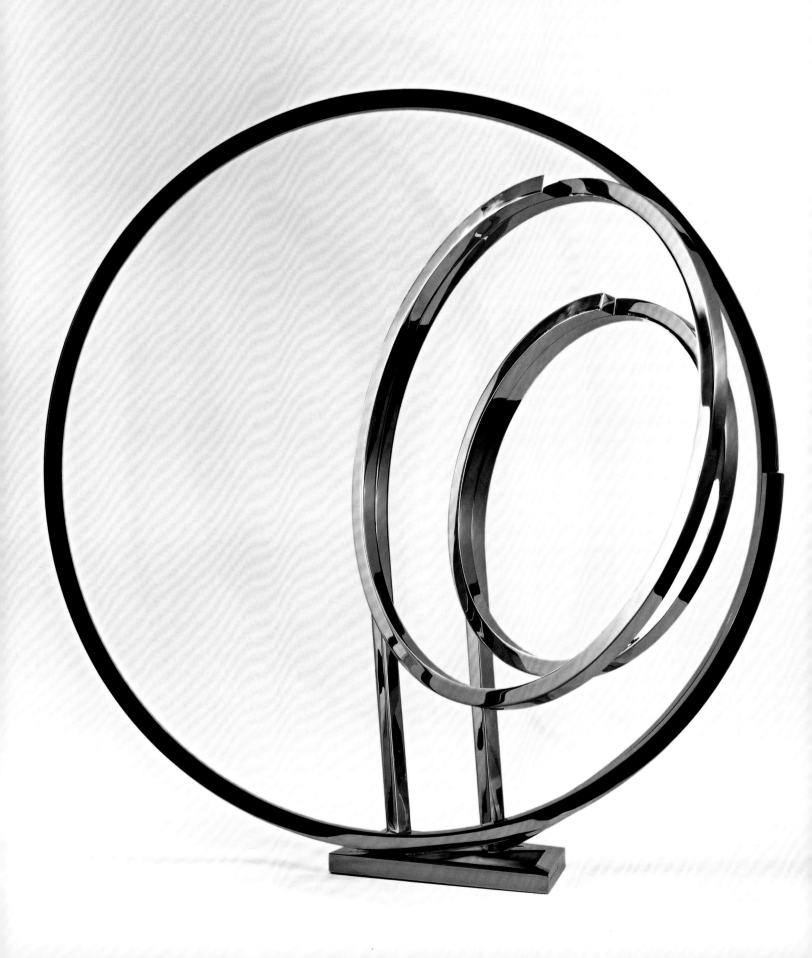

A Circle Intersected by Two Concentric Circles at 30 Degrees, 2001.
Polished stainless steel, 39½ x 39½ x 26 in.

OPPOSITE: *A Circle Intersected by Two Concentric Circles*, 2003.
Polished stainless steel, 41 x 40 x 24 in. Using the telescopic spiral to
capture space, *A Circle Intersected by Two Concentric Circles* rapidly
leaves the straight chord to explore the arc at its apogee.

Study for Construction.
Charcoal on paper, 8 x 6 in.

Study for Construction.
Charcoal on paper, 8 x 6 in.

OPPOSITE: *Intersecting Ellipses*, 2005. Bronze with blue patina, 52 x 52 x 52 in.

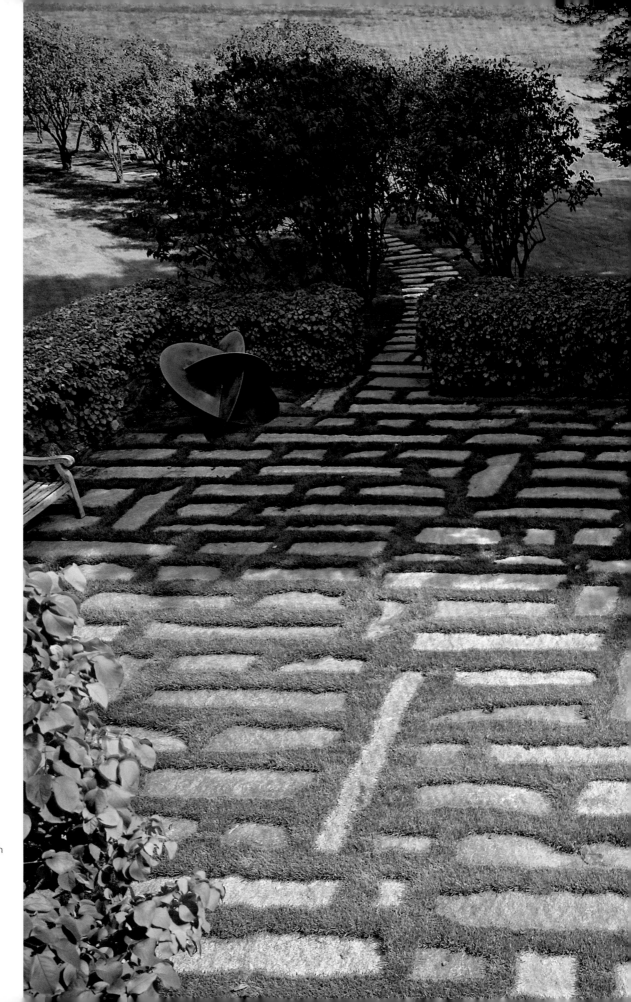

Stone Courtyard, 1995.
Granite, 480 x 480 in.
Tucked in a corner of
the courtyard at Carter's
Connecticut farmhouse,
Intersecting Ellipses stands
by the first steps of the path
that leads among lilacs to
the artist's studio.

Study for Construction. Charcoal on paper, 8 x 6 in.

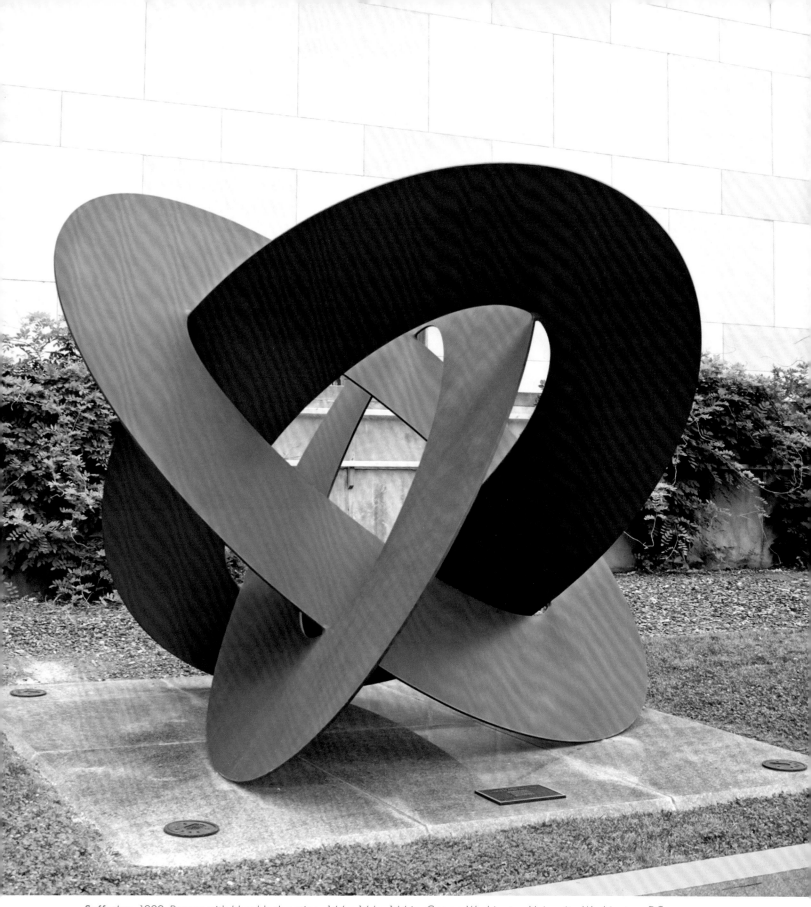

Suffusion, 1999. Bronze with blue-black patina, 144 x 144 x 144 in. George Washington University, Washington, DC.

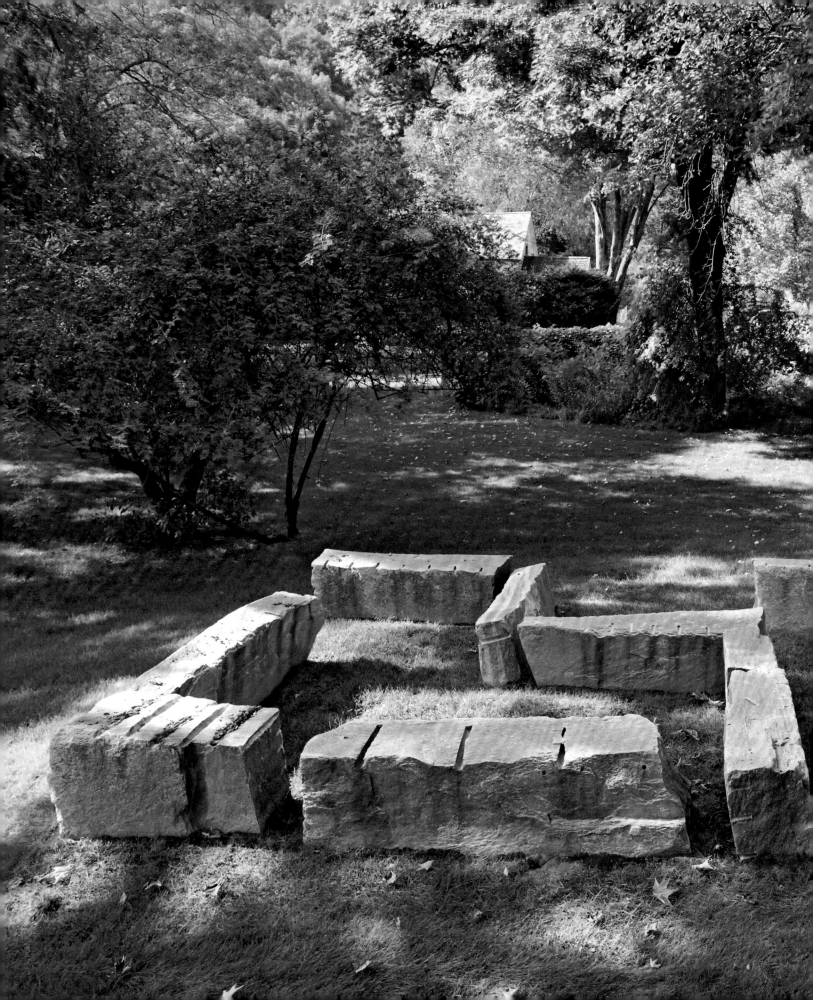

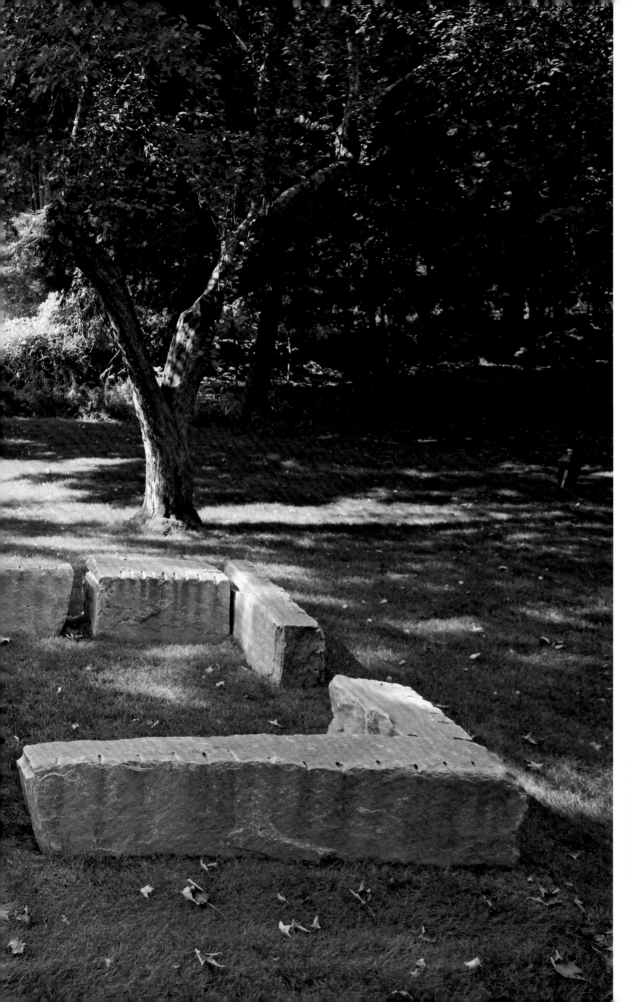

Stone Structure, 2003.
Granite, 20 x 228 x 144 in.
Carter's only essay in
horizontal stone, *Stone
Structure* reaches deep into
the history of the maze to
extract a timeless, recursive
experience.

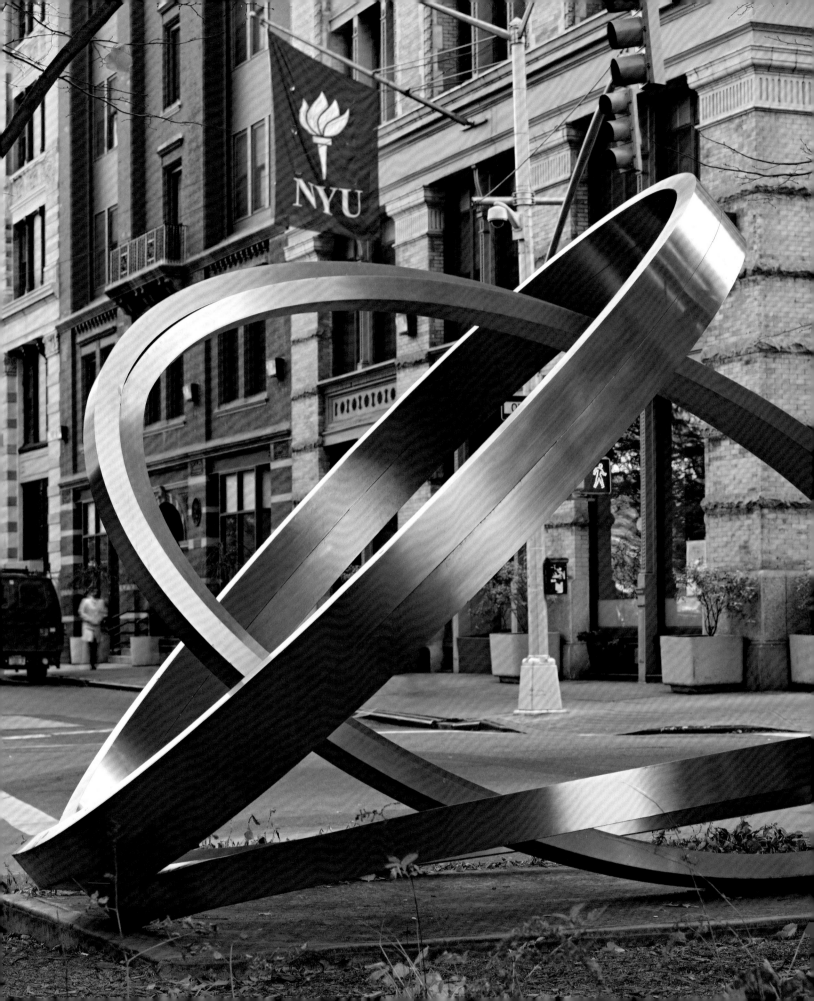

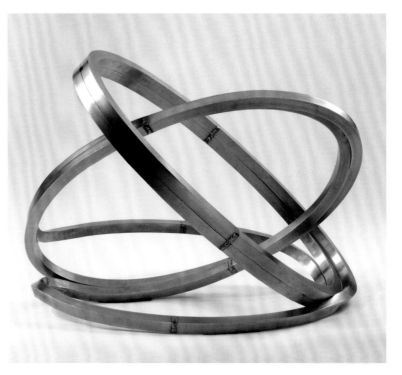

Continuous Connecting Ellipses, 2002. Stainless steel, 30 x 40 x 25 in.

LEFT: *The University*, 2003. Stainless steel, 88 x 124 x 79 in. New York University, New York, NY. One of the highlights of the New York University art collection, installed on Washington Square, *The University* is a doubled ellipse brimming with the sense of sprung tension it would unleash if the cycling bands were suddenly released.

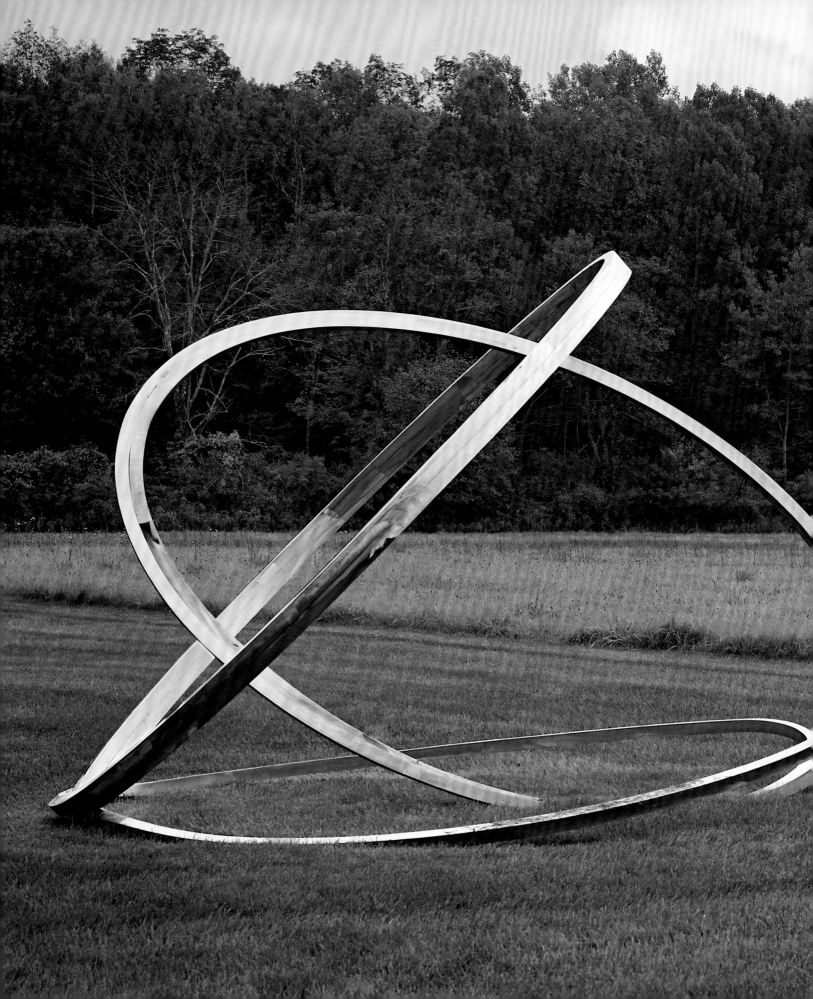

Untitled, 2003. Stainless steel, 87 x 128 x 78 in. Slowed into gracefully swinging ellipses that gently lift from the grass, this untitled work rhymes with the undulations of the Connecticut hillside surrounding it.

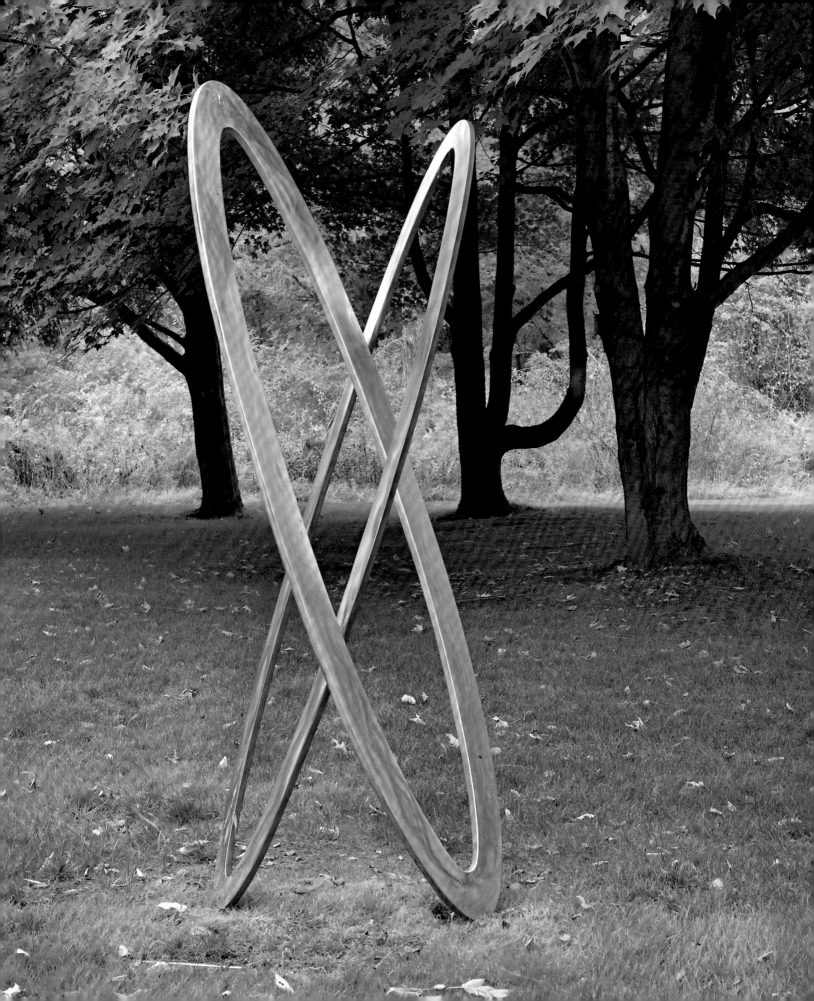

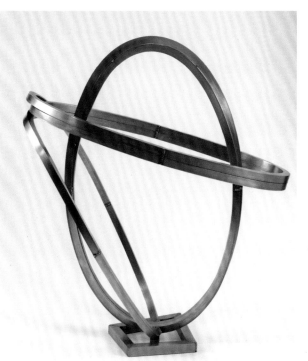

An Ellipse Intersected by Two Ellipses at 45 Degrees, 2002. Stainless steel, 40 x 36 x 24 in.

OPPOSITE: *The Couple*, 1999. Stainless steel and bronze, 91 x 32 x 24 in.

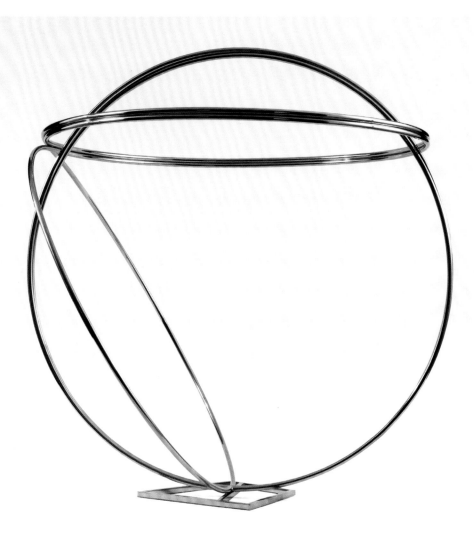

A Circle Intersected by Two Circles, 2001. Polished stainless steel, 40 x 40 x 35 in. The tight, Euclidean composition of *A Circle Intersected by Two Circles*, all centripetal force and control, is revisited with a freer hand and heightened centrifugal complexity in *A Circle Intersected by Two Concentric Circles* (2003) (see page 58).

The ongoing counterpoint of straight edges and curves culminates in a vibrant series of vertically oriented works collectively referred to under the rubric of "arcs and chords" (where chords are the musically inspired straight elements). Naturally emanating from the earlier works in which circular and elliptical flourishes surmount straight, leglike supports, the theme of "arcs and chords" plays out through a broad-ranging suite of variations. The lead changes hands often in this dance of S-curves and straight edges, as arcs overlap and intersect with chords through permutations that may change the aspect significantly but maintain the Fibonacci ratios as their guide to points of intersection and tangency.

Study for Construction.
Copper wire on clay base, approximately 4 x 2 x 2½ in., with base.

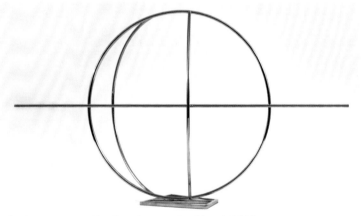

A Circle Intersected by Two Arcs and a Chord, 2002.
Polished stainless steel, 30½ x 54½ x 20 in.

OPPOSITE: **An Ellipse Intersected by Two Arcs and a Chord**, 2002. Stainless steel, 31 x 31 x 18 in.

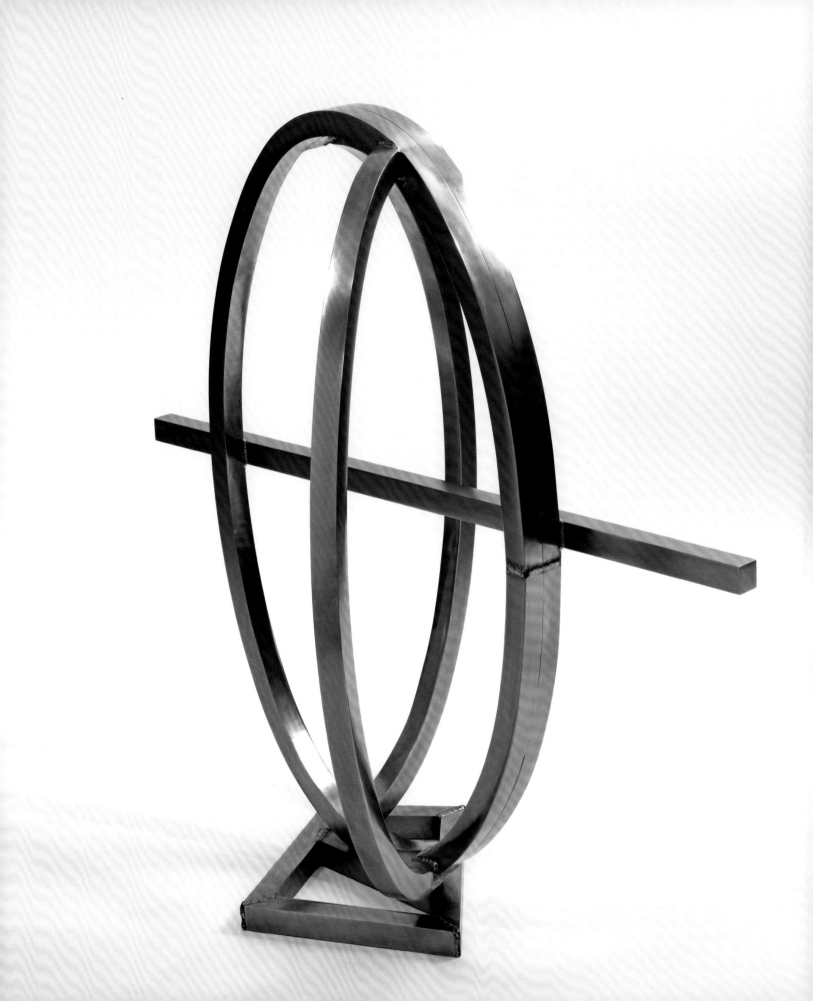

Study for Construction. Charcoal on paper, 8 x 6 in.

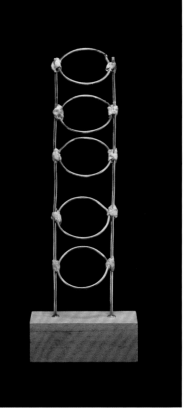

Study for Construction. Copper wire on wood base, approximately 12 x 2 x 2½ in., with base.

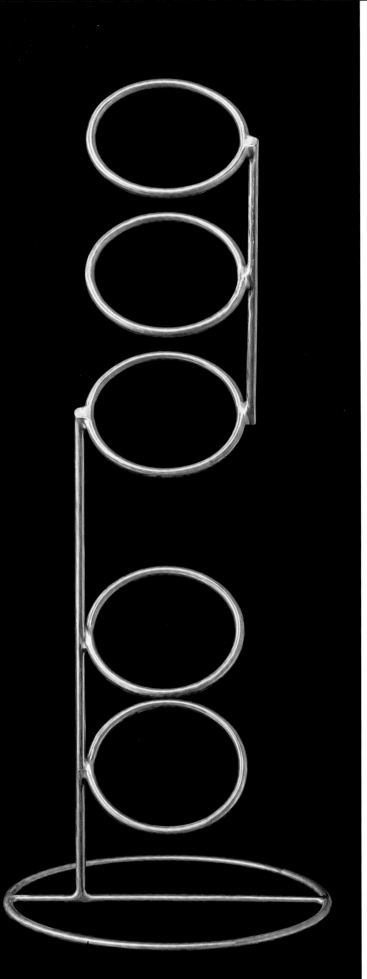

'5 circles in a column at 45°

Study for Construction. Pencil on paper, 8 x 6 in.

Five Circles in a Column at 45 Degrees, 2000. Bronze, 30 x 6 x 4 in. From the lightest pencil drawing to the delicate maquette and the sturdy bronze realization, the creative sequence for *Five Circles in a Column at 45 Degrees* is tightly pursued.

Four Helical Circles, 2002.
Bronze, 30 x 14½ x 11 in.

OPPOSITE: *A Perpendicular with
Partial Helix*, 2002. Bronze, 31½
x 22 x 18 in.

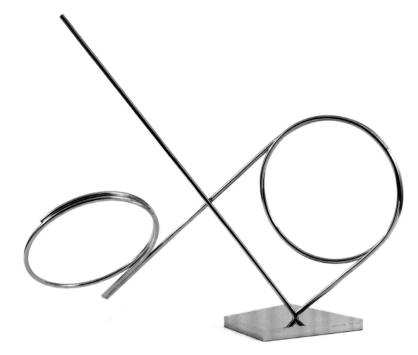

Two Circles Connected by a Tangential Chord, 2002. Polished stainless steel, 29 x 34 x 17 in.

OPPOSITE: **Concentric Loops**, 2001. Polished stainless steel wire, 41 x 44 x 33 in. The gestural exuberance of *Concentric Loops* broadens as it swings outward in a cantilevered escape from its base.

Intersecting Circles with Three Chords to the Base, 2002. Polished stainless steel, 41½ x 16 x 12½ in.

Study for Construction. Charcoal on paper, 8 x 6 in.

Study for Construction. Charcoal on paper, 8 x 6 in.

OPPOSITE: *Parallel Ellipses at 30 Degrees*, 2002. Stainless steel painted red, 108 x 72 x 36 in. Fast as light, the beam of cinnabar *Parallel Ellipses at 30 Degrees* was nicknamed "Rosefire" by the sculptor.

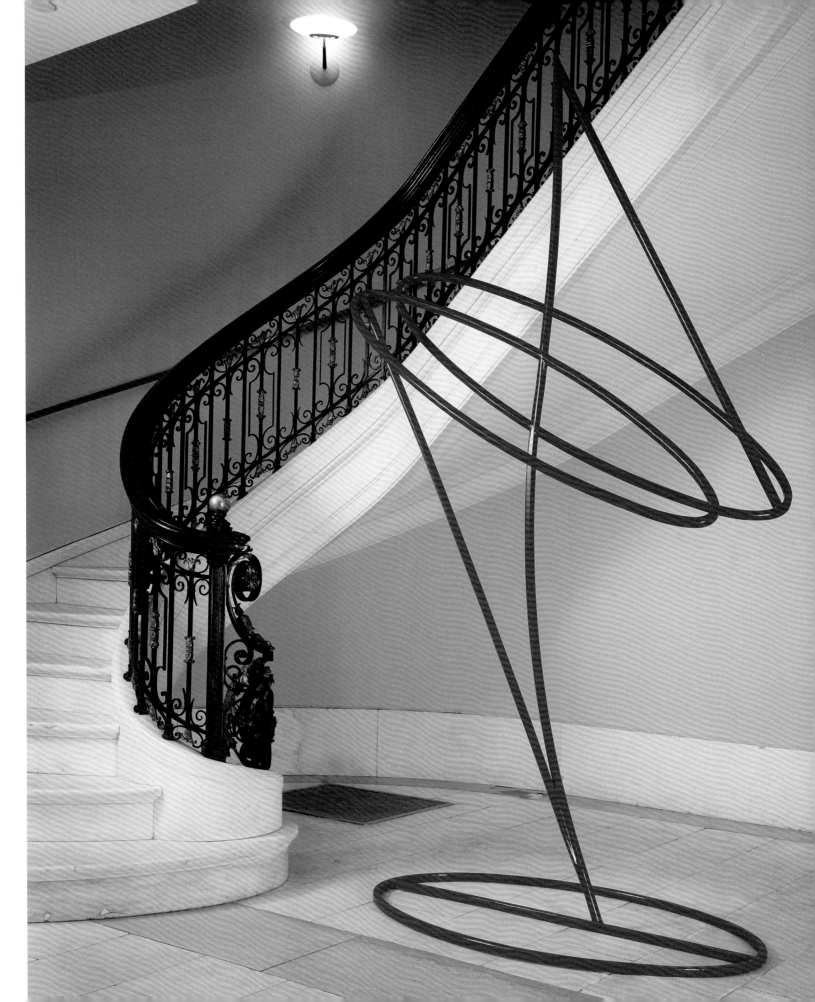

Study for Construction. Pencil and ink on paper, 8 x 6 in.

OPPOSITE: *Untitled*, 2003. Stainless steel, 48 x 30 x 22 in.

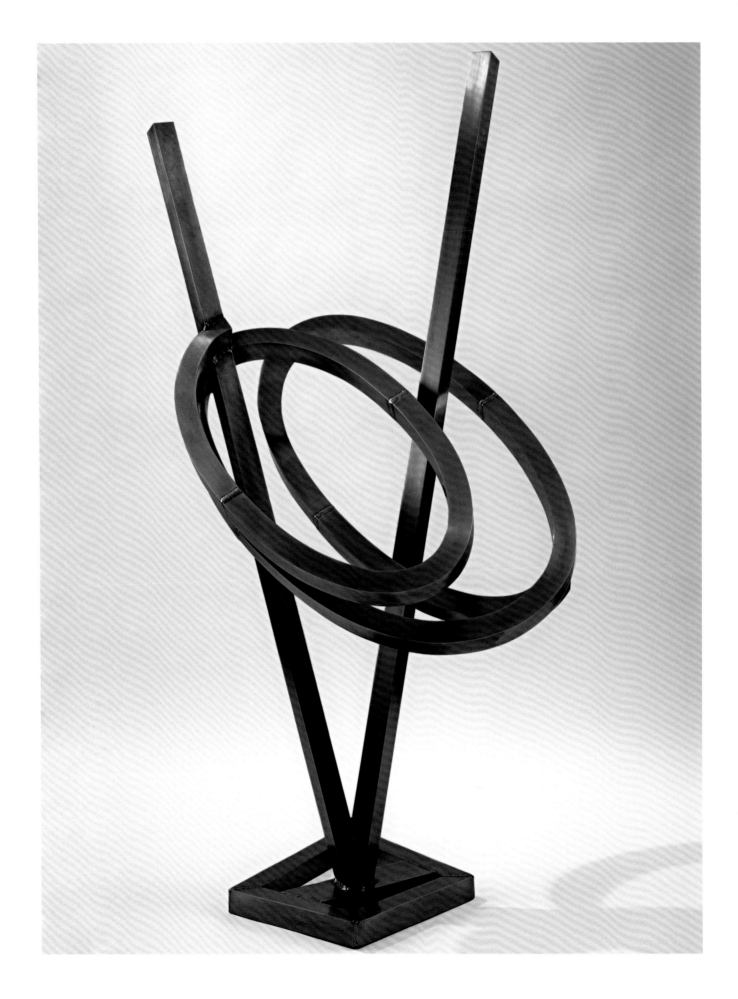

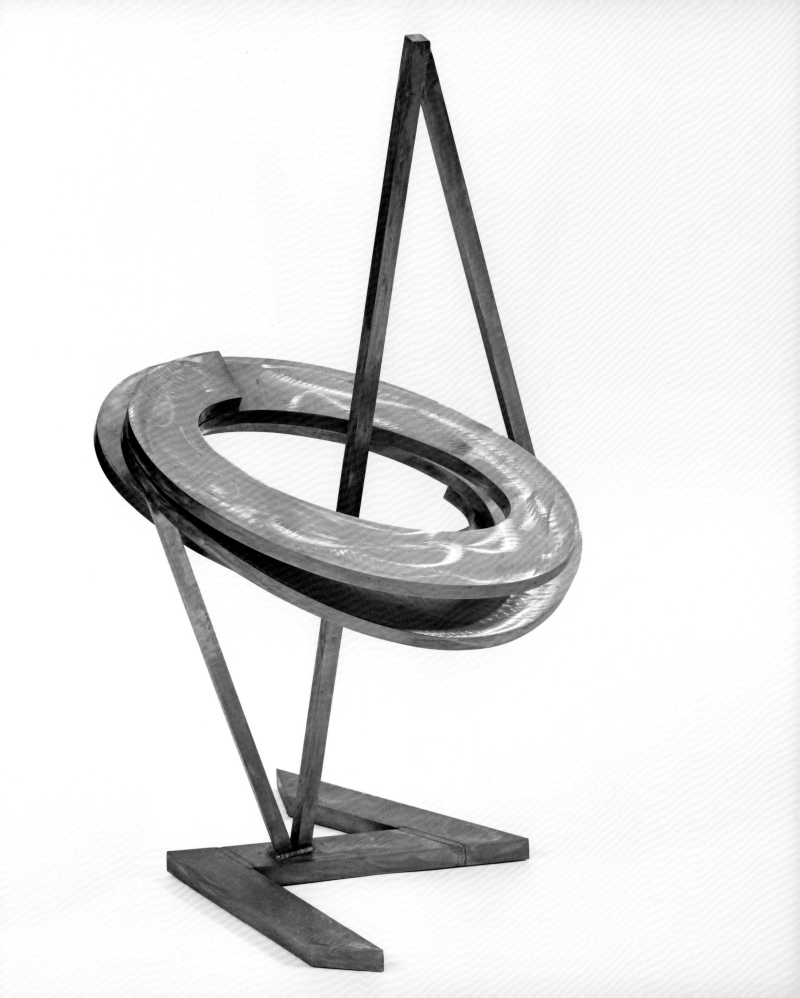

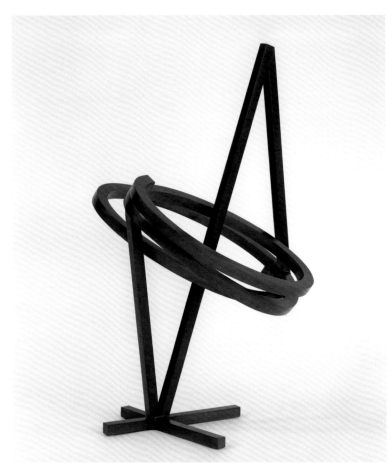

Parallel Ellipses Intersected by Acute Angles, 2002. Bronze with green patina, 36 x 22 x 16 in.

OPPOSITE: *Untitled*, 2004. Stainless steel, 38 x 21 x 18 in. A superb example of the gestural patterns made by the sanding of the stainless steel surface, this untitled work offers a painterly surface.

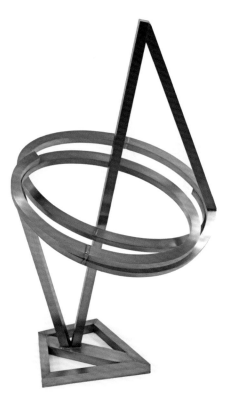

Untitled, 2004. Stainless steel, 36 x 22 x 18 in.

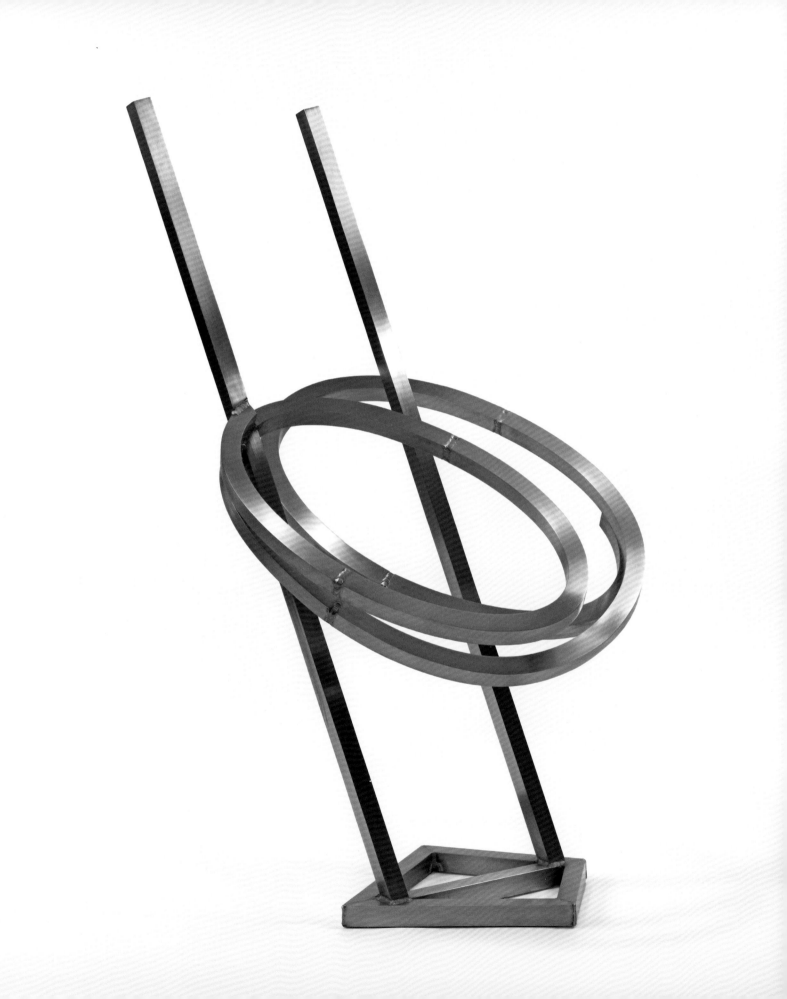

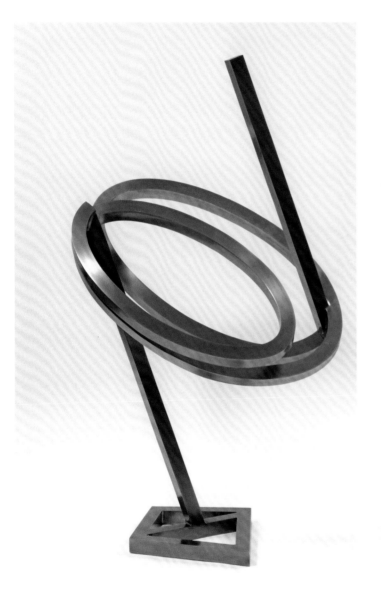

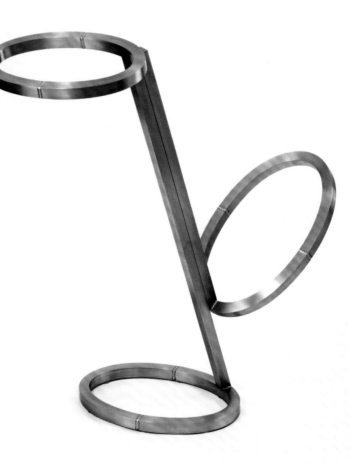

Untitled, 2003. Stainless steel, 48½ x 30½ x 22 in.

Untitled, 2004. Stainless steel, 34½ x 26 x 18 in.

OPPOSITE: *Untitled*, 2004.
Stainless steel, 40 x 22 x 19 in.

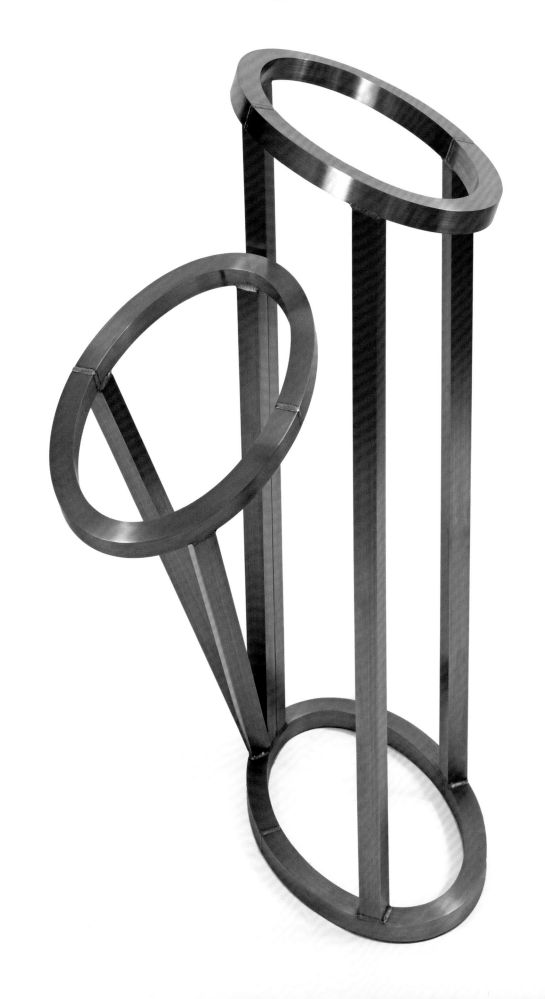

Study for Construction. Pencil and ink on paper, 8 x 6 in.

OPPOSITE: *Untitled*, 2004. Stainless steel, 37½ x 15 x 18 in.

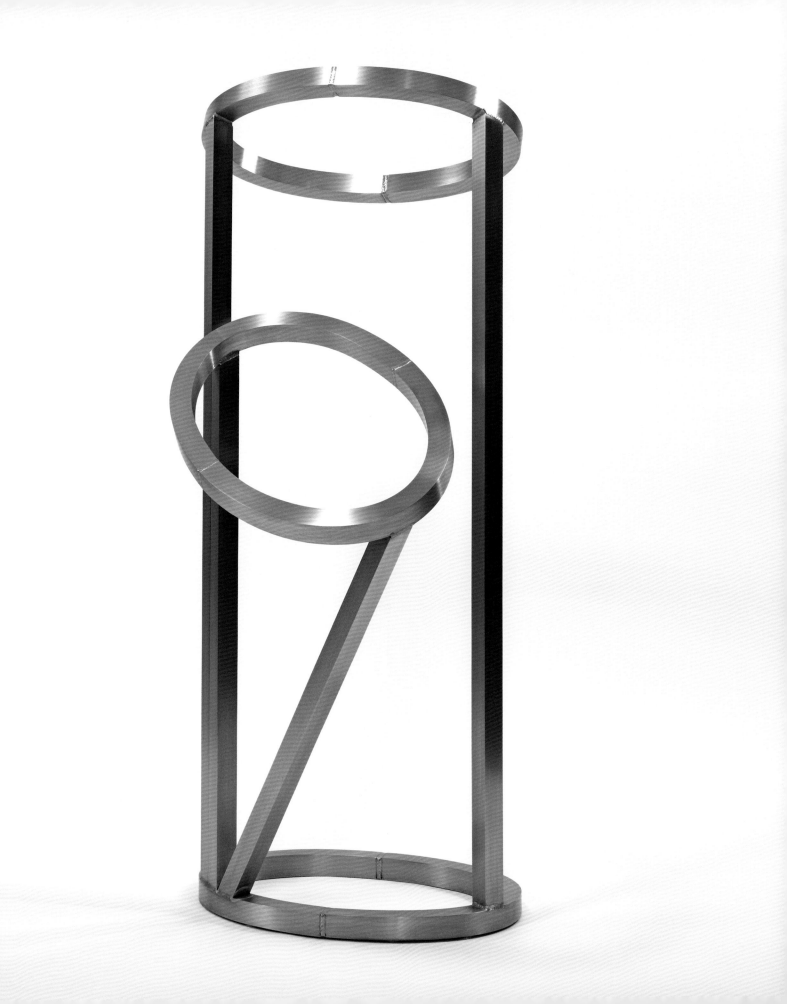

Study for Construction. Pencil and ink on paper, 8 x 6 in.

Study for Construction. Pencil and ink on paper, 8 x 6 in.

Study for Construction. Charcoal on paper, 8 x 6 in.

OPPOSITE: **Untitled**, 2004. Stainless steel, 37 x 15 x 18 in.

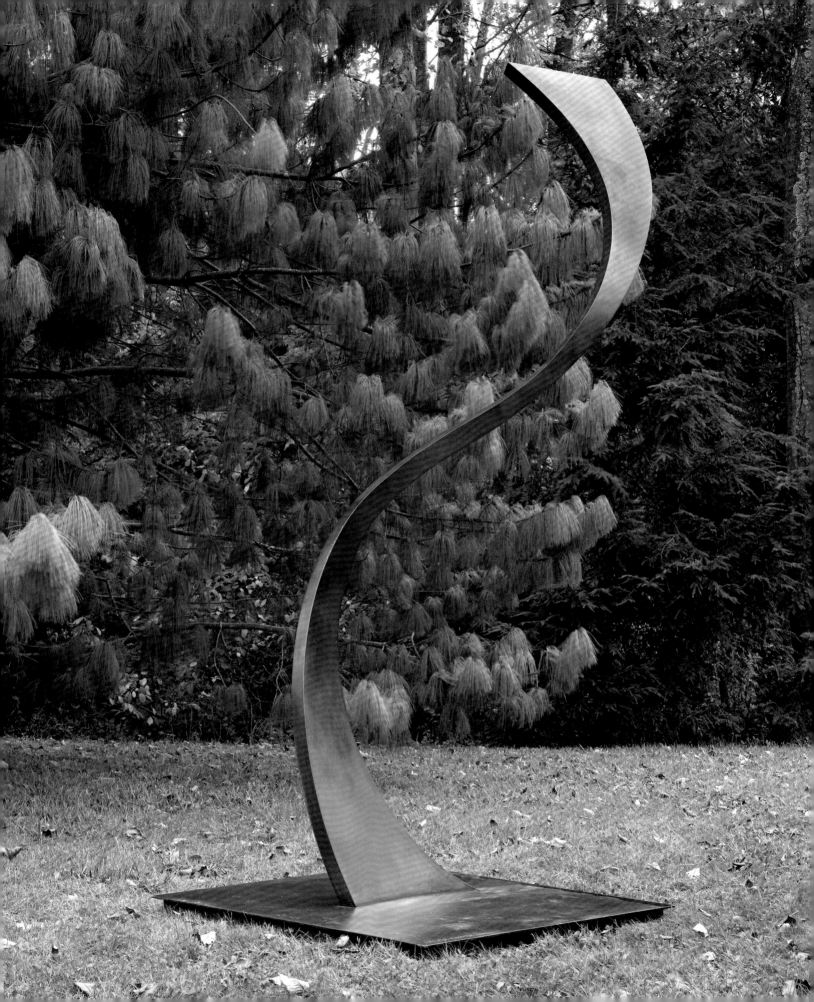

Two Connecting Inverted Arcs, 2000.
Stainless steel, 30½ x 16 x 13 in.

OPPOSITE: *Morph*, 1998. Bronze with carbon
black patina, 120 x 64 x 56 in.

AK 98

Study for Construction. Charcoal on paper, 8 x 6 in.

OPPOSITE: **Musika**, 1998. Bronze with carbon black patina, 84 x 72 x 30 in.
Carter's advanced training as a pianist informs the melodic grace of *Musika*.

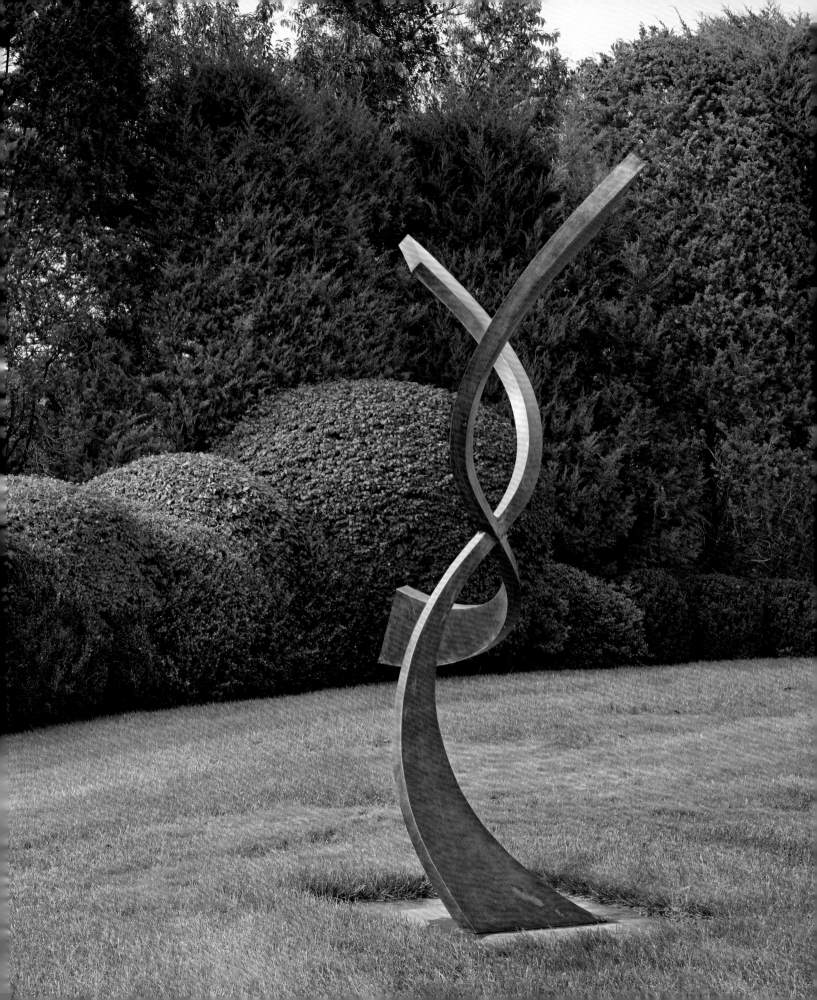

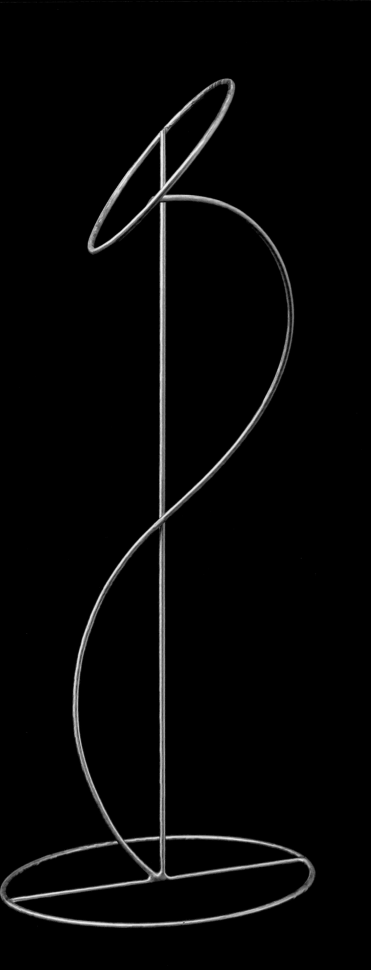

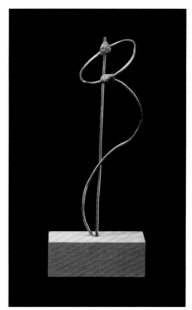

Study for Construction. Copper wire on wood base, approximately 10 x 2 x 2½ in., with base.

LEFT: **An Ellipse Suspended by an Arc and a Chord**, 2000. Bronze, 30 x 12 x 12 in.

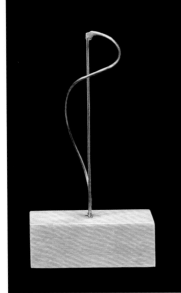

Study for Construction. Copper wire on wood base, approximately 10 x 2 x 2½ in., with base.

RIGHT: ***A Partial Helix Connected by a Chord***, 2002. Stainless steel painted blue, 40 x 16 x 6 in.

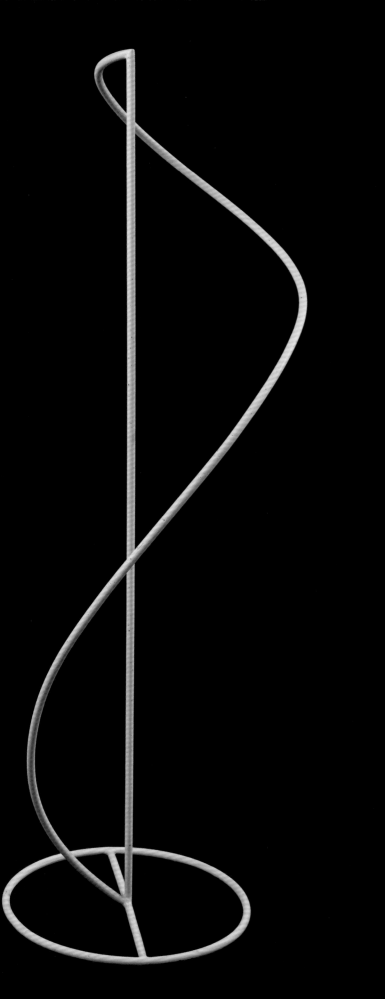

A Helix Connected by a Chord,
2002. Stainless steel painted yellow,
40 x 14 x 13 in.

OPPOSITE: *Two Parallel Inverted
Arcs with Parallel Chords*, 2000.
Stainless steel, 31 x 14 x 12 in.

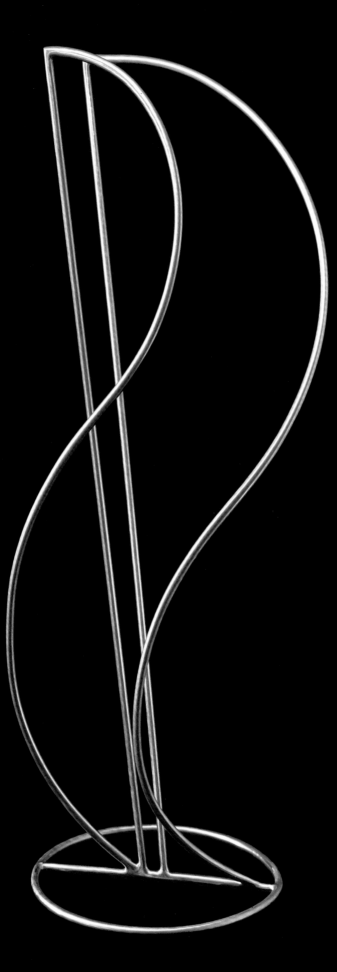

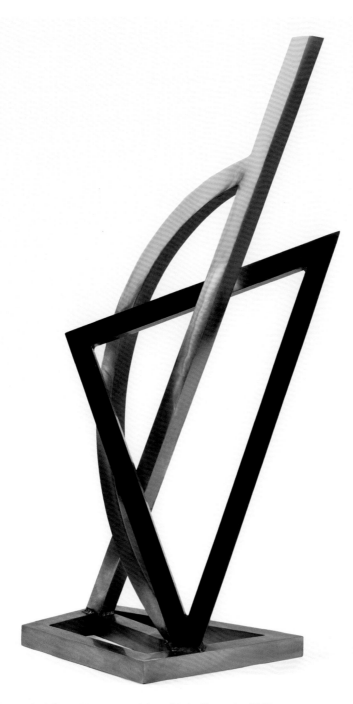

An Arc and an Extended Chord Intersected by a Right Triangle, 2002.
Stainless steel, 42 x 17 x 10 in.

OPPOSITE: *An Arc and an Extended Chord Intersected by a Right Triangle*,
2000. Stainless steel, 31 x 12 x 12 in. *An Arc and an Extended Chord Intersected
by a Right Triangle* (2000) interweaves triangular and hemispheric forms.

Study for Construction. Pen and ink on paper, 8 x 6 in.

Study for Construction. Pen and ink on paper, 8 x 6 in.

OPPOSITE: *Triax*, 2001. Stainless steel, 108 x 76 x 1 in. *Triax* is a classic "drawing in air" that translates a Fibonaccian idea into a figure in nature.

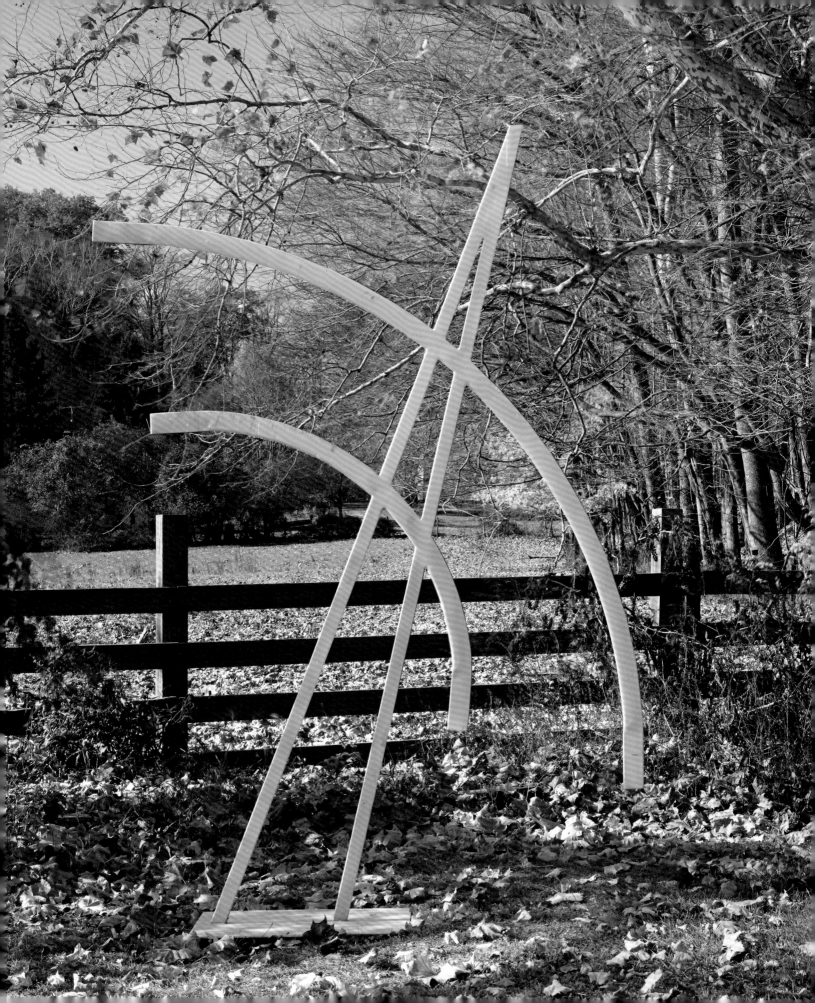

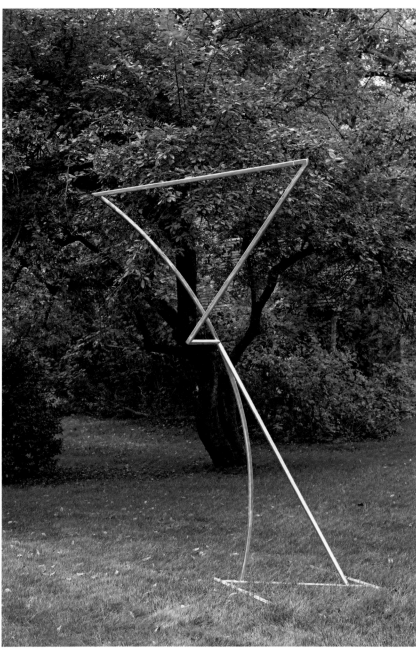

Study for Construction. Pen and ink on paper,
8 x 6 in.

OPPOSITE: *Parallax*, 2000. Stainless steel,
106 x 100 x 54 in.

Pulsar, 2000. Stainless steel, 96 x 59 x 60 in.

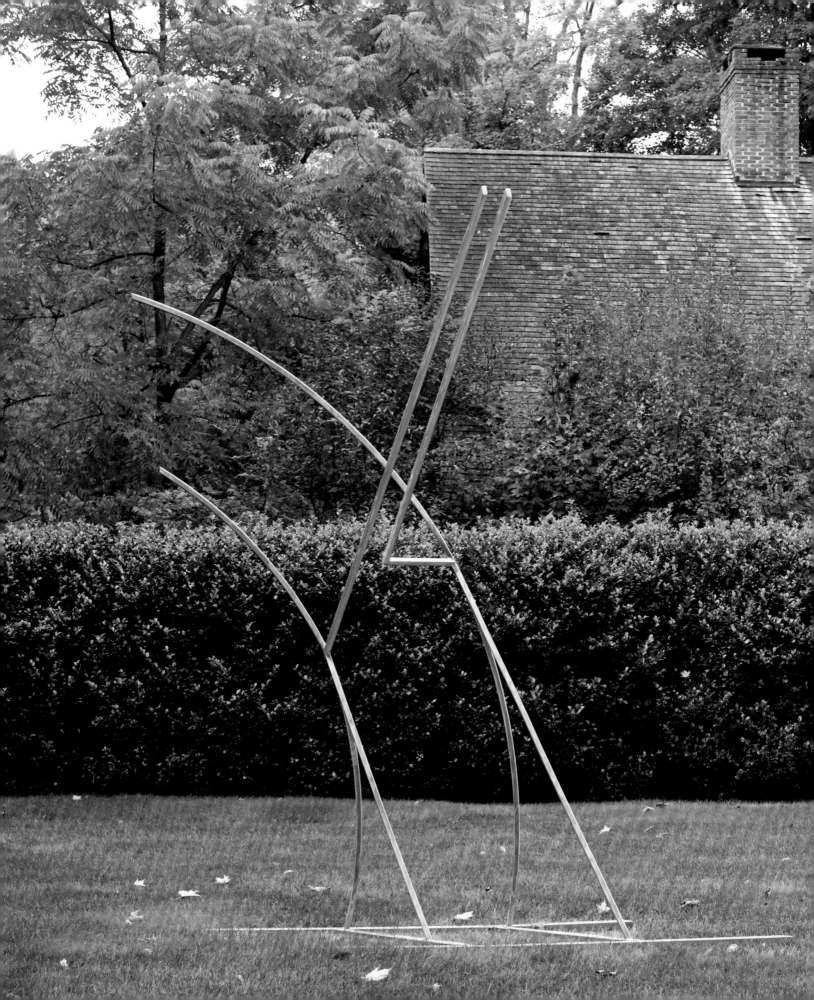

Tektonics, 2000.
Stainless steel painted
blue, (left to right) 101
x 72 x 30 in., 124 x 54 x
1 in., 108 x 40 x 1 in.

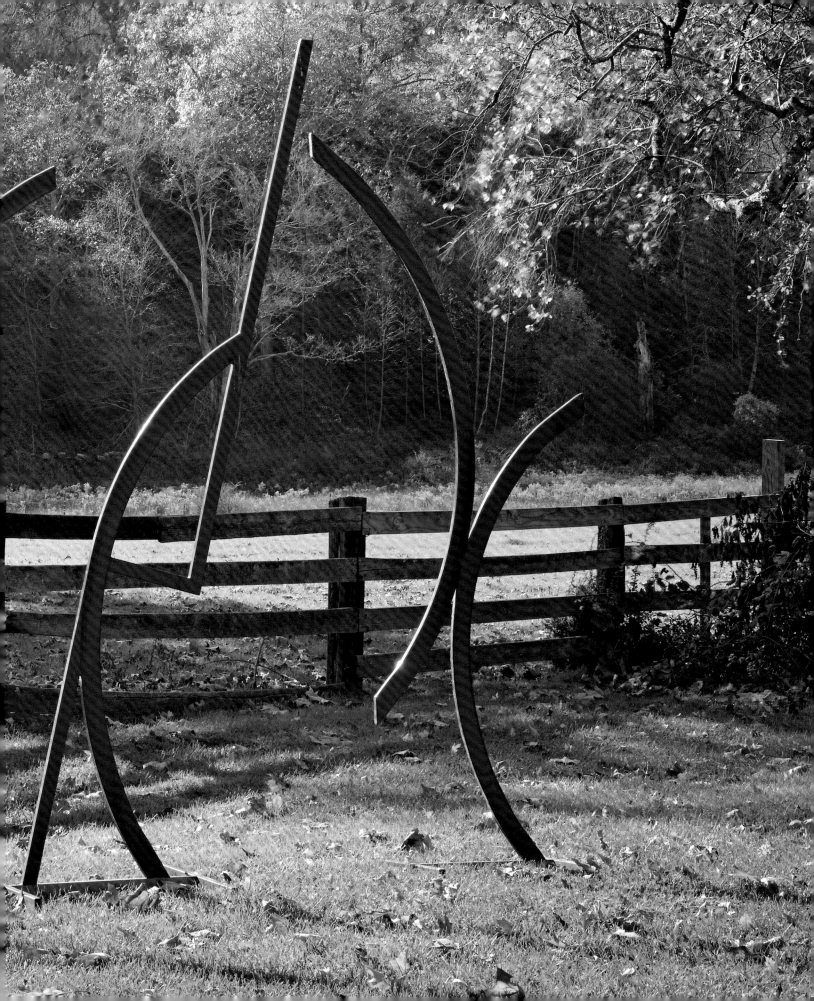

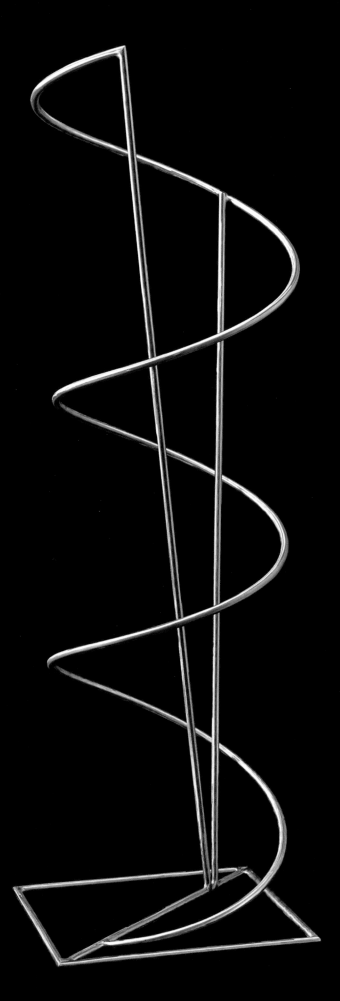

Three Inverted Arcs with Parallel Chords,
2002. Polished stainless steel, 41 ¼ x 8 x 8 in.

OPPOSITE: *A Helix Intersected by an Acute
Angle*, 2002. Bronze, 40 x 12½ x 12½ in.

Having explored the transparency of the open forms in the arcs and chords, Carter began experimenting with opacity. He added "membranes" to fill part of the windows, and they offered a tempting surface upon which color and form could interact.

Study for Construction. Pencil and ink on paper, 8 x 6 in.

OPPOSITE, LEFT: *Overlapping Arcs at 90 Degrees*, 2002. Stainless steel, 41 x 9 x 8 in.

OPPOSITE, RIGHT: *Overlapping Arcs at 90 Degrees with Inserted Membranes*, 2002. Stainless steel, 41 x 9 x 8 in.

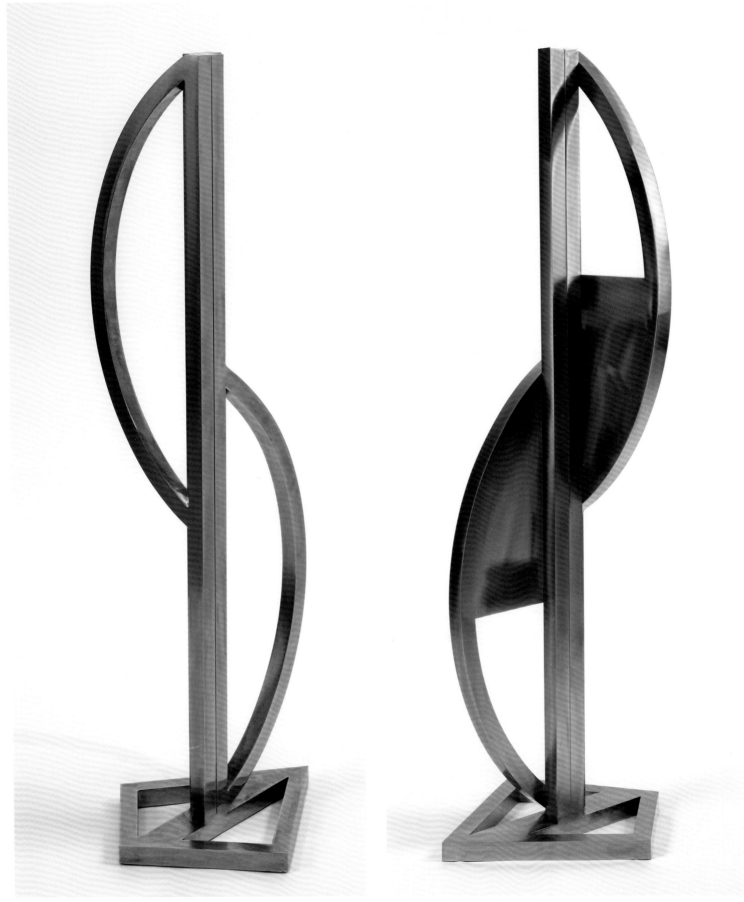

Study for Construction. Charcoal on paper, 8 x 6 in.

Study for Construction. Pencil on paper, 8 x 6 in.

OPPOSITE: **Untitled**, 2005. Bronze
painted blue, 41 x 9 x 8 in.

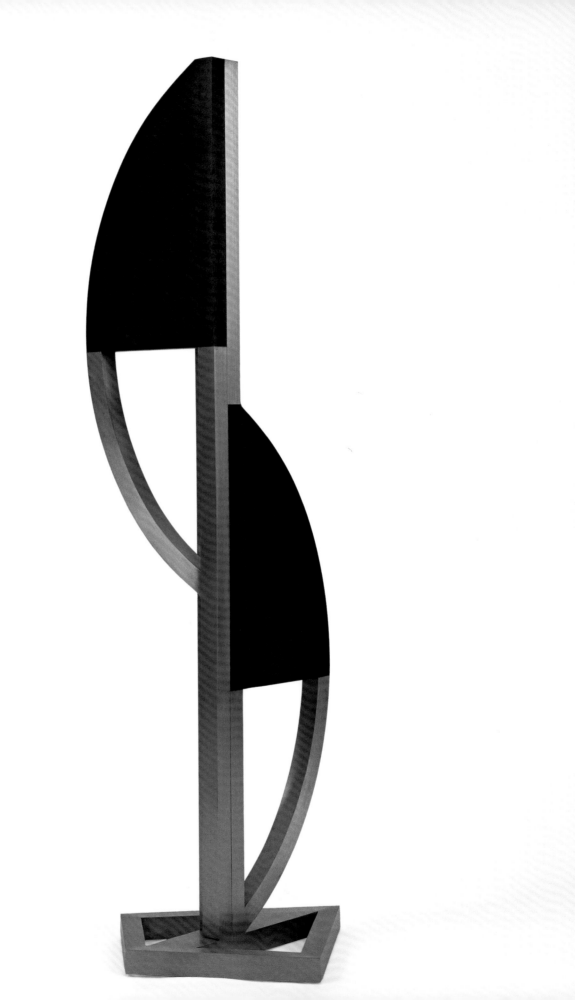

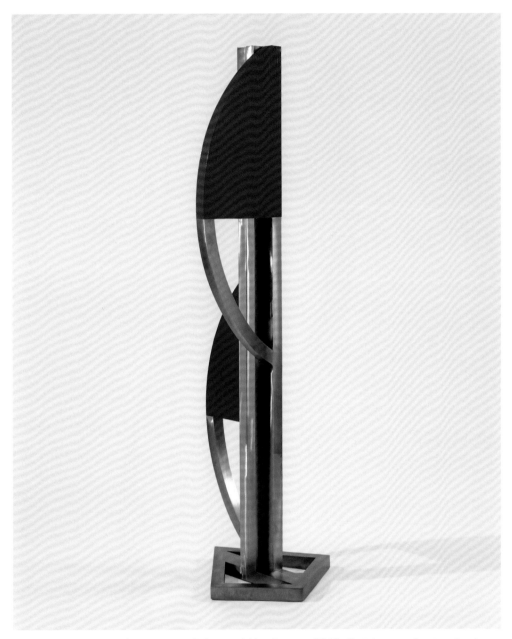

Overlapping Arcs at 90 Degrees with Inserted Membranes, 2002. Stainless steel painted red and blue, 41 x 9 x 8 in.

OPPOSITE: *Overlapping Arcs at 90 Degrees with Inserted Membranes*, 2002. Stainless steel painted yellow and green, 41 x 9 x 8 in.

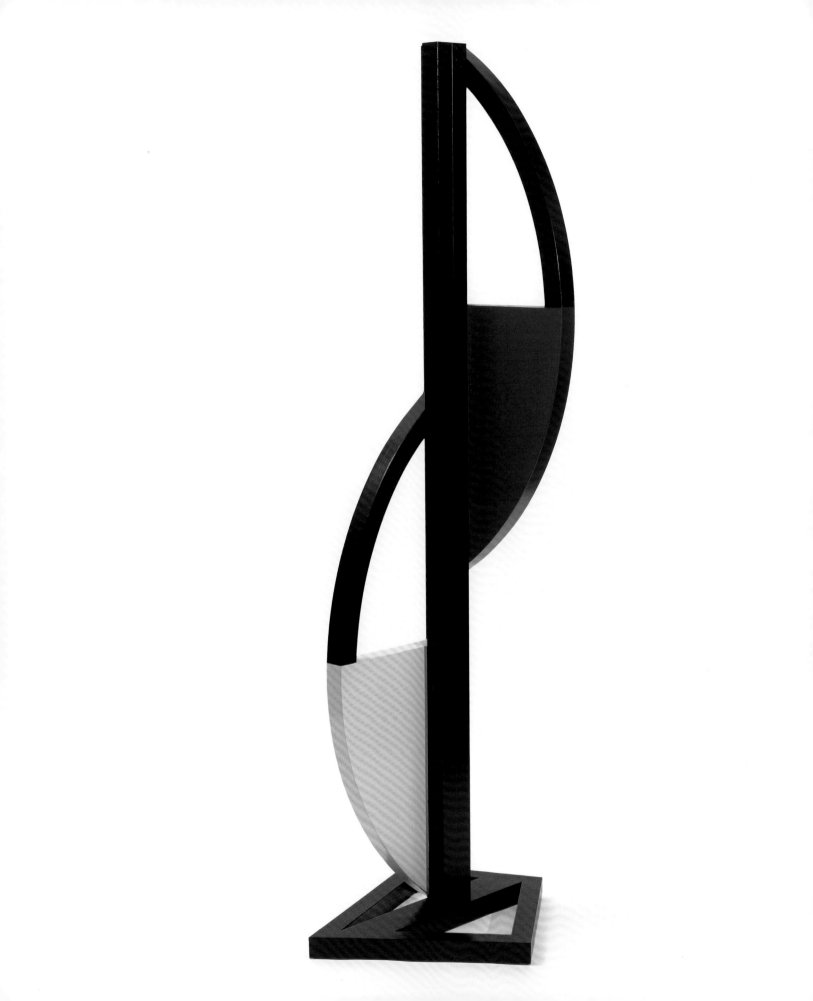

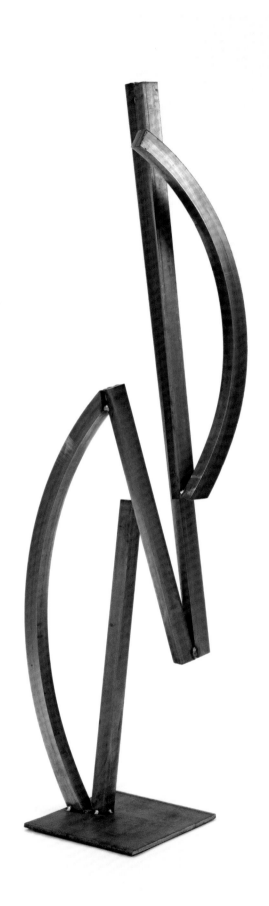

Study for Construction. Ink on paper, 8 x 6 in.

Study for Construction. Pencil and ink on paper, 8 x 6 in.

LEFT: *Arcs and Chords in Series*, 2003. Stainless steel, 41 x 16 x 9 in. An early version of *Arcs and Chords in Series* (see page 119) initiates the vocabulary of the straight lines partnering the curves.

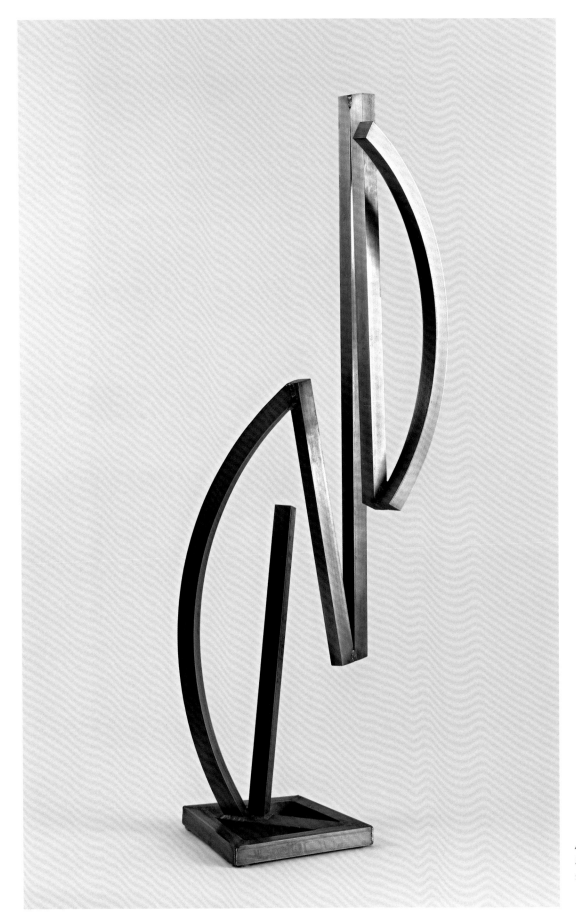

Arcs and Chords in Series, 2003. Stainless steel, 41 x 16 x 9 in.

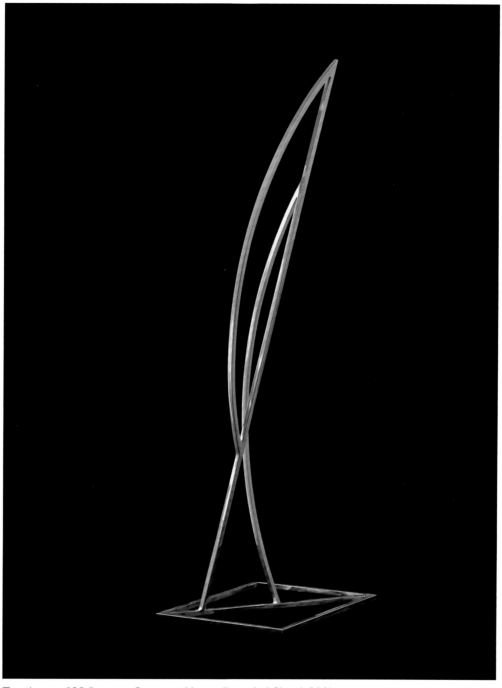

Two Arcs at 100 Degrees Connected by an Extended Chord, 2001.
Bronze, 70 x 11 x 10 in.

OPPOSITE: *Two Arcs at 100 Degrees Connected by an Extended Chord*, 2001. Bronze, 70 x 11 x 10 in.

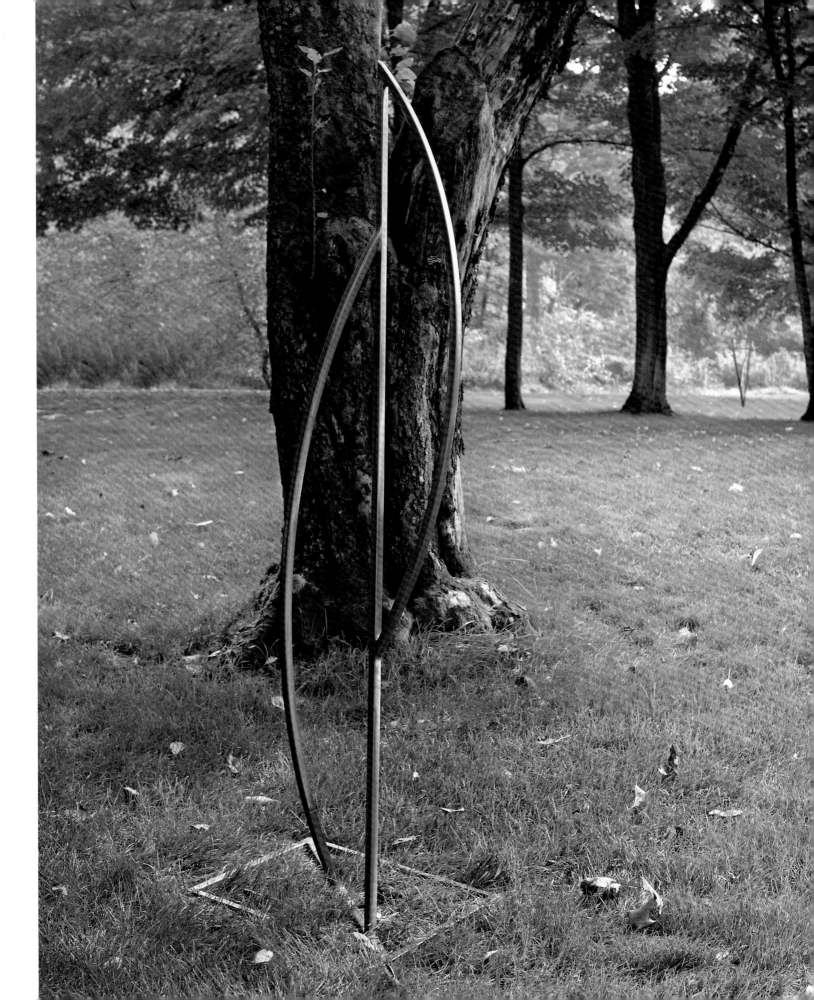

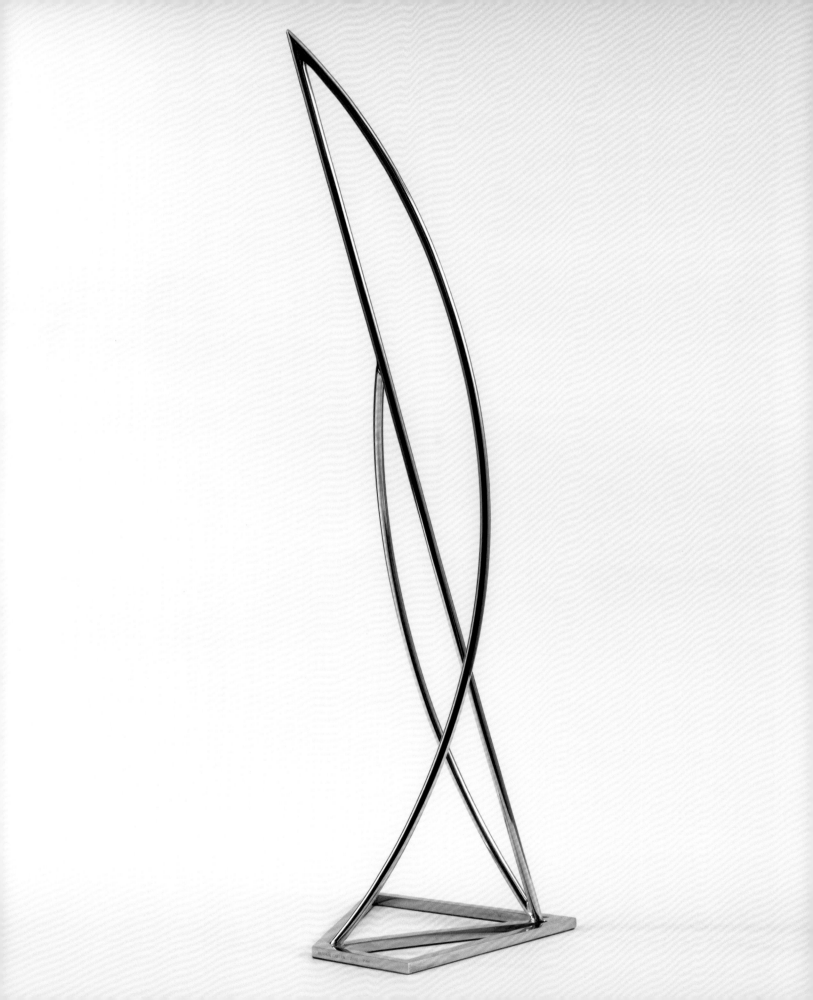

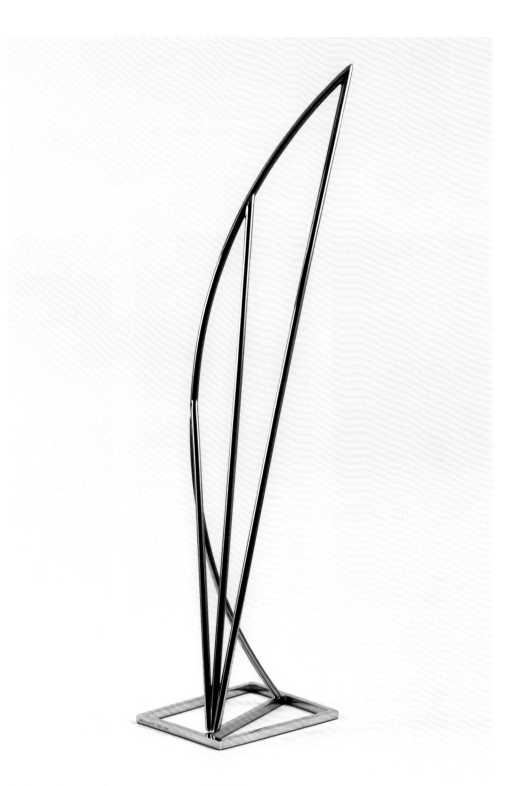

An Arc with Three Chords to the Base, 2002. Stainless steel, 41 x 12 x 8½ in.

OPPOSITE: *Two Arcs Connected by a Chord*,
2002. Stainless steel, 40 x 12 x 6 in.

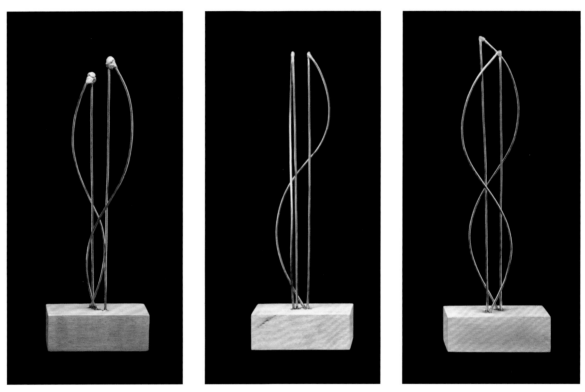

Studies for Constructions. Copper wire on wood base, each approximately 12 x 2 x 2½ in., with base.

OPPOSITE: *Inverted Arcs at 90 Degrees with Parallel Chords*, 2005. Darkened bronze, 40 x 12½ x 10 in. The mirror effect familiar from the continuous ellipses, along with richly patinated bronze, lends a classical formalism to *Inverted Arcs at 90 Degrees with Parallel Chords*.

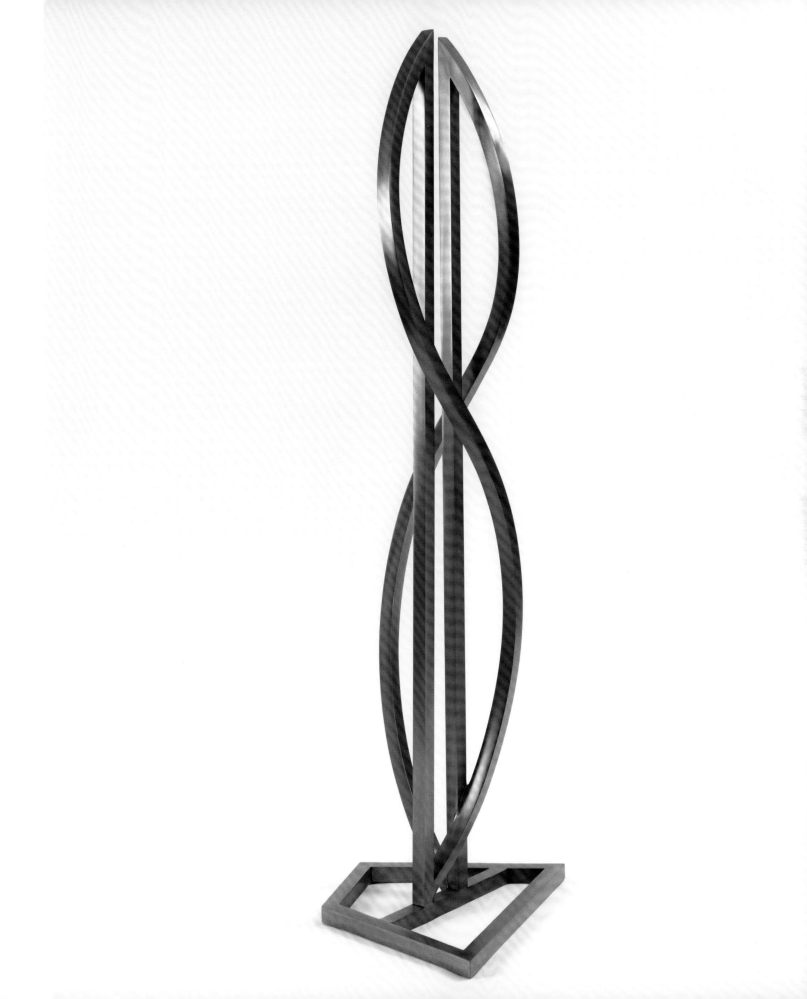

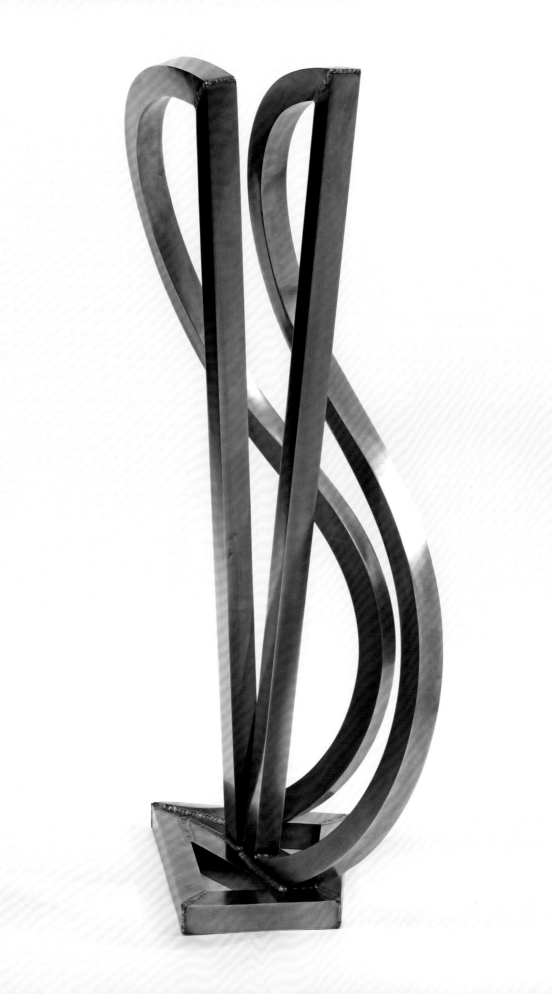

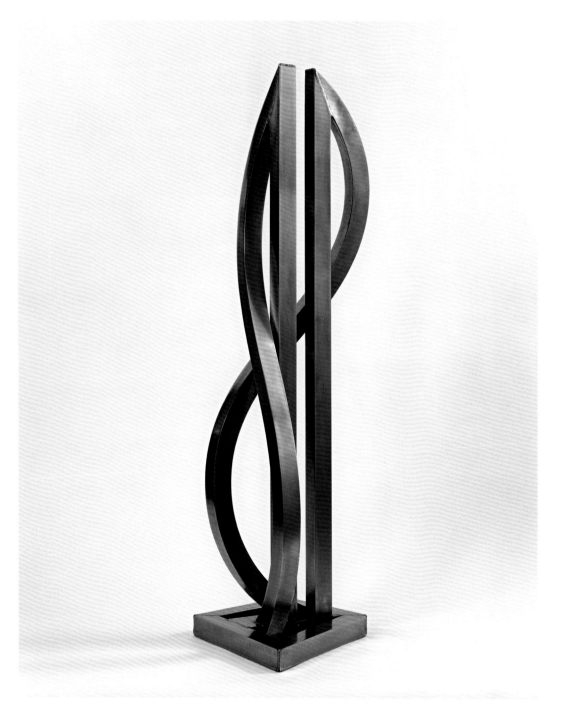

Inverted Arcs at 90 Degrees with Parallel Chords, 2003.
Stainless steel, 42½ x 11 ½ x 11 in.

OPPOSITE: *Two Parallel Inverted Arcs with Parallel Chords*,
2003. Stainless steel, 43 x 22 x 16 in.

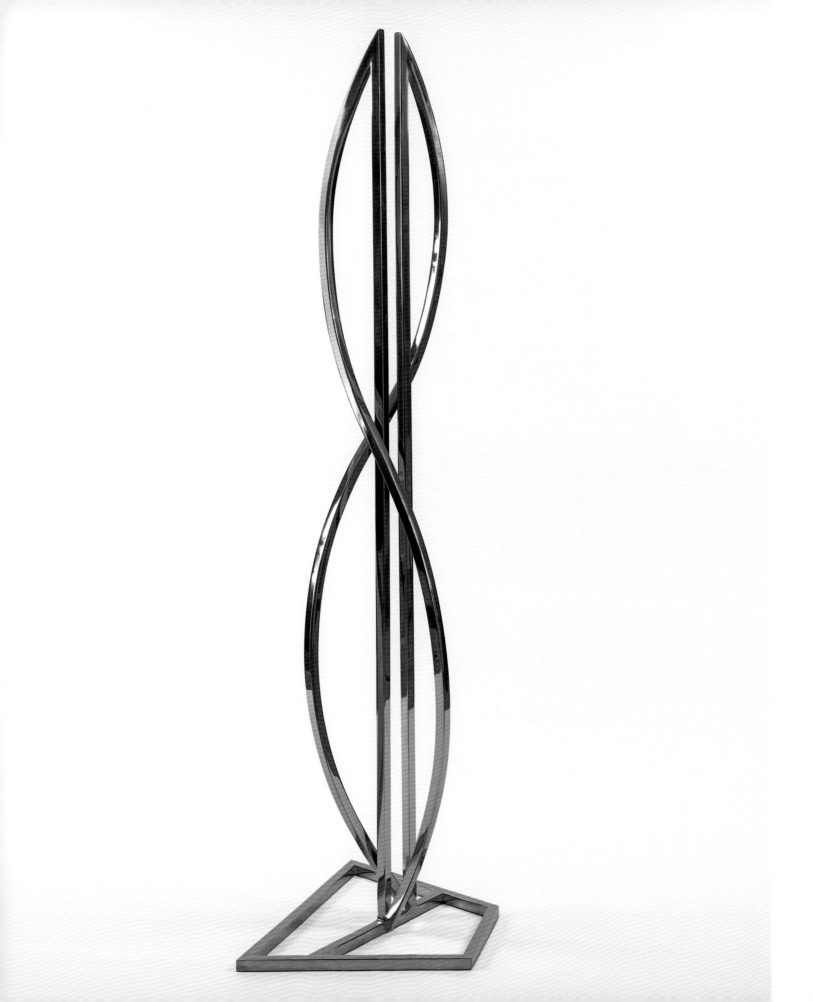

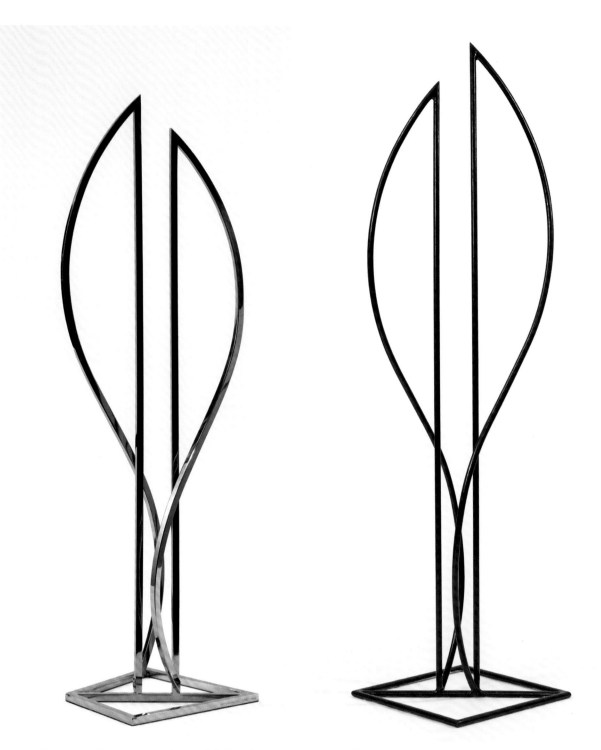

Inverted Arcs at 180 Degrees with Parallel Chords,
2000. Stainless steel, 40 x 12½ x 3 in.

Inverted Arcs with Parallel Chords, 2001. Stainless steel
painted dark blue, 50 x 12½ x 12½ in.

OPPOSITE: *Inverted Arcs at 90 Degrees with Parallel Chords*, 2000. Stainless steel, 40 x 12½ x 10 in.

Study for Construction. Charcoal on paper, 8 x 6 in.

RIGHT: *An Obtuse Triangle Intersected by an Arc*, 2001. Stainless steel painted green, 49½ x 23 x 22 in.

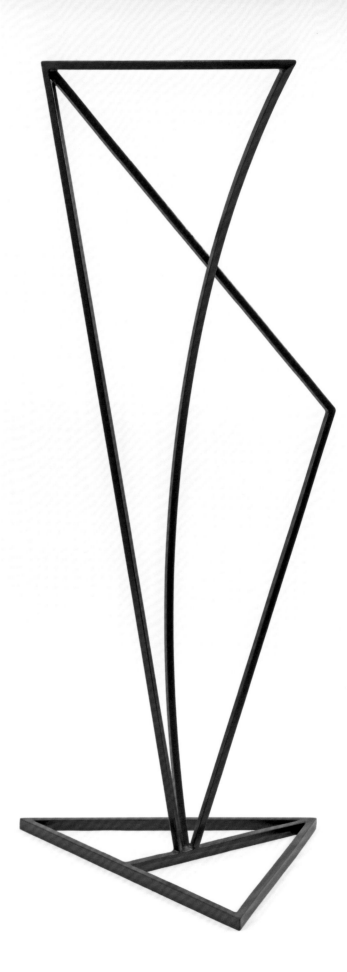

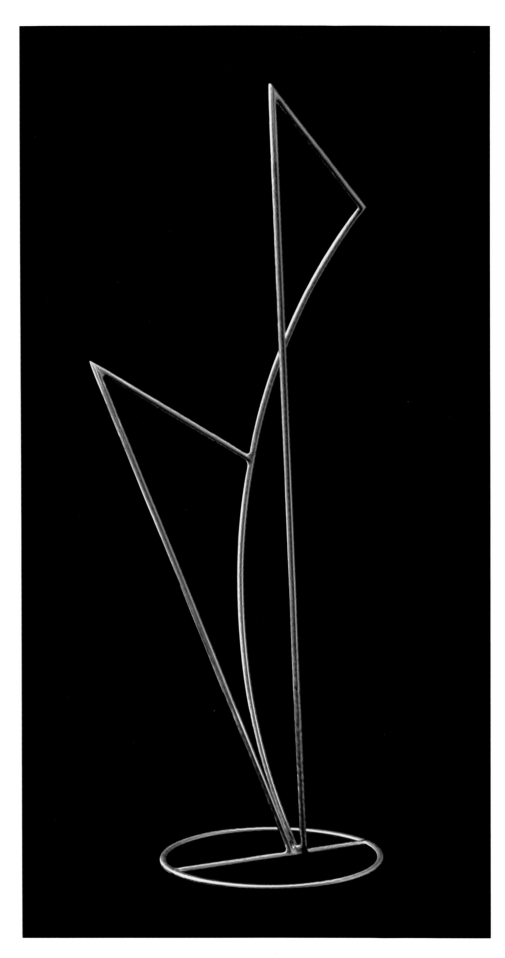

An Arc Connected by
an Acute Angle, 2001.
Bronze, 40 x 15 x 13 in.

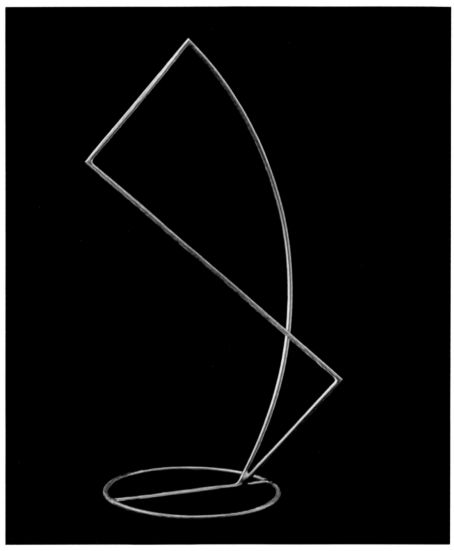

An Arc Connected by Two Parallel Perpendiculars, 2000. Bronze wire, 30¼ x 17 x 12½ in.

OPPOSITE: *An Arc Connected by Two Parallel Perpendiculars*, 2003. Stainless
steel, 40¼ x 20 x 15½ in.

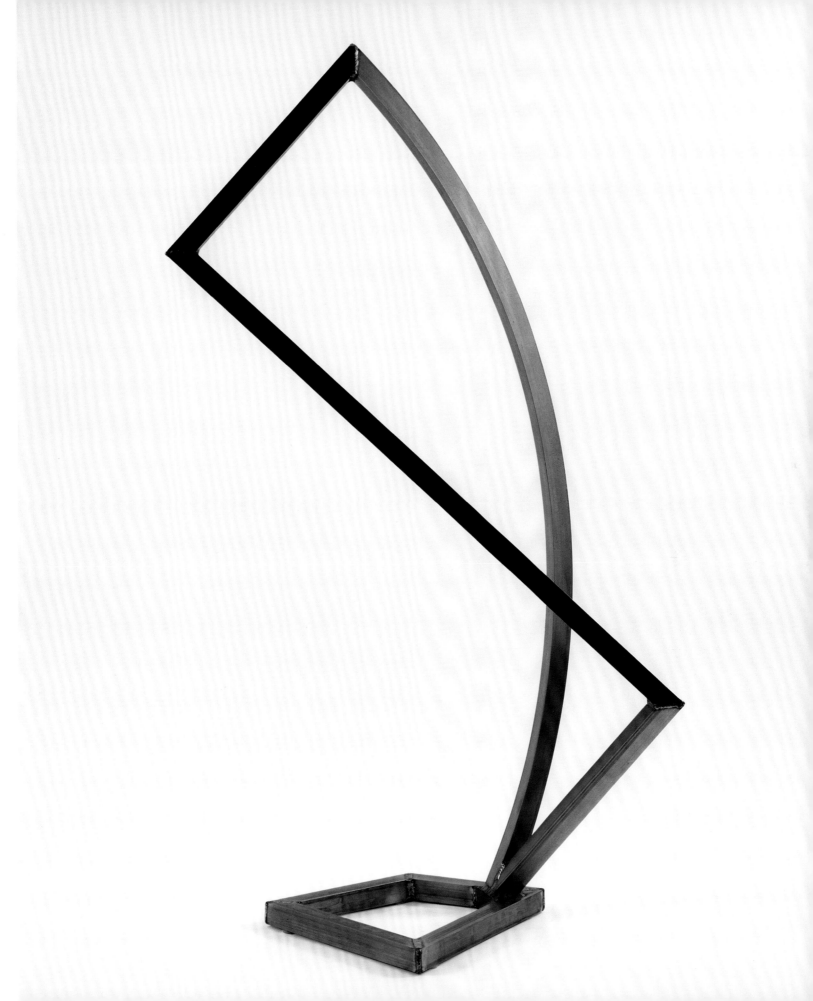

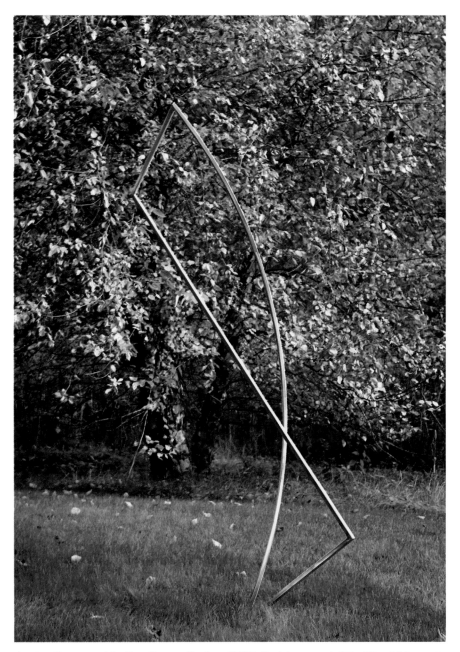

An Arc Connected by Two Perpendiculars, 2000. Stainless steel, 80 x 36 x 36 in.

OPPOSITE: *A Triangle Intersected by an Arc*,
2000. Bronze, 80 x 36 x 36 in.

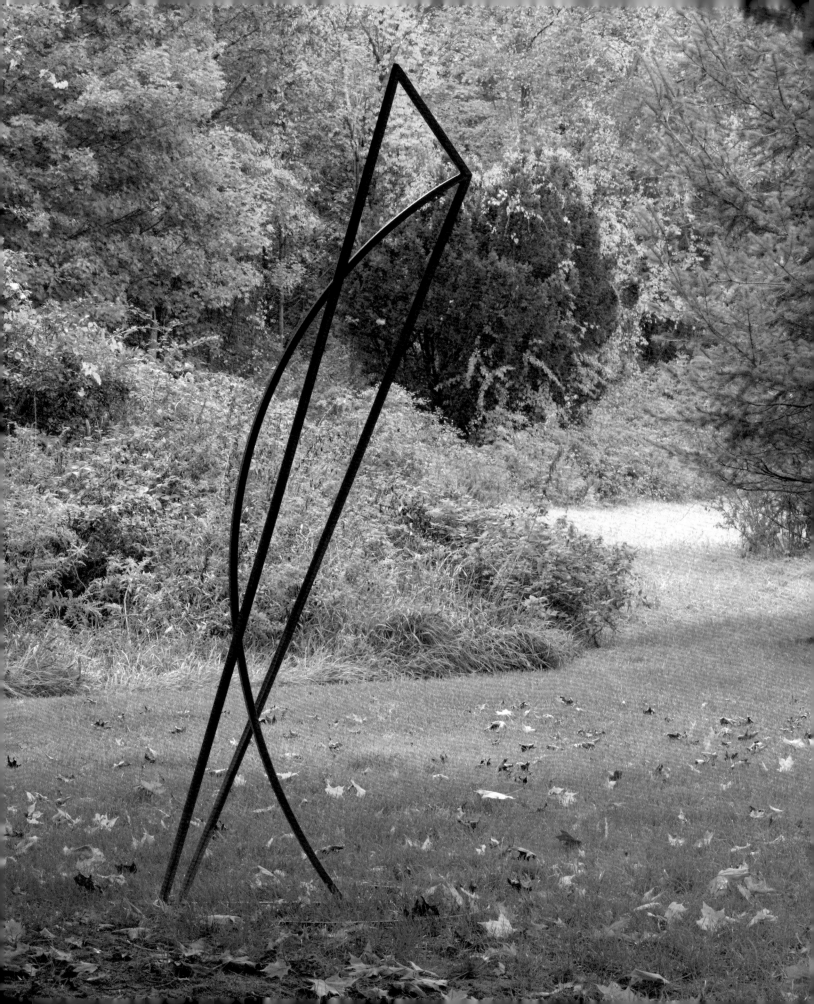

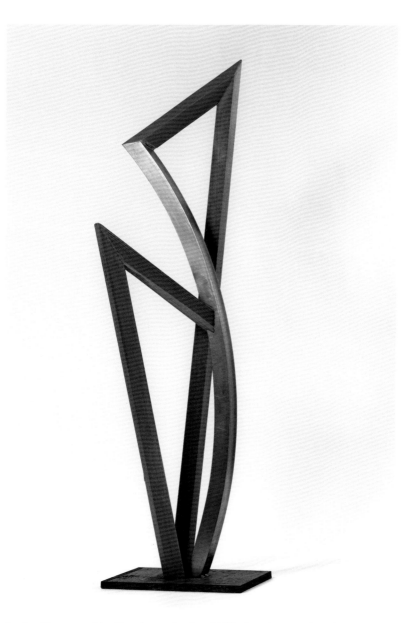

An Arc Connected by Two Acute Angles, 2002. Stainless steel and
wood, 46 x 15 x 10 in.

OPPOSITE: *An Arc Connected by Two Acute
Angles*, 2003. Stainless steel, 46½ x 12 x 10 in.

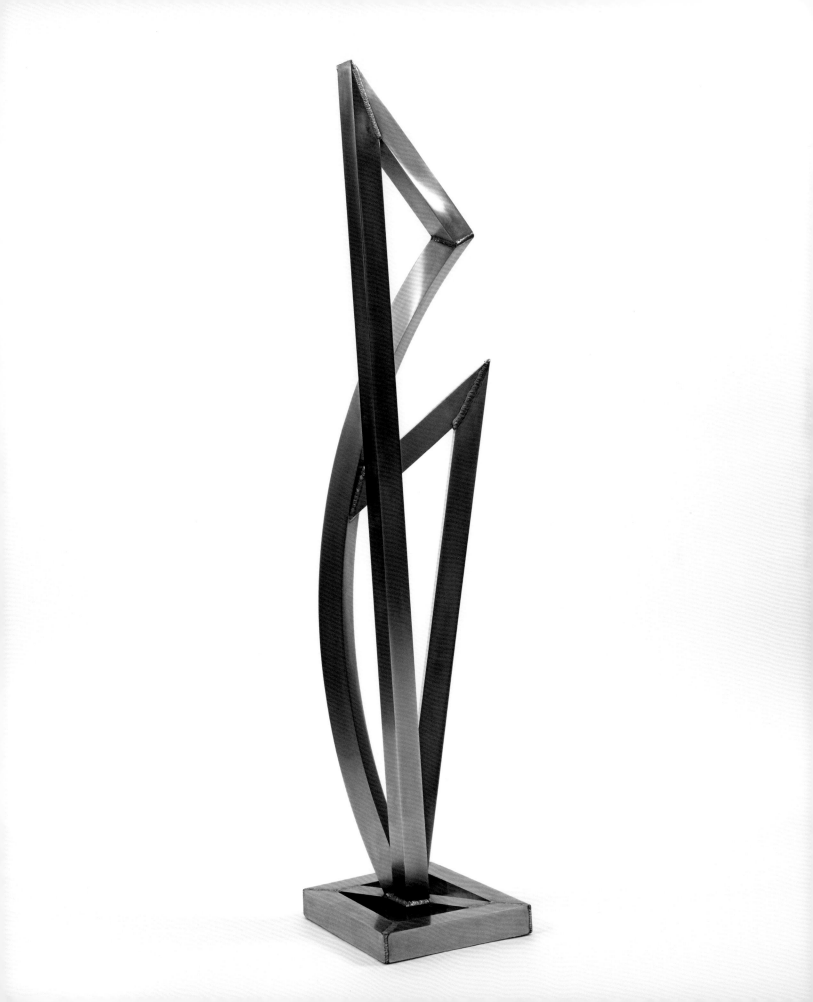

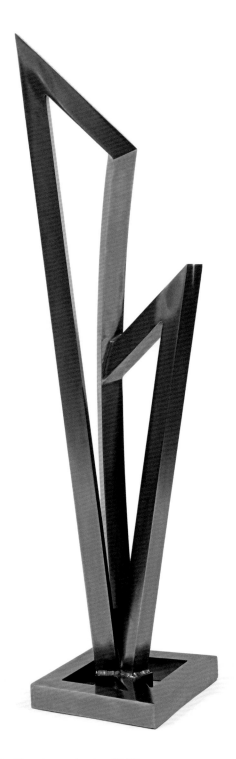

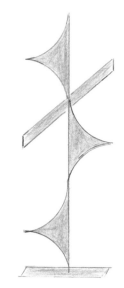

Study for Construction. Charcoal on paper, 8 x 6 in.

An Arc Connected by Two Acute Angles, 2002.
Stainless steel, 42 x 12 x 10 in.

Study for Construction. Charcoal on paper, 8 x 6 in.

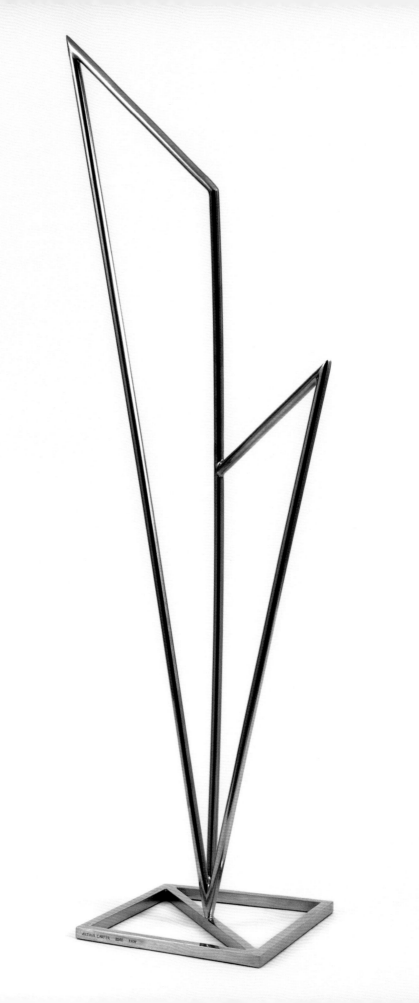

*An Arc Connected by
Two Acute Angles*, 2002.
Polished stainless steel,
41 x 16 x 10 in.

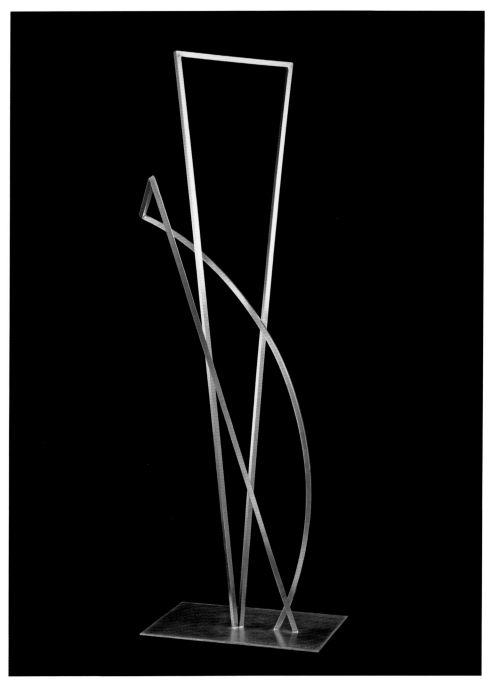

A Triangle Intersected by a Connecting Arc and a Chord, 2001. Polished stainless steel, 35¼ x 11 x 9 in.

OPPOSITE: *Untitled*, 2007. Polished bronze, 22½ x 11 x 8 in.
The Child Advocacy Award is given annually by the Child Study Center at New York University. The base is configured to be the initial of the award recipient's last name.

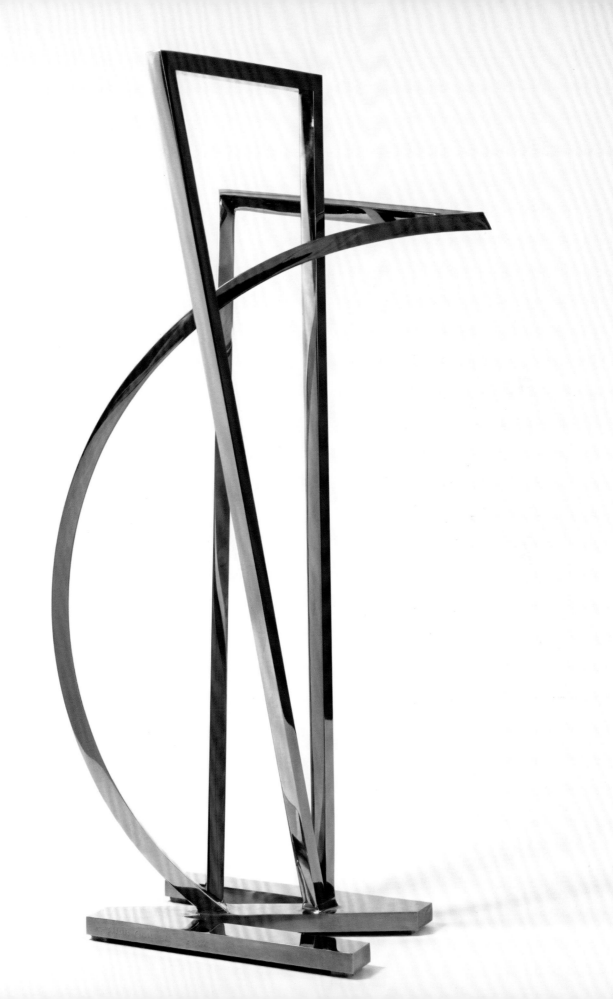

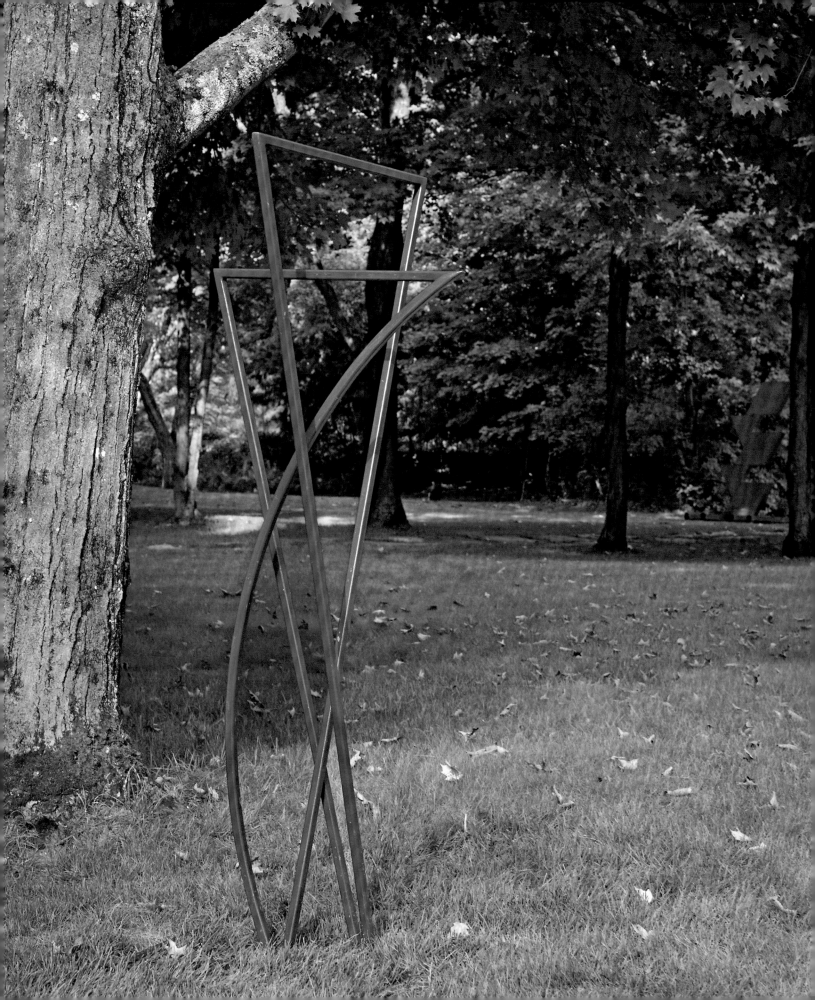

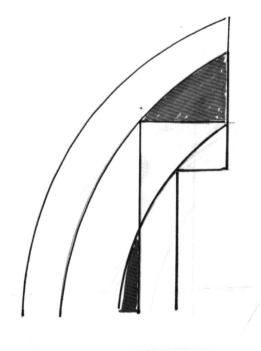

Study for Construction. Pencil and ink on paper,
8 x 6 in.

Study for Construction. Pencil and ink on paper,
8 x 6 in.

OPPOSITE: *A Triangle Intersected by a Connecting Arc
and a Chord*, 2001. Stainless steel painted blue, 60 x 24
x 24 in.

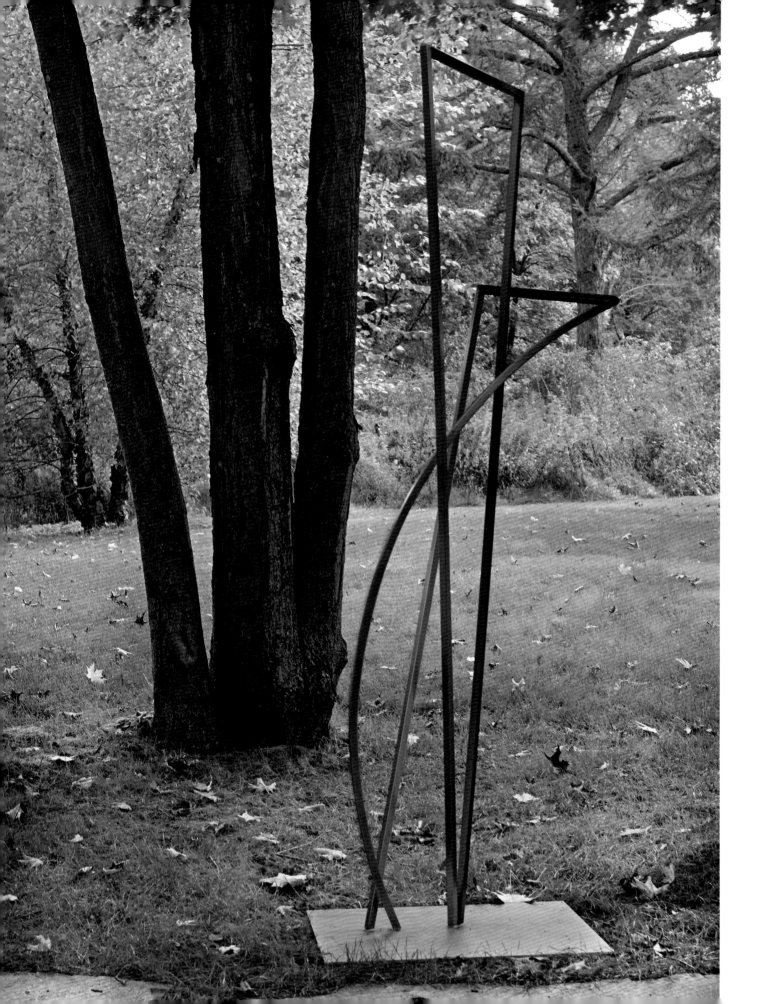

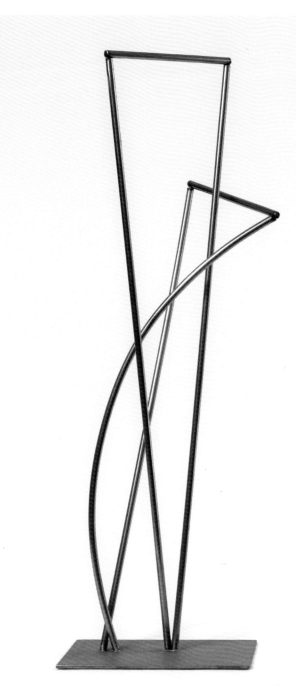

A Triangle Intersected by a Connecting Arc and a Chord,
2002. Stainless steel, 31 x 11 ½ x 10 in.

OPPOSITE: *A Triangle Intersected by an Arc and a Connecting*
Chord, 2002. Stainless steel painted blue, 80 x 30 x 30 in.

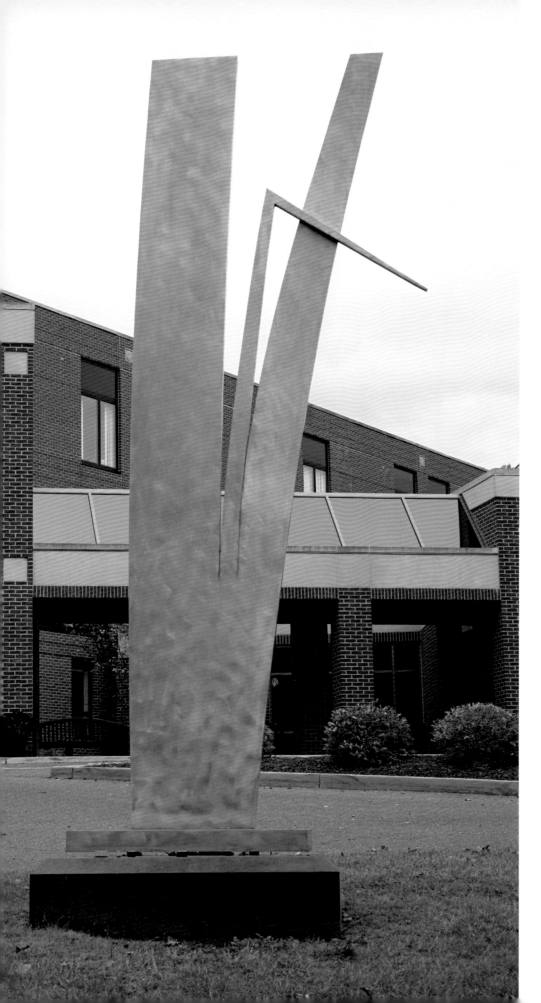

Triad, 1997. Stainless steel, 120 x 40 x 4 in. New Milford Hospital, New Milford, CT.

Study for Construction. Charcoal on paper, 8 x 6 in.

Study for Construction. Charcoal on paper, 8 x 6 in.

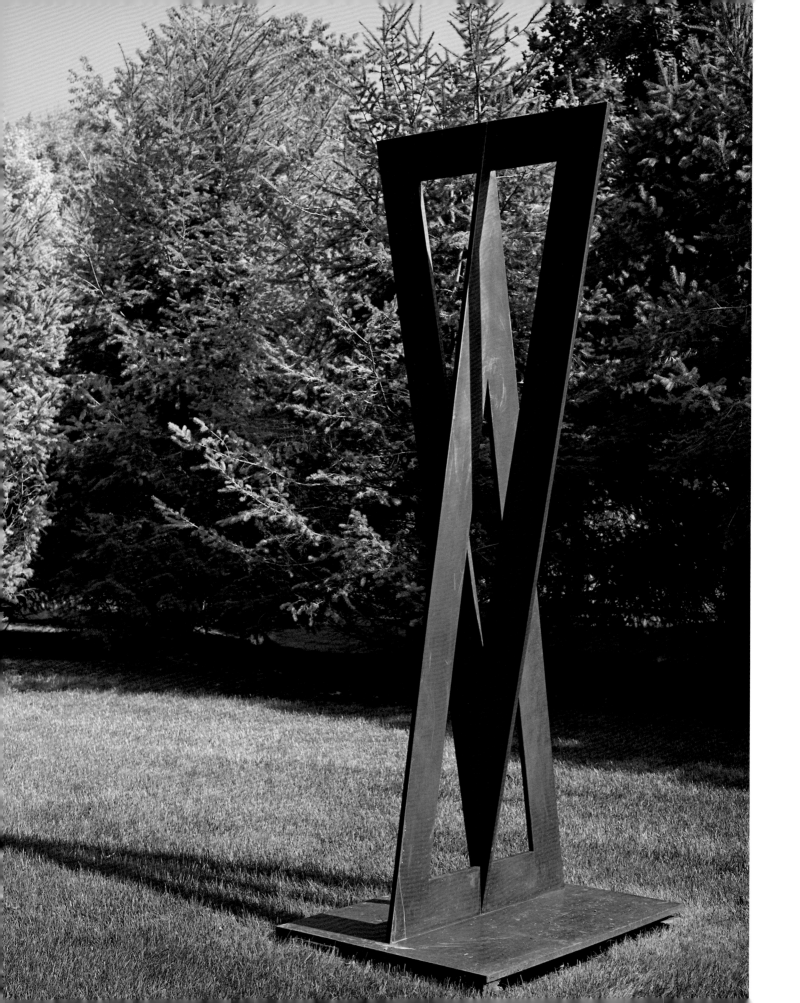

Study for Construction. Pencil and ink on paper,
8 x 6 in.

RIGHT: *Inversion*, 2000. Stainless steel, 18 x 8
x 8 in. Carter created individual sculptures for
the recipients of the Jason Robards Award for
Excellence in Theater given by the Roundabout
Theatre in Manhattan.

OPPOSITE: *Inversion*, 2001. Bronze,
96 x 36 x 36 in.

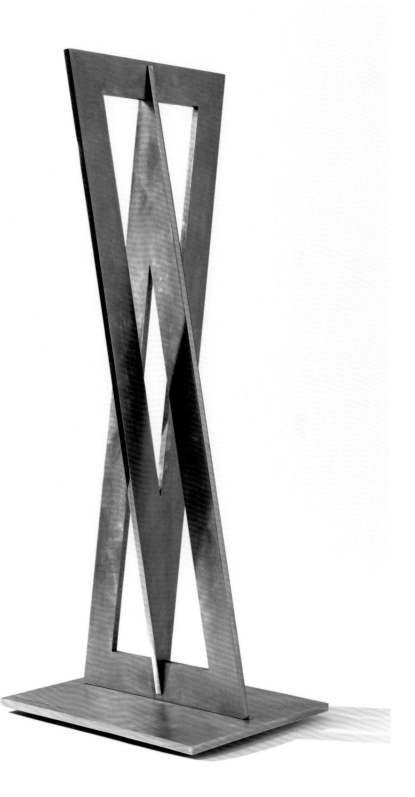

Study for Construction. Charcoal on paper, 8 x 6 in.

Study for Construction. Charcoal on paper, 8 x 6 in.

OPPOSITE: *Intersecting Ellipses with Parallel Chords*, 2003. Stainless steel,
30 x 33 x 32 in. Launching a multi-dimensional labyrinth of considerable
complexity from the simple, open interplay of one or two arcs and chords, the
dramatically more intricate *Intersecting Ellipses with Parallel Chords* depends
on strict, isomorphic discipline to retain its essential unity.

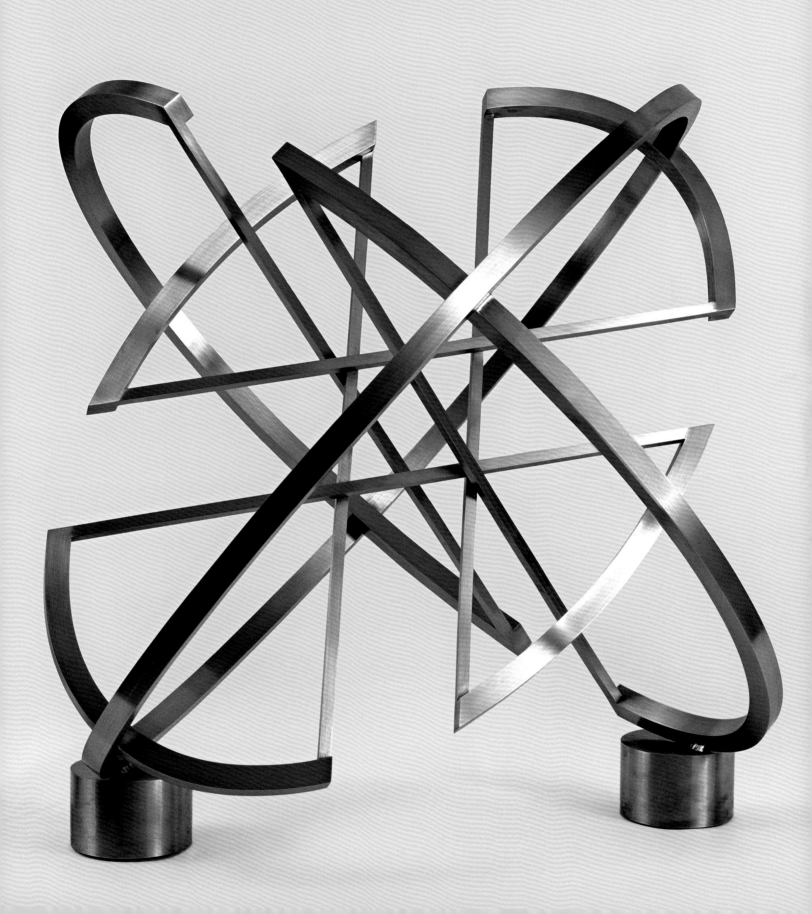

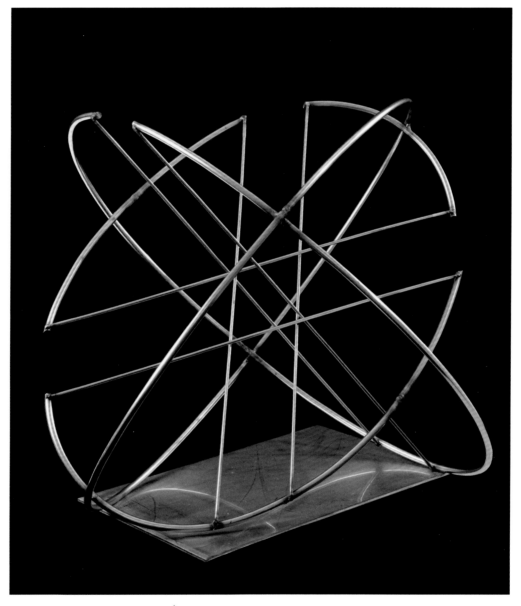

Intersecting Ellipses with Parallel Chords, 2003. Steel,
13½ x 17 x 17 in.

OPPOSITE: *Untitled*, 2003. Stainless steel with
mahogany base, 30 x 36 x 36 in.

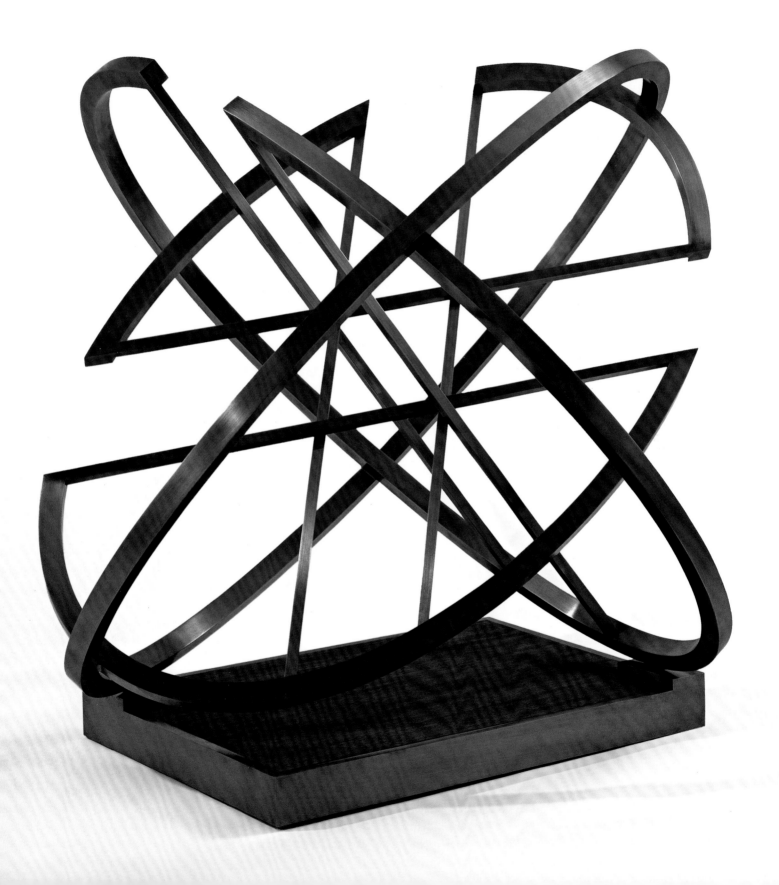

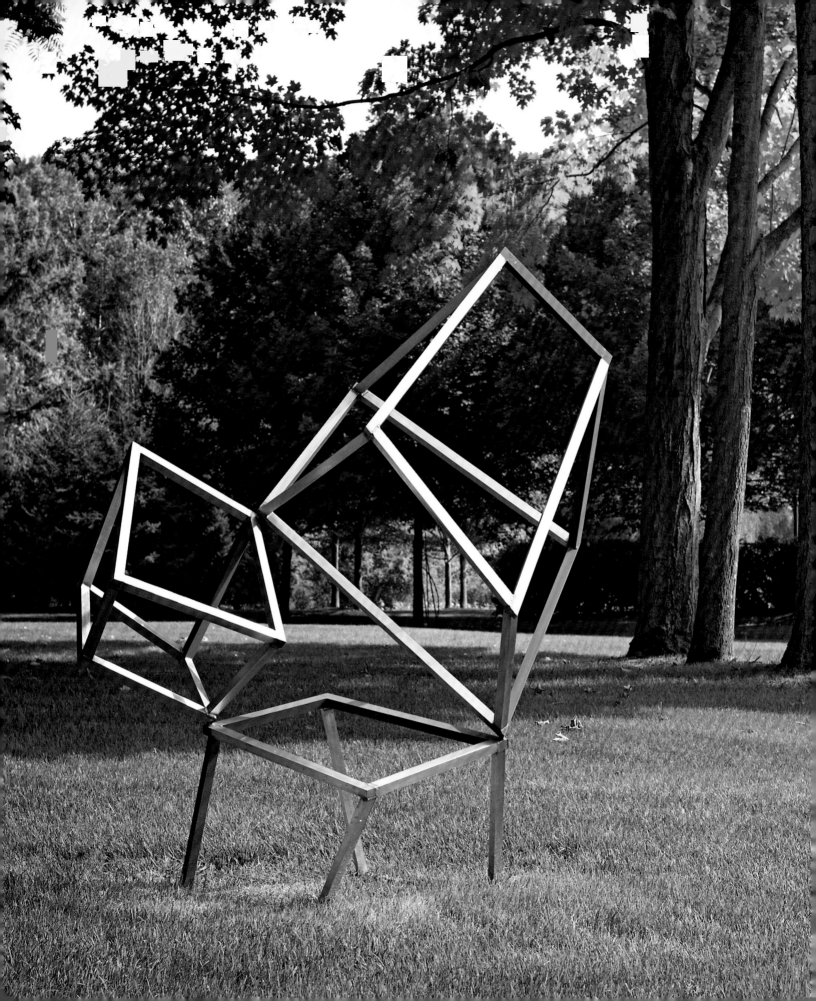

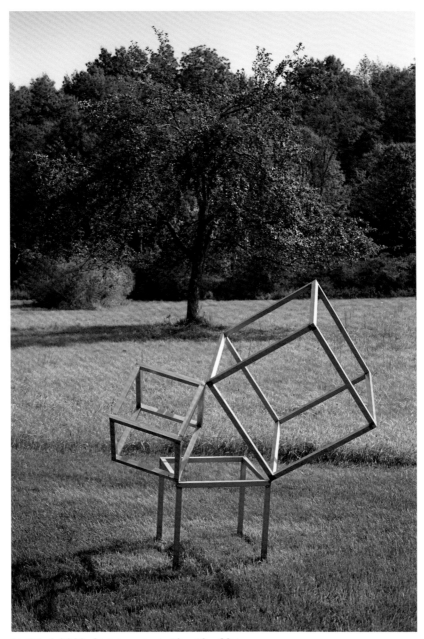

Untitled, 2003. Stainless steel, 58 x 60 x 32 in.

OPPOSITE: *Untitled*, 2003. Stainless steel painted blue, 66 x 55 x 30 in. The perambulating cubes offer a kinetic riff on the sober, triangulated geometry of *Mathematika* (see pages 6 and 200).

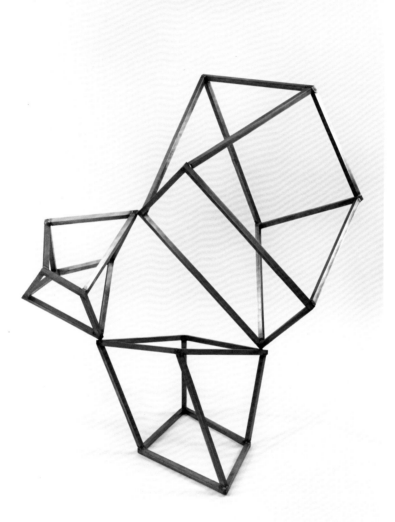

Untitled, 2003. Stainless steel, 36 x 34 x 24 in.

OPPOSITE: *Untitled*, 2008. Stainless steel, 36 x 34 x 24 in.

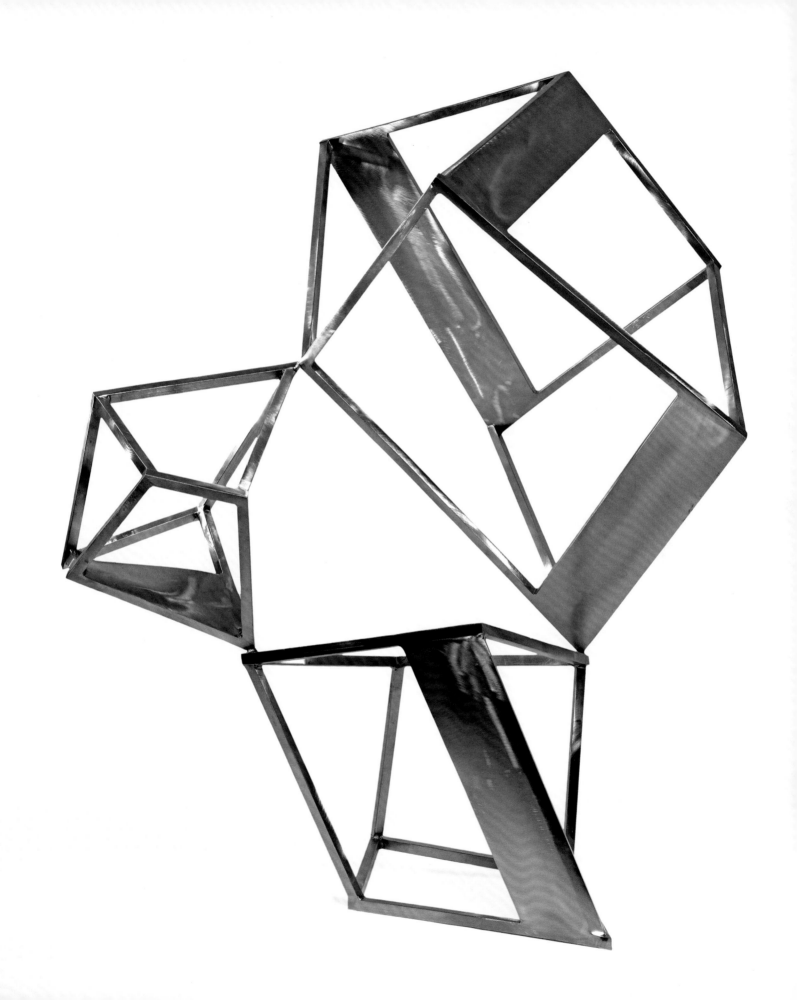

Study for Construction. Pen and ink on paper, 8 x 6 in.

Study for Construction. Pen and ink on paper, 6 x 8 in.

OPPOSITE: **Untitled**, 2008. Sanded stainless steel, 21 x 13 x 5 in. The gently curved wing of Carter's most recent sculpture elegantly bends the planar forms of its antecedents into a lyrical meditation on Euclidean themes.

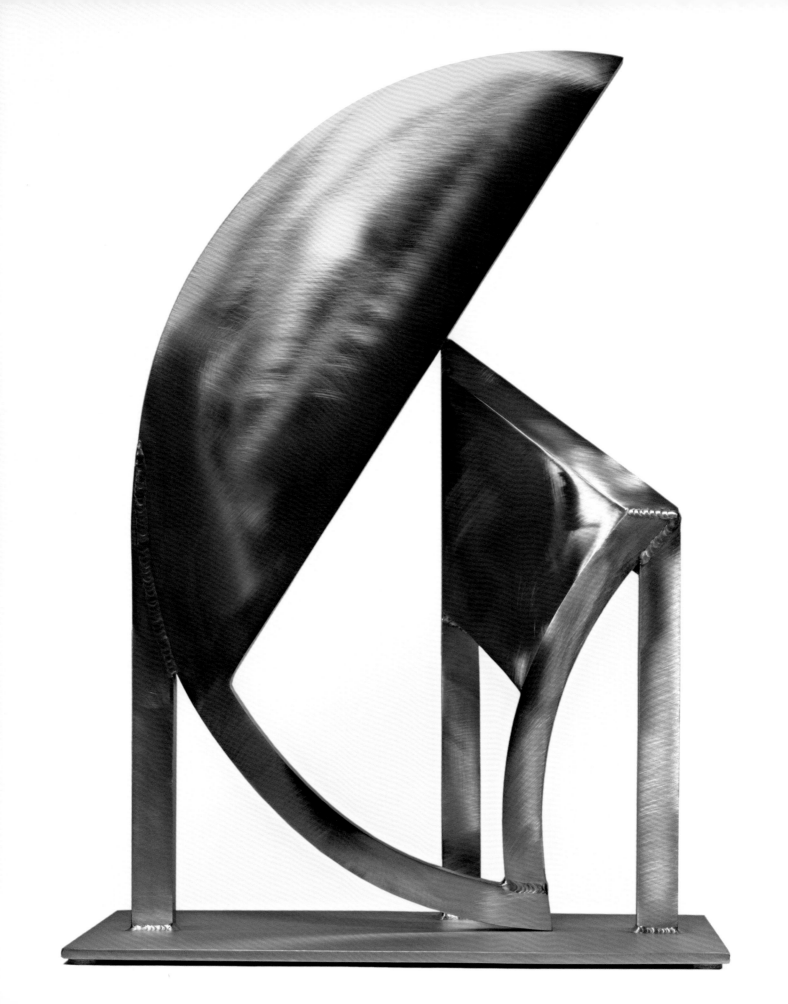

Study for Construction. Pen and ink on
paper, 6 x 8 in.

OPPOSITE: ***Untitled***, 2008. Sanded
stainless steel, 21 x 13 x 5 in.

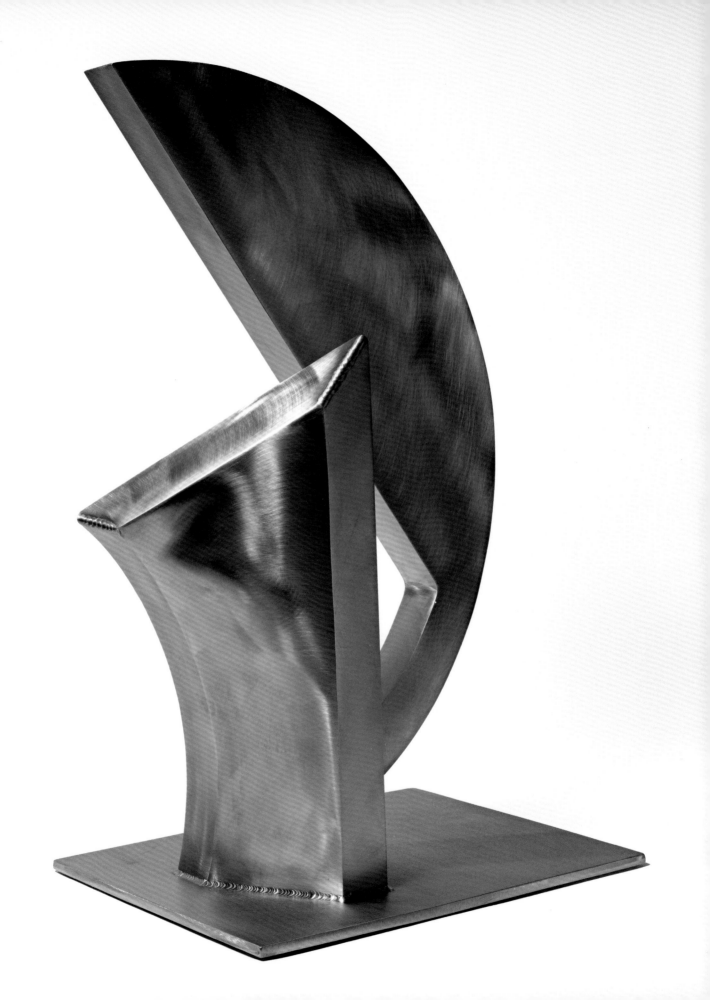

Study for Construction. Pen and ink on paper, 6 x 8 in.

Untitled, 2008. Sanded stainless steel, 21 x 13 x 12½ in.

OPPOSITE: *Untitled*, 2008. Sanded stainless steel, 21 x 13 x 14 in.

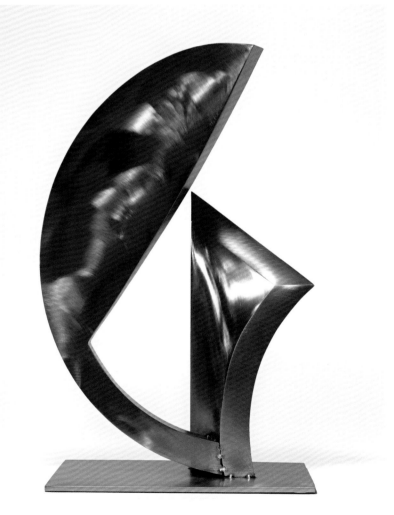

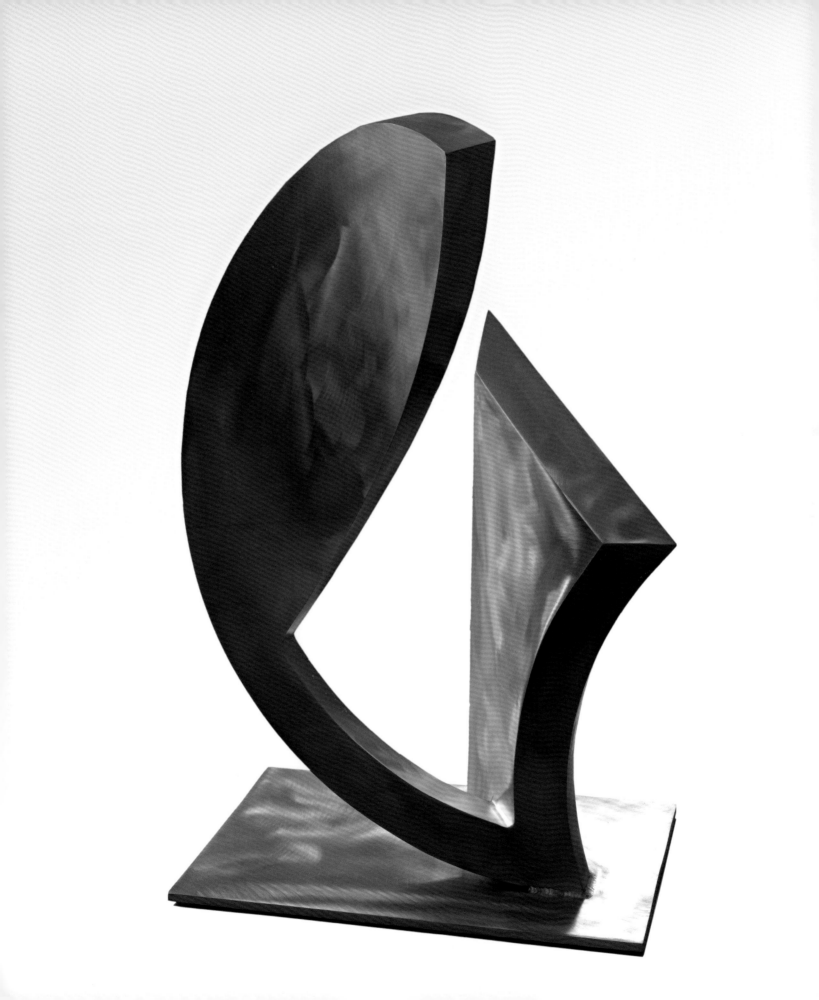

Untitled, 2008. Aluminum, 25 x 42 in.

Aluminum Elements Spaced According to Fibonacci, 2008.
Aluminum, 25 x 42 in. Shifting from color (a secondary quality)
to form (a primary quality), Carter's relief adds shadow to the
rhythm of the painted version.

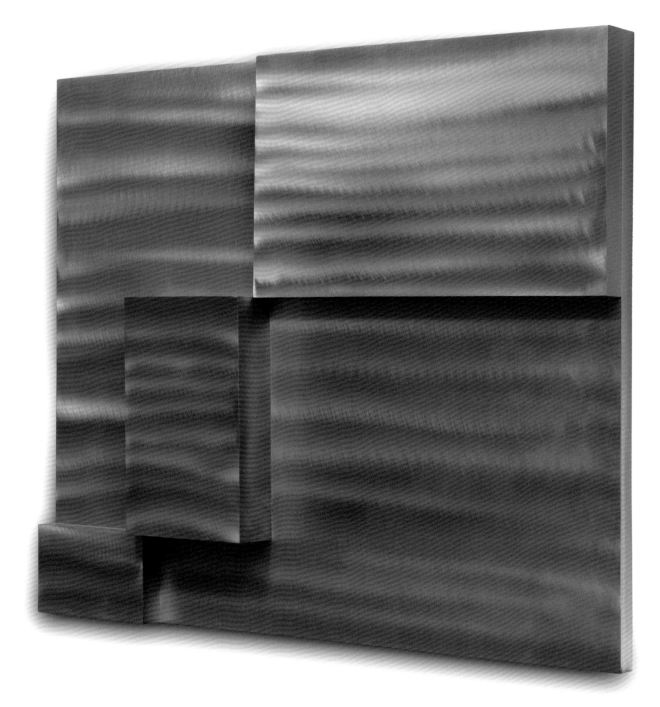

Untitled, 2008. Bronze, 31 x 37 in.

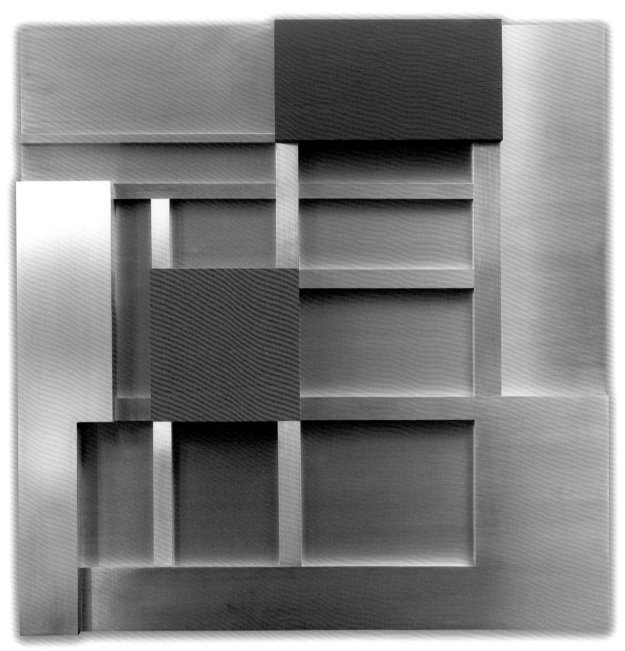

Untitled, 2008. Aluminum painted red and blue, 33 x 33 in.

In tandem with sculpture, Carter maintains an active painting studio. The works emphasize the linear and predominantly horizontal forms that are familiar from the sculpture. Crisply rendered in acrylic on brilliant white fields, the rhythmic intersections of black grids and vibrant geometric forms arise from ideas that the artist has drawn but, as he says, has decided in some cases he cannot build.

Study for Construction. Pen and ink on paper, 8 x 6 in.

Studies in Fibonacci 3, 2007. Acrylic on canvas, 30 x 50 in. The boldly vibrant red and pulsing yellow play off the whispered grays of this series, which bases the length and position of the units on the Fibonacci sequence.

Studies in Fibonacci 5, 2007. Acrylic on canvas, 30 x 50 in.

Studies in Fibonacci 2, 2007. Acrylic on plywood, 24 x 55 in.

Studies in Fibonacci 1, 2007. Acrylic on plywood, 24 x 55 in.

Studies in Fibonacci 4, 2007. Acrylic on canvas, 30 x 50 in.

Study for Construction. Pen and ink on paper, 8 x 6 in.

OPPOSITE: *Composition in Red, Yellow, Blue, and Gray*, 2007. Acrylic on canvas, 26½ x 32 in. The sheer lightness of this open composition subtly supports the rational complexity of the proportions demarcated in color.

Studies for Constructions. Pen and ink on paper, each 8½ x 6 in.

OPPOSITE: *Composition in Red, Yellow, and Blue 5*, 2007. Acrylic on plywood, 17 x 24 in. The best way to enjoy the movement and metamorphic play of substitutions in the paintings and drawings is to view them in sequence.

Composition in Red, Yellow, and Blue 1,
2007. Acrylic on canvas, 30 x 42 in.

LEFT: *Composition in Red, Yellow, and
Blue*, 2008, acrylic on canvas, 60 x 84 in.
Arthur L. Carter Journalism Institute at
New York University, New York, NY.

Study for Construction. Pen and ink on paper, 6 x 8 in.

Study for Construction. Pen and ink on paper, 8 x 6 in.

OPPOSITE: ***Composition in Red 1***, 2007. Acrylic on plywood, 17 x 24 in.

Study for Construction. Pen and ink on paper, 6 x 8 in.

Study for Construction. Pen and ink on paper, 6 x 8 in.

Study for Construction. Pen and ink on paper, 6 x 8 in.

OPPOSITE: *Composition in Red, Yellow, and Blue 4*, 2007. Acrylic on canvas, 30 x 42 in.

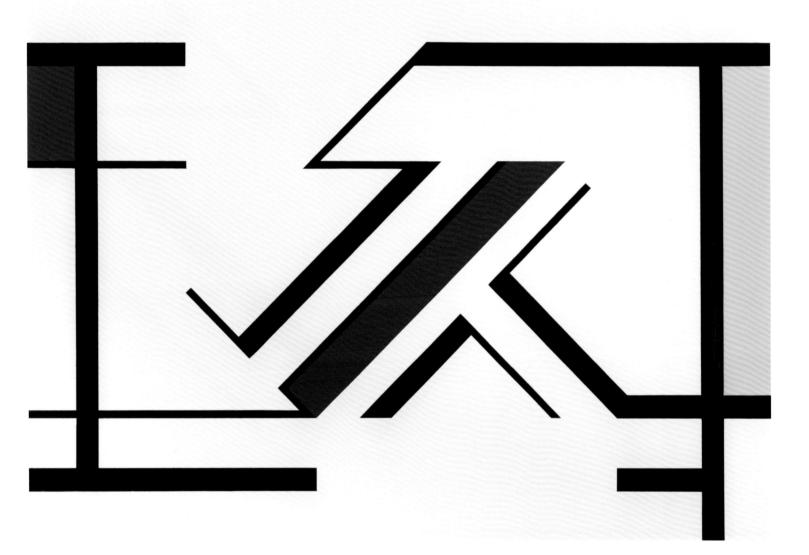

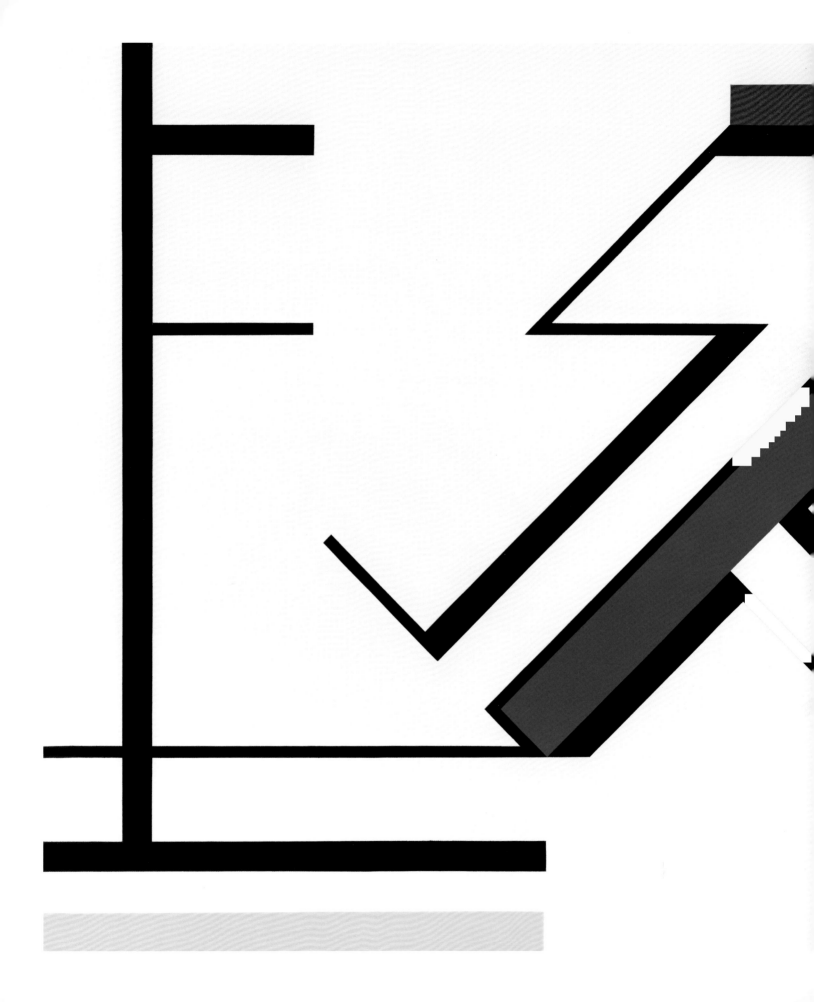

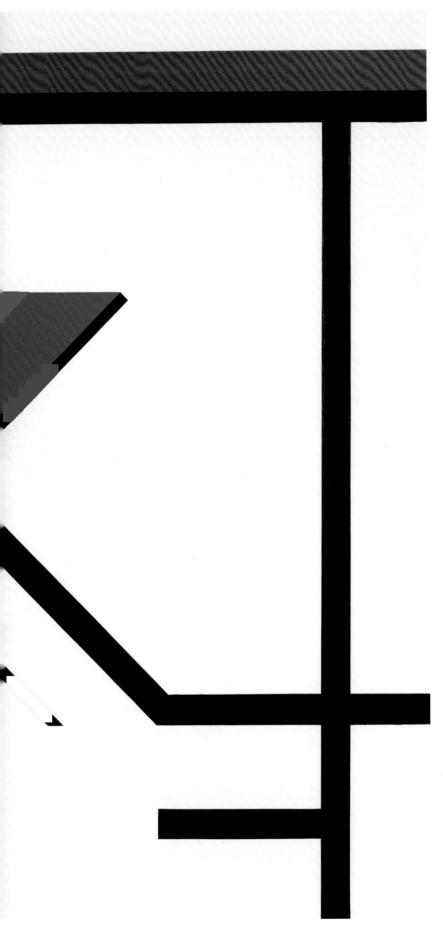

Composition in Red, Yellow, and Blue 3,
2007. Acrylic on canvas, 30 x 42 in.

Untitled, 2008. Acrylic on canvas, 42 x 30 in.

OPPOSITE: *Untitled*, 2008.
Acrylic on canvas, 40 x 30 in.

Untitled, 2007. Acrylic on canvas, 32 x 26 in. Reminiscent of the dancing forms of Alexander Calder, the paintings in this series have a lightness and kinetic spontaneity that seem more organic than geometric.

OPPOSITE: ***Untitled***, 2007. Acrylic on canvas, 40 x 30 in.

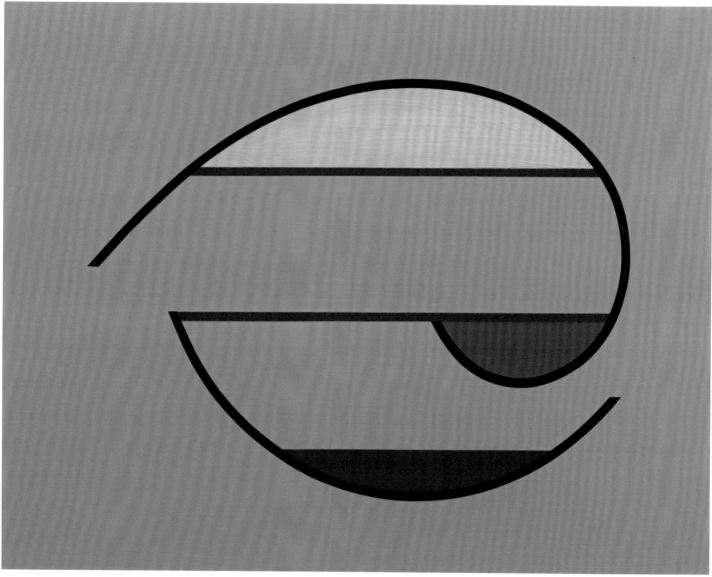

Untitled, 2007. Acrylic on plywood, 15½ x 20 in.

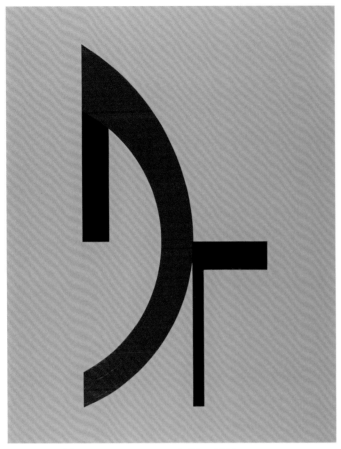

Untitled, 2007. Acrylic on plywood, 20 x 15½ in.

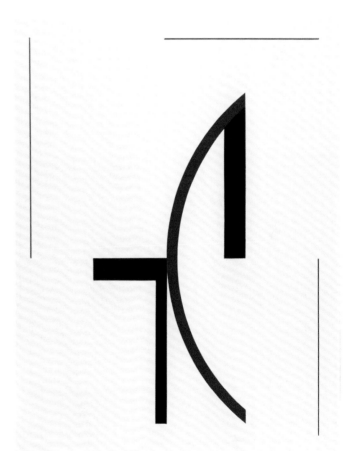

Untitled, 2007. Acrylic on plywood, 20 x 15½ in.

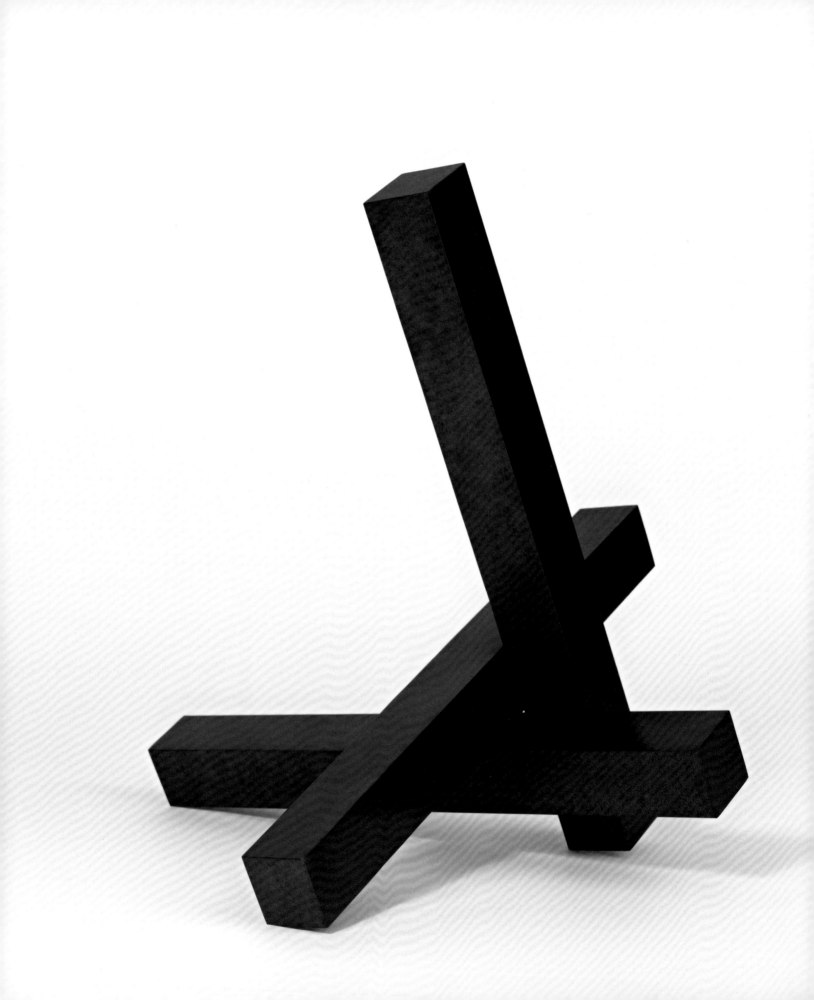

ARS GRATIA ARTHUR

PETER W. KAPLAN

Arthur Carter is a man of devouring, scouring intelligence, furious deductive powers, and occasionally slashing wit. He can be reassuring, but rarely complacent; warm, but rarely tepid. Before he was a man of shapes, he was primarily a man of numbers, sometimes terrifyingly so: He can read a balance sheet and spit out the results like what we used to call a Univac.

In many ways, Arthur Carter likes to present himself as a no-nonsense man, but as you have seen, there's plenty else going on inside. "Creativity," Alexander Liberman, the impossibly dapper Condé Nast publishing genius who was also a vibrant sculptor, wrote, "is the exteriorization of the life instinct." It is Arthur Carter's life instinct and his intellectual interior that can be seen in these pages.

Arthur Carter is also a human chrysalis; he has shown himself in a full set of life stages, from his earliest days on Long Island, through his years on Wall Street, through time as a business pioneer, through a period as a newspaper and magazine publisher, to this current position as a sculptor and painter. He has emerged over and over, each time surprising his friends and the city in which he lives, displaying an extraordinary

OPPOSITE: *Three Elements at 90 Degrees*, 2004. Bronze with blue patina, 14 x 13 x 13 in.

combination of courage and adventure, as well as significant and well-earned self-knowledge.

Arthur Carter grew up in Woodmere, Long Island, a town with which I'm familiar, since it was the home of my grandparents—whom Arthur remembers—and where my father and uncle were boys. Arthur's mother and father were Rosalind and Eugene Carter: She was deeply cultured, a French teacher and valedictorian at Hunter High School, and he was an IRS man for forty-seven years. Arthur once told me that he did Wall Street for his father, but the newspapers were for his mother. Woodmere was, in both pre- and post-war America, an upper middle-class community with high cultural aspirations; as a boy, Arthur studied classical piano. I asked him if he had any particular interest in art as a child.

"None," he said, rather dispassionately. He then went on to inform me just what he thought of the kids who took art classes at Woodmere High School. What *did* he like in high school? He thought, not very long, and perked up. "Geometry," he said, unambiguously, and then went on an extended disquisition about mathematics, about the twelfth- and thirteenth-century mathematician Fibonacci and the Golden Ratio, the mathematical proportion that was applied to everything from the Acropolis to the structures of Le Corbusier. "It gave me the closest thing to a core connection between mathematics and aesthetics," he said. "It was the very precision of it, the aesthetic of it that intrigued me"—and when you look at the sculptures in this book, with their happy ratios and satisfying interchanges, you may find a little of the reassurance Arthur Carter found in their certainty. These abstracted relationships may create for the artist, and also the viewer, a kind of solid ground in a chaotic world.

Between Woodmere and Wall Street, there was a serious flirtation with classical piano and Juilliard, but mostly more hard-nosed choices: Brown Univer-

sity, the Coast Guard (he commanded a ninety-five-foot patrol craft and learned to weld), a few years at Lehman Brothers, then Tuck School of Business at Dartmouth. He said that if someone had told him, when he was on Wall Street, starting up what turned out to be the world-beating firm of Carter, Berlind & Weill—which spawned a Murderer's Row lineup of partners that included Sanford Weill, Roger Berlind, Arthur Levitt, and Marshall Cogan—that he would be an artist someday, he would have told them "they were crazy." Back then, Arthur Carter's creativity was showing itself in business—buying public companies, restructuring them, taking them private—early versions of what entered the business culture as the leveraged buyout and private equity. But he did buy some art. Picassos, at first. But later, along came Leger, Kandinsky, Braque, Milton Avery, and Balthus. And then sculpture: Alexander Archipenko, Jean Arp, Henry Moore, and Aristide Maillol.

Next came the Arthur Carter who fused his business and intellectual ambitions as the editorially demanding publisher who bought and rehabilitated *The Nation* magazine, then founded and published two newspapers: an exquisite throwback country weekly near his Connecticut farm, *The Litchfield County Times*, and a broadsheet city weekly a few blocks from his Manhattan home, *The New York Observer*. He was determined to turn *The Observer* into the classiest little newspaper in America. It was this Arthur Carter that I met in 1994, when I became editor of the weekly. He was publishing *The Observer* from a red brick townhouse on East 64th Street—down the block from Kitty Carlisle Hart and Mike Wallace—a building whose intimate nineteenth-century New Yorkness seemed almost every day to embody the adage of Charles Foster Kane, "I think it would be fun to run a newspaper."

His long, carpeted office on the second floor of the building was dominated by a few things, unusual to a

newspaper publisher's office, that held their ground: a George III desk, a pretty, regal, red paisley wing chair, a few good nineteenth-century sculptures, the walls ringed with black-and-white photographs of Thomas Mann and Albert Einstein, as well as portraits of his father, his mother, his wife, and various adorable Carter children.

The floor above held the ad sales and circulation staffs; and one more above that, the fourth floor, held the impossibly crowded editorial offices, reporters stuffed around fireplaces and editors doubled up in former bedrooms, dueling daily with the New York City building occupancy code laws. The working bathtub on the fourth floor was filled to the brim with newspapers. Why do I bring this up in an introduction to Arthur Carter the artist?

He reveled in place and space. He leapt into the controlled calibration that is newspaper design. He chose the look—the aesthetic of his places and papers—as if they were art pieces. *The Observer* building was red, almost anthropomorphic. The newsprint of *The Observer* was, *what*? Salmon! Why? Arthur understood what the European tinted newspapers did: The paper made its own intrinsic statement. He was demanding and unyielding on matters of fonts, spacing, paper stock, point sizes, and leading: "It was only with newspaper design," he told me, "that I realized I was interested in making art, in an aesthetic." Pages went in and pages went out, and Arthur would stare at redesigns and judge, as an architect, a couture designer, a gallery owner.

Something was going on in there. But the net effect was to convince us that the paper was the love of Arthur's work life, and within *The Observer's* particular screwball exteriorization, half Edith Wharton, half Howard Hawks, rationality ruled. Arthur's particular chemistry was to meld instinct and pragmatism; the result was—we on the staff liked to tell ourselves at the time—a little newspaper that was both New York

social instrument and Manhattan *objet*. It escaped nobody that the paper was an extension of Arthur Carter's persona.

During the period I worked for him as the editor of *The New York Observer*, one of our self-imposed regular occurrences, a ritual that combined professional regimen and some transference and countertransference, was the lunch we had together, once a week, like clockwork, a professional Scheherazade between Manhattan publisher and editor. Plenty of business was done during those lunches, life stories told: One of the salient stories he told was that when he was seven years old, in Woodmere, he had found a house for sale and led his father by the hand to the place itself, where he decisively declared the family would be better off owning a home than renting the one they were in. Arthur's father bought the house. Arthur was confirmed. Thus the farm in Connecticut and the townhouse on East 64th Street.

One day, he told me at lunch that he was buying a giant, bright-red outdoor sculpture for his farm; it was by Alexander Liberman, and it was called *Diablo*. "It interests me," he said. Arthur had developed a kind of fascination with Liberman and was determined to meet him. Not too long after that, he showed up at lunch and asked if I'd like to join him to see the Jackson Pollock show at the Museum of Modern Art, which was closed that day, but somehow we were let in privately. Afterward, we went on a little stroll through the Abby Aldrich Rockefeller sculpture garden. He began speaking of Anthony Caro and David Smith—the garden had in its permanent collection the pieces *Midday* by Caro and *Cubi X* and *Sentinel* by Smith. He stopped at one of the Smith pieces in the garden and began speaking of Smith, of his materials and techniques, and of his life story, with complete admiration and fascination. I took it to be a collector's crush, but it was something else: The more he seemed preoccupied, the more he seemed to

be measuring the ground around the work of other sculptors. The more fascination he showed in materials and metals fabrication—from the brick-size gray rectangular clay slabs he began implanting with heavy metal wiring to tracking down trained personnel for the industrial-size project he began preparing—the more I began to guess that the consuming fascination he generally brought to the design of *The Observer* was brewing elsewhere. Reporting!

If you ask Arthur what his work is about, he'll brush you off, as an artist should. He may bring up Mondrian and Brancusi, or Paul Klee, then move on to David Smith and Anthony Caro, then on to the materials, the bronze and the steel, and the fabricators, then on to the installation, conveniently avoiding telling you what kind of satisfaction they give him.

"I'll tell you what they're not about," he might say. "They're not about two elves jumping over a nymph in a forest." That's fair; most of them have names like "Construction No. 23: An Arc Connected by Two Parallel Perpendiculars." That's not "Sunrise at Montauk" or "Stella by Starlight." But for anyone who knows Arthur Carter, that particular structural certitude is an assertion of protective, comforting logic in a slam-bam world often stripped of rationality by its careless custodians. And if the sculptures hold their space in this world and assert their meanings, it has something to do with an investment in a kind of agreeable security, even optimism, and even balletic friendliness, that is due to their pleasing proportionality. Arthur Carter would either accept or reject this take, but it's right there for the viewer, not only in their constructions, but in their persimmon reds and tungsten blues, their brushed steel and deep bronzes. Arthur Carter makes a great show of his unsentimentality, but for the viewer, there's an assertive optimism

in his work that is consistent with the artist's world view, his ongoing belief in a merger of the pragmatic with an ambitious aesthetic.

"They're pure abstracts," he says, "There's not a scintilla of storytelling in them," and that's a fair statement. And he makes a claim for their "existential nihilism. Art for art's sake." Or, as they used to say at Metro-Goldwyn-Mayer, "*Ars gratia artis.*" If you ask him what he sees in his work, he'll say, "I see a well-put together piece." That's all very nice. But among those triangles and helixes and chords and arcs and ellipses, there's an affirmation of the interrelatedness of things in physics and nature, a reverence for the shapes of the universe, a real satisfaction taken from the geometry of things.

And a respect for the materials, the metals, and the tints. And then in the human work that has been attached to fabricating them. Arthur Carter makes many claims for himself as an abstractionist; but the more you live with his work, and focus on it, the more infused with a world view and vibrant it seems. From the little maquettes he starts with to the graceful swoops, chunks, swirls, curvilinears, and hunks he completes, he may call them geometry, but they dance in place. They may be abstract, but they also assert life, quote the graceful laws of geometry, and state a human intelligence trying to find calm and make sense of the magic reliable ratio that brings some order to the madness of the world.

Abstract, it is. Nihilistic, not. It's art, both thoughtful and surprisingly affirming, born welded from the memory and sensibility of this exertive, driven, complicated, literate, blow-torch sensibility, devourer of novels and budgets who finds shape and solace in numbers and nature. They are pieces that surely give back to the artist: *Ars gratia* Arthur.

OPPOSITE: *Largo*, 1997. Bronze, 72 x 60 x 30 in.

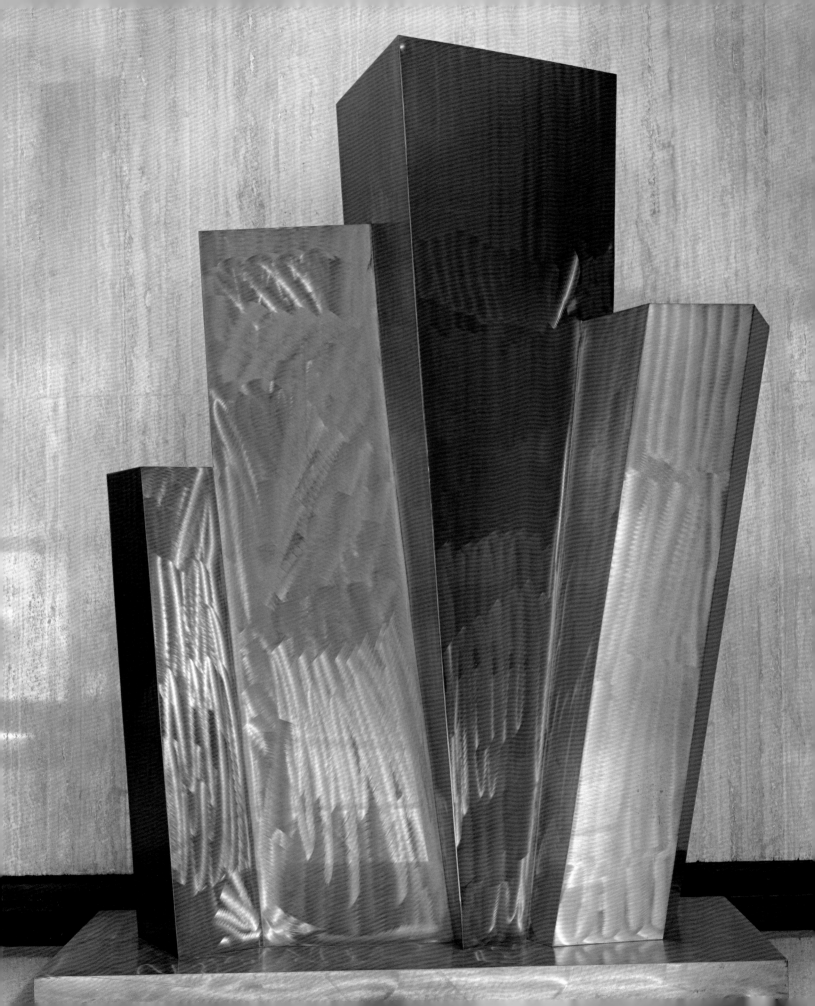

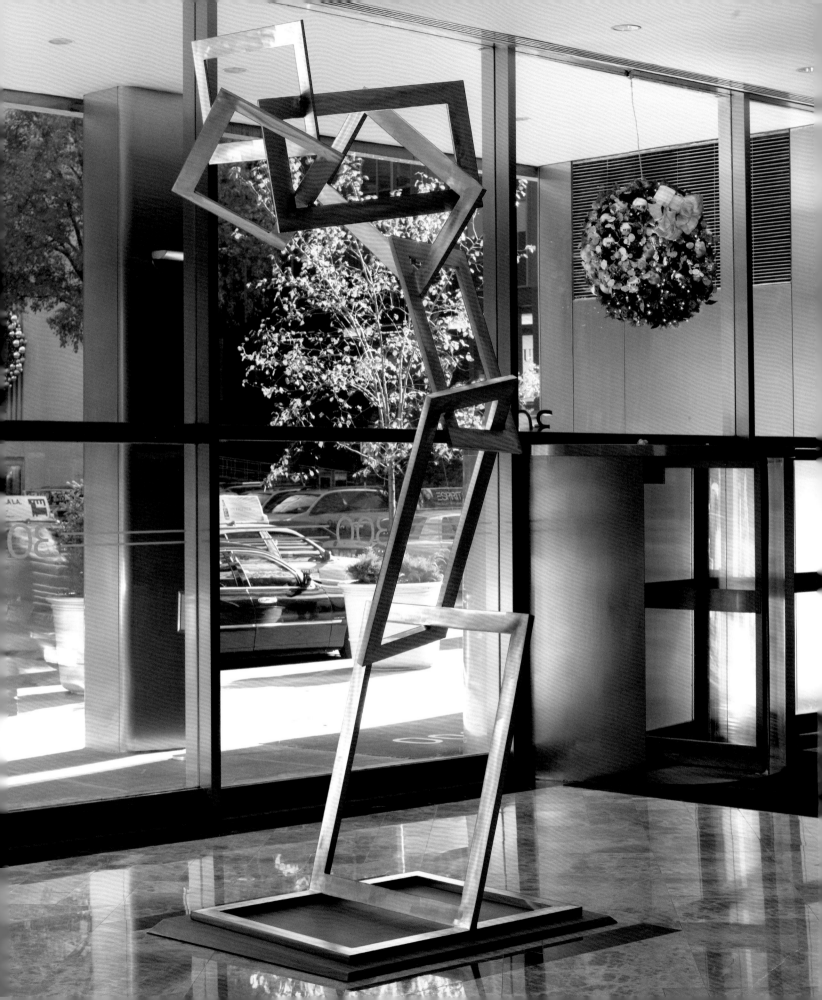

But they give to us as well: Take a walk through New York City. It is, in many ways, still Arthur Carter's town, the town where he built businesses and published a newspaper, but more than that, a town where he has left his massive steel and bronze markers on the street. At 90 Park Avenue South between 39th and 40th Streets, you'll find *The Couple* (see page 2), his pair of giant merging ellipses. At 300 Park Avenue between 49th and 50th Streets, *Psyche* (see page 198). And down at NYU, right next to the Bobst Library, *The University* (see page 68). A few years ago, in the nineties, he had sculptures placed in a sculpture garden outside the General Motors Building. The outdoor pieces have no names listed, but they are indisputably Arthur Carter, in their strength, weight, and unpredictable rationality. They are his legacy and, even in their abstraction, his autobiography. They speak to the sidewalk passers-by, but mostly assert their presence with a kind of impatience that comes right from the metabolism of the sculptor who inhabits these pages. And very much like him, they argue, dominate, and commune with the air and light of the city whose confident constructions only occasionally yield to the laws and conventions of the street traffic's universe, but more often attempt to scrape against time itself.

OPPOSITE: *Psyche*, 1999. Bronze, 144 x 60 x 48 in.

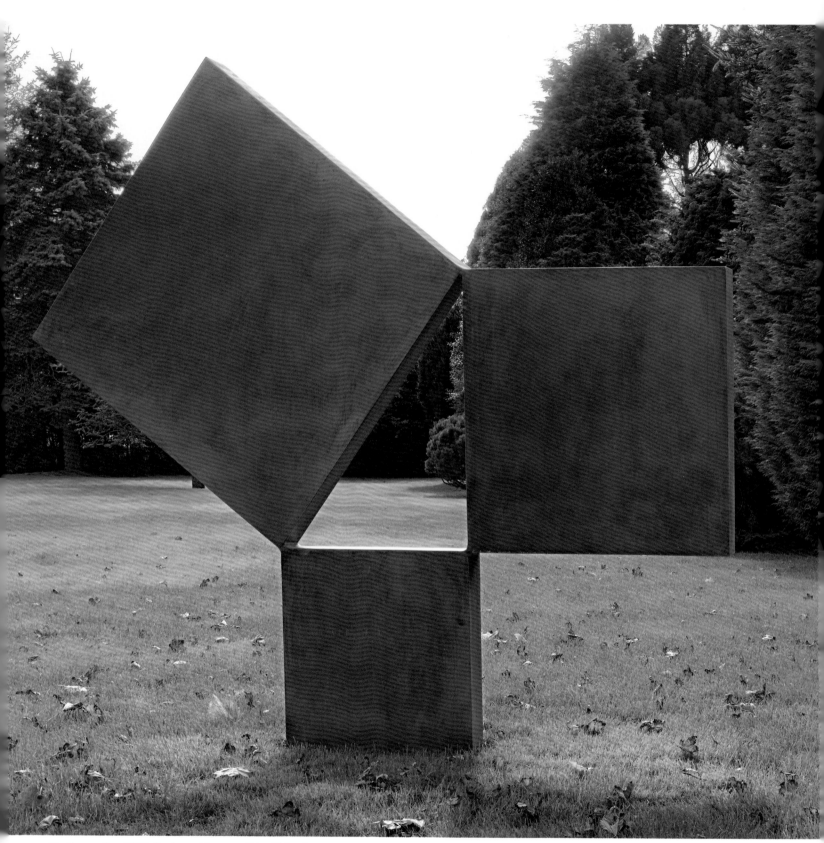

Mathematika, 1997. Darkened bronze, 96 x 105 x 5 in.

CHRONOLOGY

1931 Born in New York to Rosalind and Eugene Carter. Rosalind Carter is a French teacher; Eugene Carter is an IRS agent with the United States Department of the Treasury.

1932 The family moves to Woodmere, New York, where they live for many years.

1936 Begins public school in Woodmere, New York.

1937 Begins training as a classical pianist.

1949 Graduates from Woodmere High School and enrolls at Brown University.

1953 Graduates from Brown University with an AB in French Literature. Begins Officer Candidate School in New London, Connecticut, for the United States Coast Guard; serves as lieutenant junior grade for three years. Learns to weld while in Officer Candidate School.

1956 Honorably discharged from the United States Coast Guard. Joins Lehman Brothers, an investment banking firm in New York, where he works in the industrial department.

1957 Takes a leave of absence from Lehman Brothers to attend the Tuck School of Business at Dartmouth College.

1959 Graduates from the Tuck School with an MBA.

1960 Founds the firm of Carter, Berlind, Potoma & Weill with partners Roger Berlind and Sanford Weill.

1962 Carter, Berlind, Potoma & Weill becomes Carter, Berlind & Weill. Shortly thereafter, Arthur Carter is named president and chief executive officer of the firm.

1964 Teaches corporate finance at The New School in New York.

1968 Leaves Carter, Berlind & Weill to launch The Carter Group, a private equity company that acquires controlling interests in public companies.

1976	Teaches business economics at Iona College in New Rochelle, New York.
1978	Founds Telepictures Corporation, a movie distribution company for television.
1980	Acquires a 1,500-acre dairy farm in Roxbury, Connecticut, which he soon uses as a studio and fabrication facility for steel and bronze constructions.
1981	Founds *The Litchfield County Times* and serves as publisher. Oversees the graphic design of the newspaper, which leads to his interest in art and design.
1985	Acquires *The Nation* magazine and is named publisher. Appointed a trustee of New York University.
1987	Founds *The New York Observer* and serves as publisher. Also serves as lead graphic designer, which expands his interest in sculpture, drawing, and painting.
1990	Builds a studio in Roxbury, Connecticut; begins to construct maquettes from copper wire and clay, as well as larger, welded constructions from stainless steel and bronze.
1991	Acquires a 50 percent interest in *The East Hampton Star* and serves as publisher.
1992	Named adjunct professor of philosophy at New York University.
1995	Sells his interest in *The Nation* magazine.
2000	One-person exhibition at the Salander-O'Reilly Galleries in New York. Sculpture exhibition at Galerie Piltzer in Paris, France. Named adjunct professor of journalism at New York University.
2001	Sells his 50 percent interest in *The East Hampton Star*. Appointed chairman of New York University's Arts and Science Board of Overseers. Installs six sculptures in the plaza of the General Motors Building in New York.
2002	Second one-person exhibition at the Salander-O'Reilly Galleries in New York. One-person exhibition at the Minor Memorial Library in Roxbury, Connecticut.
2003	Sells *The Litchfield County Times*.
2004	Third one-person exhibition at the Salander-O'Reilly Galleries in New York; the show includes sculptures and drawings. Sculpture exhibition at Gallery Henoch in New York. Exhibits six stainless steel and bronze sculptures in the United Nations Gateway Sculpture Exhibition in New York.
2005	One-person exhibition at the Tennessee State Museum in Nashville, Tennessee.
2006	Fourth one-person exhibition at the Salander-O'Reilly Galleries in New York. Sells an 80 percent interest in *The New York Observer*.
2008	Opens The Gallery at 50 East 78th Street in New York, primarily to exhibit his paintings, sculptures, and drawings, as well as selected works of other artists. New York University inaugurates the Arthur L. Carter Journalism Institute.
2009	One-person exhibition at the Grey Art Gallery at New York University.

OPPOSITE: Arthur Carter in his studio, 2008.

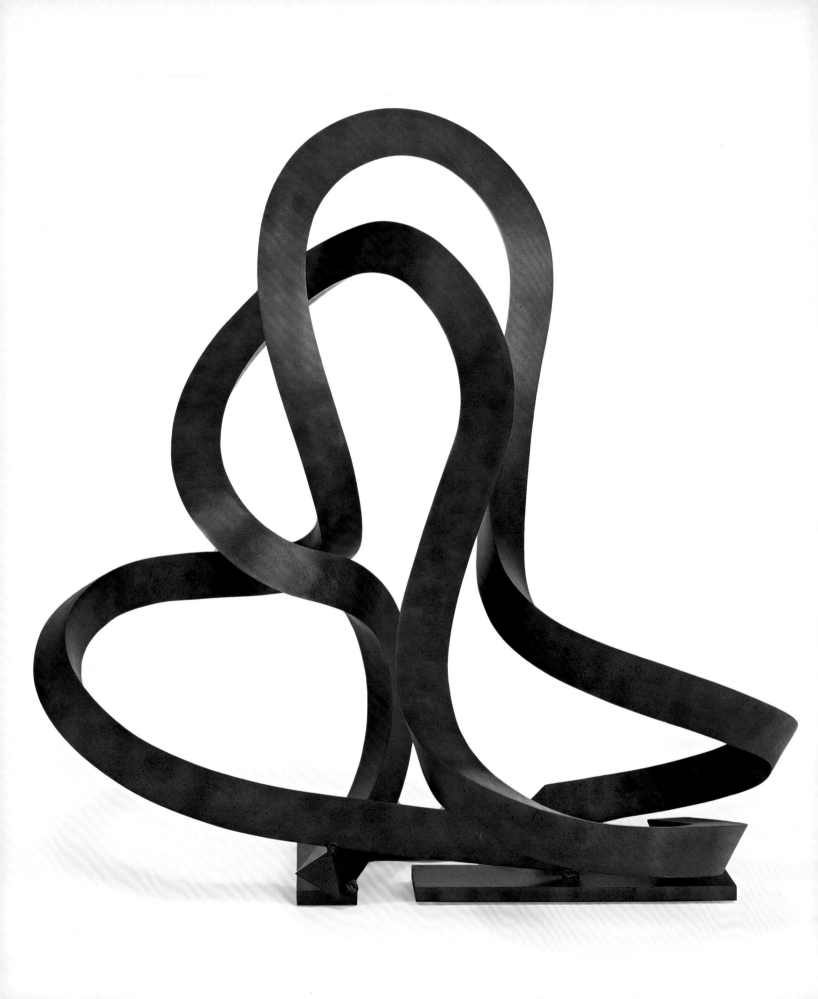

INDEX

OPPOSITE: **Elliptical Loops**, 2005. Bronze with green patina, 38 x 37 x 22 in.